Manga

Sixty Years of Japanese Comics

'Back in those days
when you could only get
your hands on specialist
rental books of gekiga
comics in out-of-the-way
stores, they had ten times
more ferocity, vitality,
power and cruelty.'

Yukio Mishima

'Now we are living in the age
of comics as air.'

Osamu Tezuka

'For me, the manga Maki
Sasaki drew have had the
continued effect of opening
a window to a particular
place inside me....
Through my books,
I wanted to pass on to the
younger generation that
same intensity which Sasaki
provided for my generation.'

Haruki Murakami

Manga

Sixty Years of Japanese Comics

Paul Gravett

Laurence King Publishing
in association with
Harper Design International
An imprint of HarperCollinsPublishers

Dedicated to my Mum and Dad
who never threw out my comics collection

LAURENCE KING

Published in 2004 by Laurence King Publishing Ltd
71 Great Russell Street
London WC1B 3BP
United Kingdom
Tel: +44 20 7430 8850
Fax: +44 20 7430 8880
e-mail: enquiries@laurenceking.co.uk
www.laurenceking.co.uk

First published in the United States in 2004 by
Harper Design International, an imprint of HarperCollins *Publishers*
10 East 53rd Street
New York, NY 10022
Fax: (212) 207 7654

HarperCollins books may be purchased for educational, business,
or sales promotional use. For information, please write to:
Special Markets Department,
HarperCollins*Publishers* Inc.,
10 East 53rd Street, New York, NY 10022.

A catalogue record for this book is available from the British Library.

ISBN: 1 85669 391 0

Printed in Singapore

Designed by Peter Stanbury

On the front cover and spine: Astro Boy by Osamu Tezuka
© Tezuka Productions
On the back cover: Peach Girl by Miwa Ueda
© Miwa Ueda

How to use this book

The pages of manga shown in Japanese in this book
should be read from right to left, the reverse direction
to Western comics.

The pages of manga shown in English or translated
versions have been 'flopped' or reversed, and so
should be read from left to right.

In other translated pages where the original
Japanese layout has been kept, these should be read
from right to left, as indicated by the arrow symbol ◀◀.

Numbers appear next to sequences of pages to
show the order in which they should be read.

Japanese names have been Westernized by
putting the family name last. Japanese words and titles
have been romanized as simply and consistently as
possible, according to the usual spellings used by their
publishers and creators.

Contents

Introduction:

008 Irresponsible Pictures
Addressing perceptions and prejudices

Chapter 01:

010 Catch Up, Overtake
The medium, the industry, the market, the profession

Chapter 02:

018 Japanese Spirit, Western Learning
Roots in traditional arts and imported cartoons and strips

Chapter 03:

024 The Father Storyteller
The life and role of Osamu Tezuka, originator of story manga

Chapter 04:

038 From a Darker Place
Gekiga or 'dramatic pictures' from pay libraries to newsstands

Chapter 05:

052 Boys are Forever
Boys' comics as the driving force of story manga

Chapter 06:

074 Through a Woman's Eyes
The genres and genders of girls' and women's comics

Chapter 07:

096 Developing Maturity
The mass market for young males and adult men grows up

Chapter 08:

116 The All-Encompassing
A medium for every taste, interest and stage of life

Chapter 09:

132 Personal Agendas
The individualism of underground, fanzine and art comics subcultures

Chapter 10:

152 Culture and Imperialism
Manga as a major export and global influence

TIMELINE 006 RESOURCES 172 ACKNOWLEDGMENTS 174 INDEX 175

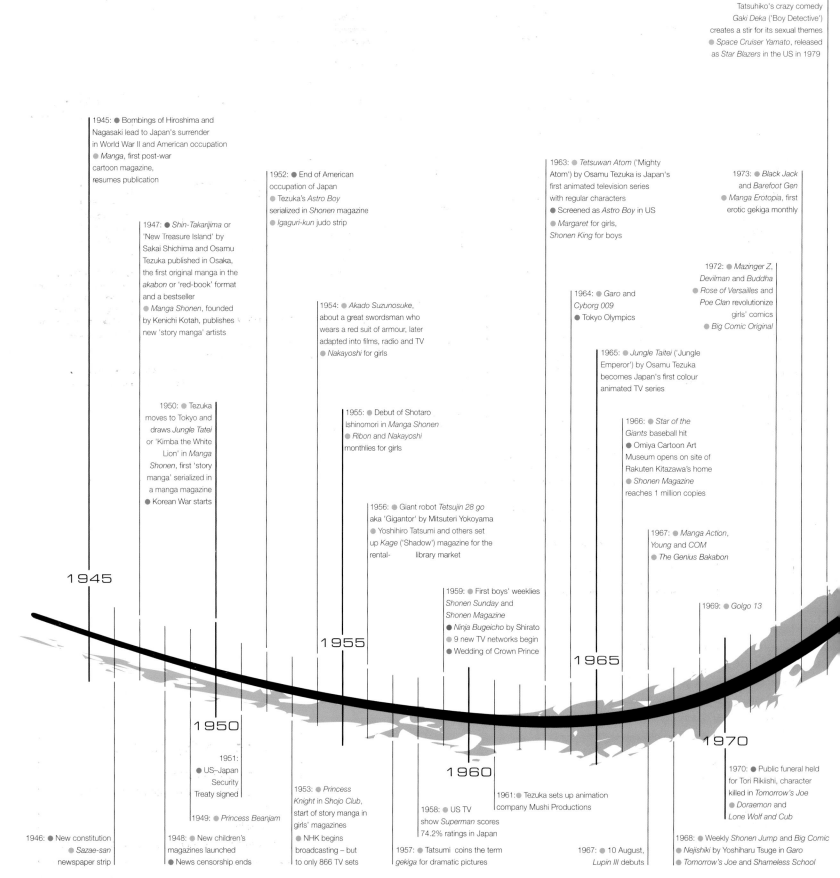

1974: ● Yamagami Tatsuhiko's crazy comedy *Gaki Deka* ('Boy Detective') creates a stir for its sexual themes ● *Space Cruiser Yamato*, released as *Star Blazers* in the US in 1979

1945: ● Bombings of Hiroshima and Nagasaki lead to Japan's surrender in World War II and American occupation ● *Manga*, first post-war cartoon magazine, resumes publication

1952: ● End of American occupation of Japan ● Tezuka's *Astro Boy* serialized in *Shonen* magazine ● *Igaguri-kun* judo strip

1963: ● *Tetsuwan Atom* ('Mighty Atom') by Osamu Tezuka is Japan's first animated television series with regular characters ● Screened as *Astro Boy* in US ● *Margaret* for girls, *Shonen King* for boys

1973: ● *Black Jack* and *Barefoot Gen* ● *Manga Erotopia*, first erotic gekiga monthly

1947: ● *Shin-Takarijima* or 'New Treasure Island' by Sakai Shichima and Osamu Tezuka published in Osaka, the first original manga in the *akabon* or 'red-book' format and a bestseller ● *Manga Shonen*, founded by Kenichi Kotah, publishes new 'story manga' artists

1954: ● *Akado Suzunosuke*, about a great swordsman who wears a red suit of armour, later adapted into films, radio and TV ● *Nakayoshi* for girls

1972: ● *Mazinger Z*, *Devilman* and *Buddha* ● *Rose of Versailles* and *Poe Clan* revolutionize girls' comics ● *Big Comic Original*

1964: ● *Garo* and *Cyborg 009* ● Tokyo Olympics

1965: ● *Jungle Taitei* ('Jungle Emperor') by Osamu Tezuka becomes Japan's first colour animated TV series

1950: ● Tezuka moves to Tokyo and draws *Jungle Tatei* or 'Kimba the White Lion' in *Manga Shonen*, first 'story manga' serialized in a manga magazine ● Korean War starts

1955: ● Debut of Shotaro Ishinomori in *Manga Shonen* ● *Ribon* and *Nakayoshi* monthlies for girls

1966: ● *Star of the Giants* baseball hit ● Omiya Cartoon Art Museum opens on site of Rakuten Kitazawa's home ● *Shonen Magazine* reaches 1 million copies

1956: ● Giant robot *Tetsujin 28 go* aka 'Gigantor' by Mitsuteri Yokoyama ● Yoshihiro Tatsumi and others set up *Kage* ('Shadow') magazine for the rental-library market

1967: ● *Manga Action*, *Young* and *COM* ● *The Genius Bakabon*

1945

1959: ● First boys' weeklies *Shonen Sunday* and *Shonen Magazine* ● *Ninja Bugeicho* by Shirato ● 9 new TV networks begin ● Wedding of Crown Prince

1969: ● *Golgo 13*

1955

1965

1950

1951: ● US–Japan Security Treaty signed

1953: ● *Princess Knight* in *Shojo Club*, start of story manga in girls' magazines ● NHK begins broadcasting – but to only 866 TV sets

1960

1958: ● US TV show *Superman* scores 74.2% ratings in Japan

1961: ● Tezuka sets up animation company Mushi Productions

1970

1970: ● Public funeral held for Tori Rikiishi, character killed in *Tomorrow's Joe* ● *Doraemon* and *Lone Wolf and Cub*

1949: ● *Princess Beanjam*

1946: ● New constitution ● *Sazae-san* newspaper strip

1948: ● New children's magazines launched ● News censorship ends

1957: ● Tatsumi coins the term *gekiga* for dramatic pictures

1967: ● 10 August, *Lupin III* debuts

1968: ● Weekly *Shonen Jump* and *Big Comic* ● *Nejishiki* by Yoshiharu Tsuge in *Garo* ● *Tomorrow's Joe* and *Shameless School*

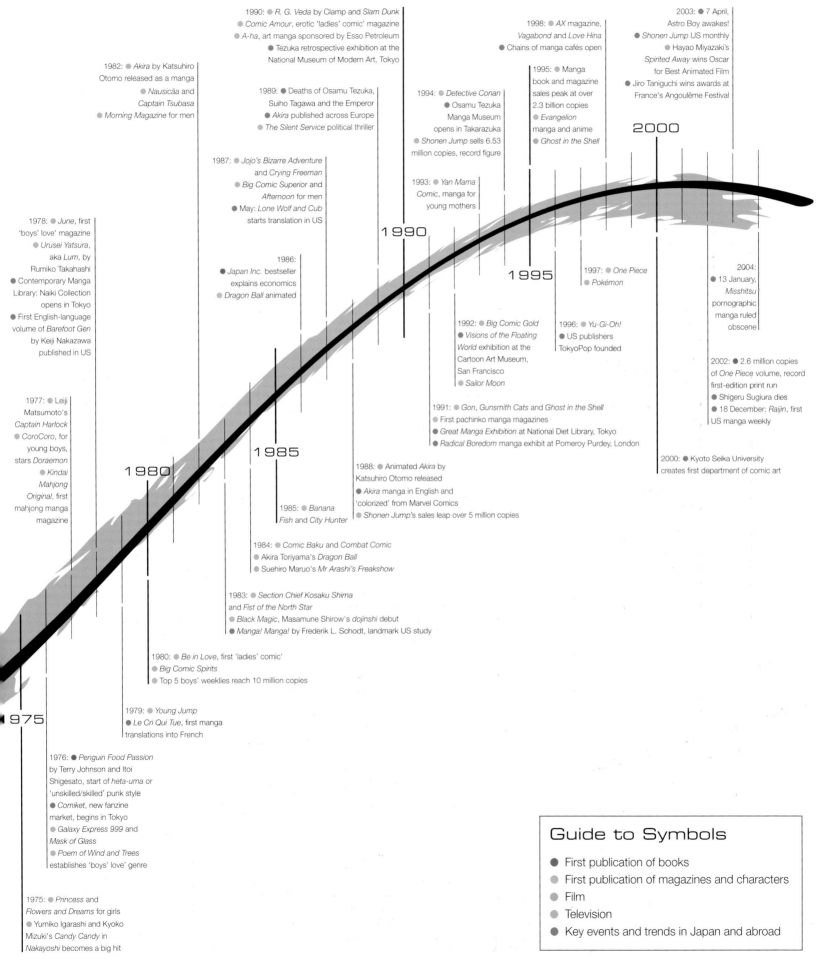

1990: ● *R. G. Veda* by Clamp and *Slam Dunk*
● *Comic Amour*, erotic 'ladies' comic' magazine
● *A-ha*, art manga sponsored by Esso Petroleum
● Tezuka retrospective exhibition at the National Museum of Modern Art, Tokyo

1998: ● *AX* magazine, *Vagabond* and *Love Hina*
● Chains of manga cafés open

2003: ● 7 April, Astro Boy awakes!
● *Shonen Jump* US monthly
● Hayao Miyazaki's *Spirited Away* wins Oscar for Best Animated Film
● Jiro Taniguchi wins awards at France's Angoulême Festival

1982: ● *Akira* by Katsuhiro Otomo released as a manga
● *Nausicäa* and *Captain Tsubasa*
● *Morning Magazine* for men

1989: ● Deaths of Osamu Tezuka, Suiho Tagawa and the Emperor
● *Akira* published across Europe
● *The Silent Service* political thriller

1994: ● *Detective Conan*
● Osamu Tezuka Manga Museum opens in Takarazuka
● *Shonen Jump* sells 6.53 million copies, record figure

1995: ● Manga book and magazine sales peak at over 2.3 billion copies
● *Evangelion* manga and anime
● *Ghost in the Shell*

2000

1987: ● *Jojo's Bizarre Adventure* and *Crying Freeman*
● *Big Comic Superior* and *Afternoon* for men
● May: *Lone Wolf and Cub* starts translation in US

1993: ● *Yan Mama Comic*, manga for young mothers

1990

1978: ● *June*, first 'boys' love' magazine
● *Urusei Yatsura*, aka *Lum*, by Rumiko Takahashi
● Contemporary Manga Library: Naiki Collection opens in Tokyo
● First English-language volume of *Barefoot Gen* by Keiji Nakazawa published in US

1986: ● *Japan Inc.* bestseller explains economics
● *Dragon Ball* animated

1995

1997: ● *One Piece*
● *Pokémon*

2004: ● 13 January, *Misshitsu* pornographic manga ruled obscene

1992: ● *Big Comic Gold*
● *Visions of the Floating World* exhibition at the Cartoon Art Museum, San Francisco
● *Sailor Moon*

1996: ● *Yu-Gi-Oh!*
● US publishers TokyoPop founded

1977: ● Leiji Matsumoto's *Captain Harlock*
● *CoroCoro*, for young boys, stars *Doraemon*
● *Kindai Mahjong Original*, first mahjong manga magazine

1991: ● *Gon*, *Gunsmith Cats* and *Ghost in the Shell*
● First pachinko manga magazines
● *Great Manga Exhibition* at National Diet Library, Tokyo
● *Radical Boredom* manga exhibit at Pomeroy Purdey, London

2002: ● 2.6 million copies of *One Piece* volume, record first-edition print run
● Shigeru Sugiura dies
● 18 December: *Raijin*, first US manga weekly

1980

1985

1988: ● Animated *Akira* by Katsuhiro Otomo released
● *Akira* manga in English and 'colorized' from Marvel Comics
● *Shonen Jump*'s sales leap over 5 million copies

2000: ● Kyoto Seika University creates first department of comic art

1985: ● *Banana Fish* and *City Hunter*

1984: ● *Comic Baku* and *Combat Comic*
● Akira Toriyama's *Dragon Ball*
● Suehiro Maruo's *Mr Arashi's Freakshow*

1983: ● *Section Chief Kosaku Shima* and *Fist of the North Star*
● *Black Magic*, Masamune Shirow's *dojinshi* debut
● *Manga! Manga!* by Frederik L. Schodt, landmark US study

1980: ● *Be in Love*, first 'ladies' comic'
● *Big Comic Spirits*
● Top 5 boys' weeklies reach 10 million copies

1975

1979: ● *Young Jump*
● *Le Cri Qui Tue*, first manga translations into French

1976: ● *Penguin Food Passion* by Terry Johnson and Itoi Shigesato, start of *heta-uma* or 'unskilled/skilled' punk style
● *Comiket*, new fanzine market, begins in Tokyo
● *Galaxy Express 999* and *Mask of Glass*
● *Poem of Wind and Trees* establishes 'boys' love' genre

1975: ● *Princess* and *Flowers and Dreams* for girls
● Yumiko Igarashi and Kyoko Mizuki's *Candy Candy* in *Nakayoshi* becomes a big hit

Guide to Symbols

● First publication of books
● First publication of magazines and characters
● Film
● Television
● Key events and trends in Japan and abroad

Introduction

Irresponsible Pictures

WHAT ARE MANGA? Try looking the word up in the Oxford English Dictionary and you'll find a very misleading definition. The OED says that they are 'Japanese comic books and cartoon films with a science fiction or fantasy theme'. This is wrong on two counts: manga are not Japanese animation (which is closely related but is properly known as anime), and they actually deal with almost every theme imaginable, not just sci-fi and fantasy.

So, roughly speaking, the word manga in English means Japanese comics. Westerners often have a number of preconceptions about them: 'All the characters have big, Bambi-like eyes'; 'The magazines are as thick as phone directories'; 'Businessmen devour them in public on trains'; 'They are full of sex and violence.' Often misrepresented as little more than 'tits and tentacles', manga were, and still are, open to being doubly damned in the West for being Japanese, and for being comics.

Wherever you go, prejudice seems inevitable where 'comics' are concerned. Personally, I have a great regard for their culture of words and pictures and I am particularly fascinated by the sheer diversity of Japanese comics. As with any popular publishing phenomenon, taking a closer look reveals surprising and unexpected qualities and truths among the ocean of overexcited pages. Part of my endeavour here is to draw attention to the creations that stand out above the ordinary, that don't just glide by forgettably but at the very least make the reader pause, admire and perhaps even think and feel. However, since some people undeniably have an 'attitude' towards comics, let's try and put some of that prejudice into perspective.

In 1951, the Japanese gave General Douglas MacArthur a hero's farewell. After nearly six years overseeing the American occupation and post-war reconstruction of Japan, MacArthur had been abruptly recalled after disagreeing with President Truman over US military policy towards the

Chinese in the Korean War. Japanese admiration for MacArthur evaporated overnight, when, during his subsequent three-day testimony to the Senate, he described the Japanese patronizingly as being 'like a boy of twelve'. In fact, he had intended to express his regard for the Japanese 'susceptib[ility] to following new models, new ideas', and therefore to declare them more trustworthy than the Germans. But his unfortunate and clumsy phraseology provided a rude awakening for the Japanese, who interpreted what was well-meant as an insult. Nevertheless, MacArthur's phrase was very revealing of how the West now saw them: childlike, immature, very much the dependent junior to a paternalistic, controlling America.

For years, this quaint caricature seemed to reassure the West of its superiority. The illusion was shattered in the late 1960s when Japanese cars and electronic goods began seemingly out of the blue to overtake global markets, and the label 'Made in Japan' no longer suggested shoddy imitation but quality and innovation. Caught off-guard, the Western powers greeted this zealous economic empire-building with a mixture of anxiety and envy, while a whole congratulatory literature sprang up extolling the unique 'Japaneseness' that had transformed a defeated country into a superpower and role model in little more than two decades. The 'boy of twelve' was growing up.

As the West looked again in puzzlement and not a little fear at the emerging giant, another equally patronizing caricature of the Japanese as being 'like a boy of twelve' was emerging via reports of their baffling, otherworldly comic books. In the early 1970s, during her two years in Japan, novelist and feminist critic Angela Carter's fascination with the Sadeian excesses she found in manga horrified readers of her dispatches to the British magazine *New Society*. Recording his fraught train journey from London to Tokyo in *The Great Railway Bazaar* in 1975, American travel writer Paul Theroux described his disgust

Below: Xenophobic stereotyping of the Japanese in American comic-book propaganda, 1944. Right: manga's two constituent ideograms, *man* and *ga*.

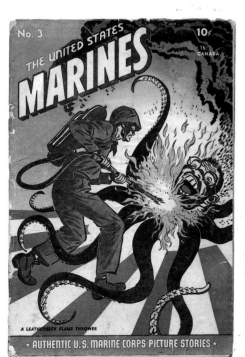

No. 3　10¢
15 CANADA
THE UNITED STATES
MARINES
A LEATHERNECK FLAME THROWER
★ AUTHENTIC U.S. MARINE CORPS PICTURE STORIES ★

at the 'decapitations, cannibalism, people bristling with arrows like Saint Sebastian… and, in general, mayhem' inside a 'distressing comic' left by a girl on the seat next to him. Unlike in the fields of literature, film, even pop music or football, where Japanese comics are concerned it seems that anybody can be taken seriously for their opinion, regardless of their knowledge of the medium.

By the 1980s, when a skewed sample of manga and anime started to be exported, one image repeatedly came to sum up Western disdain towards the Japanese and their comics: the business-suited salaryman on the commuter train to work, absorbed in his violent, sexy manga magazine. A 1987 headline in *The Wall Street Journal* mocked: 'Grown Men in Japan Still Read Comics and Have Fantasies'. This was yet another caricature of 'the boy of twelve', but with the boy now occupying an adult body and displaying a taste for the disgusting and the cruel.

The very word 'manga' entered English parlance weighed down with negative baggage. Not that it was his fault, but it was probably Frederik Schodt's landmark 1983 study, *Manga! Manga!*, that started this. Here Schodt explained the meanings of the word's two constituent Chinese ideograms: *man*, meaning 'involuntary' or 'in spite of oneself', and *ga*, meaning 'pictures'. The Japanese artist Hokusai had coined the term in 1814 for his books of 'whimsical sketches'. The ideogram *man*, Schodt added, 'has a secondary meaning of "morally corrupt"', which produced a translation of 'irresponsible pictures'. Not surprisingly, this morally charged definition was pounced on by the media and critics of the form, so ensuring the effective stigmatization of manga in the West.

The appeal of cultural snobbery is universal and extends to Japan itself. The Japanese establishment has been embarrassed by the national portrait manga transmit abroad. In 1991, as part of the largest ever Japanese cultural festival held in Britain, Oxford's Museum of Modern Art was keen to exhibit Japanese comics in all their variety; ironically it was their Japanese sponsors who were uncomfortable with the inclusion of more adult and disturbing material. When MOMA refused to compromise, the project collapsed. Stirred into action, a small independent London art gallery, Pomeroy Purdy, stepped into the breach and staged an exhibition of manga, deliberately slanting their choice of examples towards the marginal and often extreme avant-garde. Unsettling imagery such as Mitsuhiko Yoshida's menstrual nightmare of a pre-pubescent girl being chased by a phallic horned rhino only confirmed people's worst fears of 'Japanese laughing matter', as the *Daily Telegraph* described it.

Ten years later, the mounting commercial success of manga abroad forced the organizers of Britain's second Japan Festival in 2001 to admit comics alongside the more traditional tea ceremonies and examples of Kabuki theatre. The Japan Foundation decided to display 25 short stories, which had already been shown in Paris and Rotterdam. Work by four artists that had been exposed to the Dutch and French was removed, however, presumably because it was deemed unsuitable for the British palate. This revision did not stop British reviewers from reminding the public that manga were pornographic, even though only one page in the exhibit included some bare breasts. Even this nudity was swiftly covered up following a complaint at a family fun day when the exhibit was shown in Brighton.

Prejudices refuse to go away. Instead, they tend to take on new forms. The tired spectre of comics contributing to illiteracy was revived in the *New York Times* on 10 January 2002, when a report asserted that Japan had a low literacy level because people preferred to read subliterate manga instead of memorizing the thousands of characters needed to decipher Japanese. The paper was subsequently forced to print a retraction, acknowledging that Japan had a very high literacy rate, far ahead of America's.

This book is no eulogy or apology for manga. If anything, it will show that they can indeed be 'irresponsible', irredeemably so, often the products of largely unfettered individual minds allowed to respond to the moment and to their readers' desires. But it will also show that manga's 'irresponsible pictures' may well be their greatest strength.

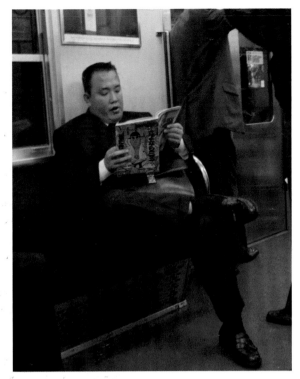

Above: Whatever next? Grown men reading manga on public transport.

Below: General MacArthur's arrival portrayed in Keiji Nakazawa's *Barefoot Gen*.

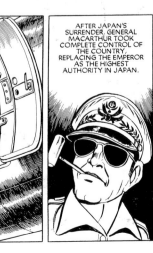

Catch Up, Overtake

THERE ARE NO 'foreigners' in Japan, only 'outside persons', or *gaijin*. This concept of the 'outside person' seems to encapsulate Japan's image as an exclusive, inward-looking, self-contained country, sealed off by blood and tradition. This national identity as a race apart was forged during nearly three centuries of self-imposed isolation. The first 'outside' nation to push its way back in was the United States, whose ships steamed into Edo Bay in 1853. The ruling Japanese shogunate was given little choice but to sign the visitors' trading treaties; other Western countries swiftly followed in the Americans' wake. There was turmoil as shogun control collapsed; when the emperor was reinstalled in 1868, he advocated 'the seeking of knowledge throughout the world in order to strengthen the country'. Thus, if the Japanese could no longer avoid it, contact with the outside world was at least to be made on their own terms, as part of their patriotic duty to help make the nation stronger.

In the campaign of the early Meiji period (1868–1912) to ensure that the people took modernization to their hearts, slogans were persuasive weapons. One extolled them to *oitsuke! oikose!* or 'Catch up! Overtake!'. The fact that the Japanese did catch up and overtake vindicates General MacArthur's high opinion of them. It could be said that the Japanese have always been quick to learn from the 'outside person'. More than a millennium ago, China was Japan's first great teacher, but this

relationship lasted only until Japan was ready to pursue its own direction. In the 19th century, the newly opened nation reinvented itself as an empire-builder by closely studying and copying the Western imperial powers. After World War II, Japan was so efficiently indoctrinated in American capitalism that the conquered frequently went on to outstrip the conqueror. Yet again the Japanese island mentality proved able to absorb a foreign concept, adapt and improve on it, and then export it back to the outside world.

With manga, the Japanese have demonstrated the same facility as with the automobile or the computer chip. They have taken the fundamentals of American comics, the relationships between picture, frame and word, and, by fusing them with their own traditional love for popular art that entertains, have 'Japanized' them into a storytelling vehicle with its own distinctive form. Manga are not comics, at least not as most people know them in the West. The Japanese have liberated the medium's language from the confining formats and genres of the daily newspaper strip or the 32-page American comic book, and expanded its potential to embrace long, free-form narratives on almost every subject, for both sexes and almost every age and

Below: Browsers can choose between the approximately 300 different manga magazine titles for all age groups and sexes that swamp the newsstands every month.

Above: Fresh off the press, bundles of some of the latest *redikomi*, or ladies' comics, waiting to be cut open. Opposite: Kodansha's top-selling weekly *Young* serves up over 340 newsprint pages of 'men's interest' serials and gag strips. This judo story cover is by Makoto Kobayashi.

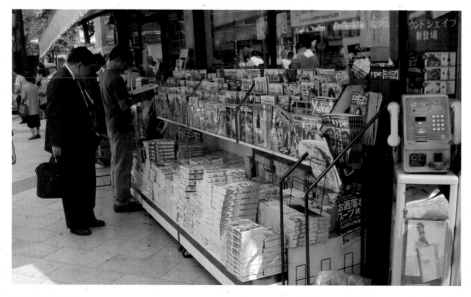

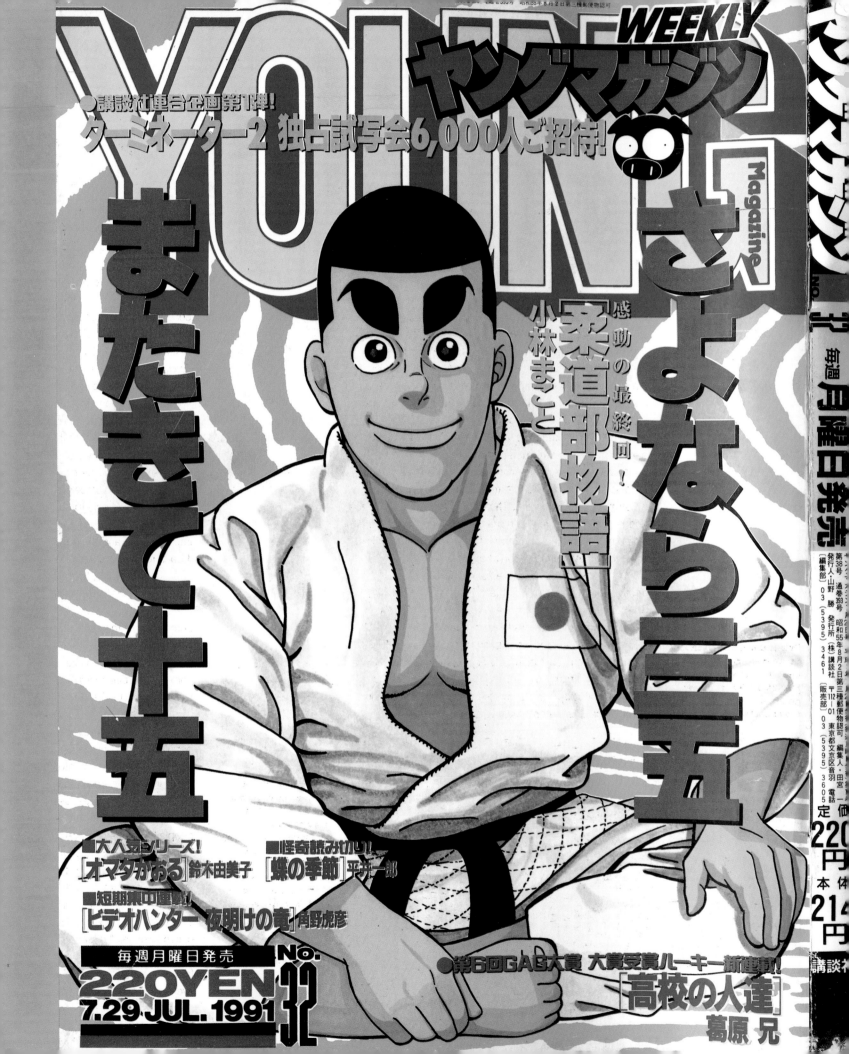

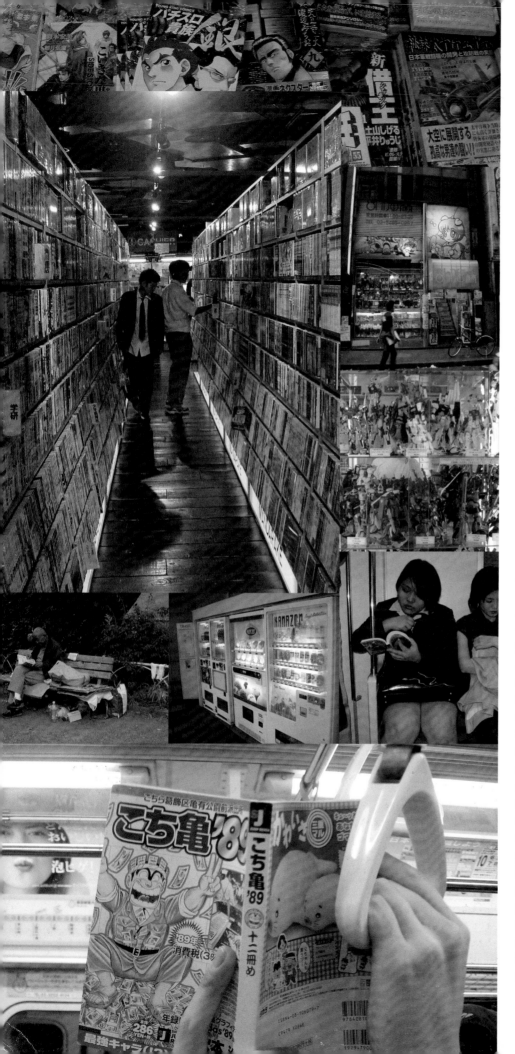

social group. The Japanese have developed comics into such a powerful mass literature that it can stand up against the seemingly unstoppable dominance of television and movies. In fact, manga have a hold over Japanese TV and film; a good many of the most successful works in both media derive from manga, having been either adapted into animation or live-action productions.

Of course, there was a time when an equally high level of media power was enjoyed by comics in America. This was back during the heyday of the newspaper strips in the early decades of the 20th century. The so-called 'funnies' were syndicated to papers from coast to coast and across the globe, their daily episodes enthralling young and old alike. When a newspaper strike hit New York, Mayor La Guardia read out the latest instalments over the radio. When Little Orphan Annie's dog Sandy went missing, none other than Henry Ford sent the publishers an anxious telegram. Rumour has it that an impatient president rang Dick Tracy's originator to find out what was going to happen the next day. The strips were spun off into radio serials, stage shows and movies, and became as potent an export and symbol of American cultural imperialism as the cinematic productions of Hollywood. The newspaper comics swept the globe, reaching Japan. Universal in their storytelling clarity and appeal, America's stories became the world's stories.

From its inception in 1933 through to its near-death in the mid-1950s, the American format of the 'comic book' (actually more magazine than book) became an almost indispensable part of everyday life in the USA. The American way of life was sold and devoured through the comic book, 'all in color for a dime'. Then, just as comic books in America were starting to address real-life issues and winning more of an adult audience, they became the target of Cold War moral panic. They also became the scapegoat for rising juvenile crime. In 1954, in the wake of the Communist witch-hunt, the most powerful and conservative publishers succumbed to patriotic fervour and imposed on themselves a strict code governing content that effectively emasculated comic books and drove them out of most adults' lives. The crime and horror genres were particularly targeted. These 'horrors' lent themselves to being exploited by anybody with a cause to promote. In America, they were demonized as being pro-Communist, whereas in Britain, motivated by anti-Americanism, the secretary of the Communist Party opposed their import on the pretext of protecting innocent minds and safeguarding jobs in Britain's own comics industry.

American comic books swept into Japan from 1945 via the occupying forces. Imagine the impact of

these strange new artefacts, all in pictures and in striking colours, on children who for years had suffered the deprivations of war. Comic books proved irresistible. Like chewing gum, they came and they stuck. Some titles were unofficially translated in pirate editions, such as the *Archie* comic books starring 'America's typical teenager'. The Japanese also began to make their own, increasingly using the same page size as American comics, but they produced them more cheaply, in black and white on low-quality paper over many more pages. Gradually, the range of themes expanded in synch with the readership, though not without resistance. Wherever you go, it seems that comics are guaranteed to court controversy when they presume to take on more challenging subjects.

Much of a Japanese person's home, school and work life is governed by strict notions of respect and hierarchy. The solitary activity of reading manga allows him or her to leave behind daily formalities and experience, if only vicariously, for the more liberated realms of the mind and the senses. In many societies where repression rules, extraordinary and provocative creativity results. For all their outward decorum and ritual, such as the precisely regulated angles of bowing and terms of address, the Japanese are inclined towards a pragmatic and tolerant approach to religion and morality. This makes quite a sharp contrast to the 'liberated' West. Compared to Europeans and Americans, the Japanese generally have far more relaxed attitudes about representations of sex and bodily functions. No wonder earlier generations of Westerners professed outrage at the explicitness of Japanese erotic prints, forerunners of some of manga's wilder moments.

Manga's success proves that size does matter. American monthly comic books of the 1930s offered a selection of different stories printed in four colours across 64 pages. As production costs rose, publishers held the cover price at ten cents, and so began to whittle down the number of pages. By the 1950s, there were only 32. This is where it has remained ever since, despite sporadic attempts to introduce formats with more pages. The 1960s saw the cover price start to rise, skyrocketing through the 1970s and 1980s, so that the average 32-page comic book today pushes $3 for 20-something story pages plus adverts. Not surprisingly, current top-ten sellers are lucky to shift 100,000 copies, mostly to collectors through specialized comic shops. At least British and Franco-Belgian weekly and monthly comics are still sold off the newsstands, even if they don't offer many pages in return for their pocket-money price. Newer titles based on the latest TV and toy crazes are a more expensive brand and so are usually bought by

parents for their kids, as much for the free gifts taped to the cover as for what's inside.

In contrast, what appears to govern the purchase of Japanese manga periodicals, or *mangashi*, is their stories – lots of them, anything from around six to 20 or more, depending on the page count. The majority are serials in episodes of around 20 pages, enough to leave you wanting to read more, true page-turners in the best storytelling tradition of Dickens and *The Perils of Pauline*. There can also be short complete pieces, the equivalent of a comedy sketch, or sections of vertical four-panel gag strips. Apart from the attention-grabbing cover, colour is confined inside to an insert or fold-out to kick off the opening strip and a few four- or eight-page signatures elsewhere, sometimes used for adverts. A second colour,

often orange, may be used to brighten a star feature, or another ink colour like blue or purple or pastel-tinted papers may be used. Everything else is in black and white. Some manga monthlies are as thick as phone directories, with a thousand pages or more, but most offer some two to four hundred side-stapled pages. When they grow too bulky, they come perfect-bound with a spine, making them a truly hefty 'comic book'.

Every day fresh deliveries are piled up on the newsstands, with their inky insides still smudgy, their paper smelling of the chemicals used to mill them. They offer a relentless tide of different stories to hook the reader. Prices are kept low to entice you to sample a story and, if it grabs you, to ensure that you keep following it issue after issue. The long-running boys' weekly *Shonen Sunday*, for instance, costs a mere 220 yen, around $2,

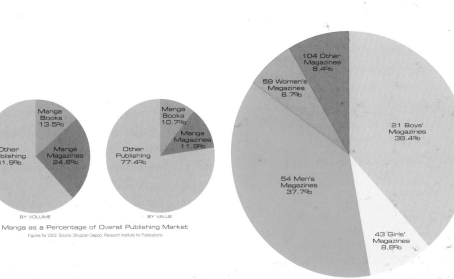

Manga as a Percentage of Overall Publishing Market
Figures for 2002. Source: Shuppan Geppo, Research Institute for Publications

BY VOLUME
Other Publishing 61.9%
Manga Books 13.5%
Manga Magazines 24.6%

BY VALUE
Other Publishing 77.4%
Manga Books 10.7%
Manga Magazines 11.9%

Types of Manga Magazines as Percentages of Total Manga Magazine Market
Figures for 2002. Source: Shuppan Geppo, Research Institute for Publications

104 Other Magazines 8.4%
59 Women's Magazines 6.7%
21 Boys' Magazines 38.4%
43 Girls' Magazines 8.8%
54 Men's Magazines 37.7%

● **Note:** Of the total of 281 different manga magazines published in 2002, the sector shown above of '104 Other Magazines' included pachinko (22), boys' love (11), four-panel gag strips (17) and sports and hobbies (4).

for over 400 pages. Manga are cheap enough for people to be able to buy a different one every day and throw it away. They are left behind on trains or in cafés and noodle bars, passed around at work or school or among friends and family, retrieved from trash and recycling bins and resold on the secondhand market or on the streets.

'Pile 'em high, sell 'em cheap' seems to work as a philosophy. Several manga weeklies have among the highest circulations of any magazines in Japan. The recession has bitten, so *Shonen Jump*'s highs of over 6 million copies may be a thing of the past, but it still shifts 3 million every week, to a population of 126 million people – roughly half that of America, just over twice that of Britain. Out of the whole magazine industry, about one-sixth, or some 250 billion yen (about $3 billion), of that turnover is accounted for by manga periodicals. Due to the potential for making massive profits, comics are the most competitive publishing sector of all. Roughly two-thirds of it is carved up between the three market leaders: Kodansha, Shueisha and Shogakukan. The rest is divided up between other substantial publishers who might hope to corner up to 5 per cent of the market, while the crumbs fall to around 70 smaller companies, often specializing in subjects such as erotica, martial arts, golf and mahjong. Fierce in-fighting can exist between competitors and even between different magazines published by the same company. But it is not unusual to find that all acrimony melts away over glasses of sake during an evening in a karaoke bar. An editor from Shueisha may sing along to the theme song of the animated TV version of *Sailor Moon* produced by rivals Kodansha; then a Kodansha editor may join in with competitors Shueisha's *Cat's Eye* tune.

Big, thick magazines are not what most Japanese buy to keep in their homes. Who has the room, especially in a tiny, cramped 'cockpit'-style city apartment? One year's worth of *Shonen Sunday*s stacks up to over four and a half feet or 1.4 metres. The end product of manga is the compact, usually paperback book that gathers together episodes of particular serials, shrunk down and printed more sharply in black and white on thicker paper in handy *tankobon* volumes of around 200 pages, or in the

Above: A sign of the times – relaxing in a manga *kisa*, or café, where for a modest price you can read from more manga books than most people can afford or fit into a typically small city apartment. Right: For rarer items, you can consult one of the manga libraries that archive the history of the medium. Opposite: Casual browsers and devoted addicts alike can buy manga from shopping-mall outlets, often dedicated to one character or creator such as Tezuka, as well as from general book chains and 24-hour convenience stores.

smaller, chunkier *bunkobon* of 300 pages or more. On the cover they tend to have a fairly sedate, one-colour design, over which is wrapped a bright, attractive colour dust jacket. When you buy a book, instead of putting it in a bag, the store will often fold its own brown-paper wrapper over the cover, enabling you to read it discreetly in public.

Obviously, there are people who, for whatever reason, do not read manga in any form. By far the majority of the millions who do read them are casual consumers, happy following a story, one that's easy to find, as a magazine serial and sometimes perhaps buying the books, as you would with a favourite TV series or author. To them, manga are cheap, disposable mass literature, as American comic books once were, bought for entertainment, for a good story, to kill time, to chill out. A smaller but sizeable readership love manga and take a more intense interest in finding and keeping works that appeal to them, regardless of their fame or popularity. Then there are the genuine *otaku*, or obsessive fans, who make manga a lifestyle. Dedicated collectors of 'rare' manga make up another much smaller group, on nothing like the same scale as the American mania for collecting old comic books as investments, a pursuit ruled by stringent 'grading' and heady prices. Why bother scrabbling after antique or first-edition manga when so much gets reprinted?

So where do you buy manga from? Many pick up the magazines from local newsstands and shops. If these are closed, there are always the impersonal vending machines and the inviting, brightly lit all-night convenience stores, hangouts for the young and the sleepless, outlets that now account for 30 per cent of all magazine sales. To buy the books, there are specialized shops, and pretty much all general bookstores have sections, aisles, even whole floors dedicated to manga. But why buy them? As another option, one enterprise that has been popping up all over the place since the recession hit in 1990 is the manga café. Free to join, these are often open 24 hours a day and have internet access. Members pay a small hourly charge to read comics that might cost thousands of yen to buy. The cafés attract a very mixed crowd, from businessmen leaving the office to late-night clubbers waiting for the early-morning train. A selection of 20,000 to 30,000 books to choose from is not uncommon. Otherwise you can borrow from a more limited range at public libraries, or join the crowds

of browsers reading their favourites while standing at the bookshelves and magazine displays in the shops.

Neither the publishers nor the creators, or *mangaka*, make their fortunes from the magazines; the real money is in the book compilations and their ongoing, multiple printings. There are a good many series that fill 20, 30, 50, and a handful that even fill 100 or more volumes. Others tell their tale in a handful of volumes, totalling, say, 600 to 1,000 pages, a movie-length read. Readers tend to acquire the set, because they want the whole story. The sales figures can be staggering. *Dragon Ball*'s sagas have amassed sales of over 120 million copies since 1984. Now that record is being challenged by *One Piece*'s 65 million, accumulated since only 1997. A recent volume of *One Piece* set the record for the highest initial print run of a manga book so far of 2.52 million copies. Now that's a bestseller, to my knowledge unrivalled by a graphic novel anywhere else, except for the huge orders in France, and even bigger orders in Germany, for the latest and possibly last *Asterix* album in 2001.

Another strength of manga is that for decades the stories and characters have been owned by their creators, or co-owned with the publishers. Any mangaka who has a hit may be tempted to milk it for all its worth, and some can spin their story out longer than it perhaps needs. Still, few devote their careers to just one series; most eventually tie it up and move on to another project. They are free to switch subjects, genres, styles, story lengths and target audiences, like a filmmaker or novelist, and produce a variety of different finite pieces. In America or Europe, lucrative, long-running properties like *Superman*, *Judge Dredd* and *Spirou*, owned by the publishers, have to be kept alive by forever passing them on from one writer or artist to the next. Their stories can never end. In Japan, the continuation of a character like Doraemon by other hands is the exception rather than the rule. In most cases, when creators stop or die,

their comics stop or die with them. This cycle of renewal provides a healthier regeneration. In Japan, Spider-Man would not live long enough to wear out his tights.

The survival of any mass-market manga depends on how well it entertains and communicates with readers. This applies equally to an established name as to a first-timer. In various ways, readers are continually consulted. Their votes and opinions are taken seriously. Incentives like free merchandise and prize draws are offered to persuade readers to fill out and return the questionnaires on detachable pre-paid postcards inside most *mangashi*. The significance attached to their votes and views varies according to the publishers. Allegedly a few can be as cruel in their use of ratings as American TV companies and axe any new series that hasn't made it into the top ten after only a few appearances. Others use the surveys as valuable, almost instant market research. For example, the youth weekly *Morning* goes on sale on Thursday. By the following Monday a thousand or so postcards are pulled out of the mailbag and tabulated into charts and comments. This feedback is never seen by the creators, but it is filtered to them via their editor to boost their egos or motivate them to do better.

In American and European comics, it is not unusual for creators to be left to their own devices, with the minimum of editorial intervention. In contrast, editors are manga's secret weapon. On a weekly there can be a hierarchy of up to 40, each assigned on average to seven or eight creators at a time. Often an editor has to wear many hats: those of coach, collaborator, critic, friend, researcher, promoter, psychiatrist, cook and more. The experience of a novice editor like Kazuyo Yasuda, who worked on *shojo* or girls' comics for five years, is not untypical: 'I had just been to university and I didn't choose the manga department, the company just told me, "Oh, you go to manga!" I had a poor knowledge of them, I didn't read them much, I preferred normal

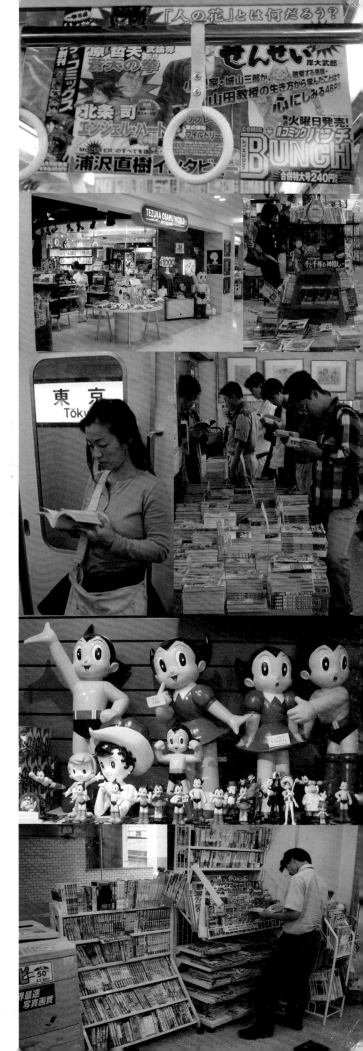

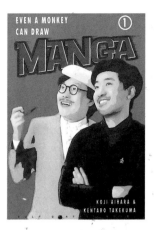

Above: Koji Aihara and Kentaro Takehuma, shown dressed in their Tezuka-style berets, produced a three-volume series, translated as *Even A Monkey Can Draw Manga*. This is a funny and critical satire of their struggles to break into the industry, at the same time a sly parody of 'How To' manuals and a sophisticated 'meta-manga' or a comic about comics.

novels. It was my first work as an editor on a magazine. People around me taught me on the job, that's what you go through in any Japanese company. If you start working as a manga editor, it's better if you don't have that much expertise already in manga, so you can bring a fresh eye to it. Takumi Kasukobe was the first mangaka I worked with properly. She had been popular but I was brought in, because at the time she was not in the top ten of the readers' polls. You have to build up the trust between artist and editor. It is probably similar to the relationship between rock musicians and their managers – if you have a good manager, your records might sell a lot. I was 22, she was 19. That is very normal in shojo manga, you have to be young to be close to the reader, otherwise you forget all the details! For her new series, she came up with the character descriptions and we'd talk about what would be a good story for them and for the magazine. She really respected my comments, because I didn't have so much experience, so my voice was like her ordinary reader's voice. You have to be aware of the trends in girls' manga and also the trends in real life, among junior-high and high-school girls. It's the same thing for comic writers too, they have to be aware of other things and read so many magazines. Her series got a really good response from readers from the first week and stayed in the top three for most of the time. To get each episode done, I used to stay at her flat quite a long time, making food. I even did a little bit of assistance – the easiest things, inking in, doing screen tones.'

Editors are very much 'hands-on', from coming up with first ideas through to the final proofing stage. They can guide a manga creator's career from its start to its maturity. Editors usually judge the competitions that most magazines run to discover new talent, often offering winners very large cash prizes and publishing deals. If an entrant is championed by an editor and wins or shows promise, he or she may well be assigned to that editor for the development stage prior to publication. To prepare a major new series, editor and artist may meet every week for as much as a year, initially in the office perhaps, but afterwards in bars, cafés, in the artist's studio, in research locations, bouncing story ideas off one another and defining a character to appeal to the largest possible number of readers. This to-and-fro and fine-tuning process continues with the generation of the

Right: A master artist directs his assistants, all seated around the same table, while an edgy editor looks on in a flashback from Keiji Nakazawa's life story, *I Saw It*.

sketches of the all-important first episode of 20 to 32 pages that will define the series' tone and style.

Regularly producing manga entails plenty of pressure and deadline-chasing. Once a serial is up and running, editors on the weeklies live in dread that 'their' artists will miss the very last deadline, usually a week before publication. Many wait anxiously for a phone call from any latecomers to tell them the next episode is ready. It is not uncommon for editors to stay at the mangaka's studio, even sleeping there, until the work is done. Others will 'can' their mangaka, isolating them in a hotel room, cut off from all distractions, until the pages are finished. Famously, the legendary Osamu Tezuka was once running late and about to fly off abroad. The very morning of his flight, he arranged to meet his editor at the airport and handed over the pages he had only just polished off en route in the taxi. With the artworks in house, it's down to the editor over three sleepless days to cut and paste in the dialogue, captions and logos already typeset, and finalize every last detail, before the first sample copies are printed and checked. Three days later the final copies hit the racks, by which time the whole process has started again.

The Japanese editors' importance may be related to the small number of writers in the manga field. Manga are regarded as 'a one-man (or one-woman) universe' and it is not nearly as common as in America for artists to collaborate with scriptwriters. Becoming a mangaka represents a serious decision. Many students join companies straight from university, having been recruited before they graduate. To reject this career system and pursue manga means gambling everything; the job prospects are thin for a failed manga artist, even with a degree. For inspiration, young hopefuls can look to manga's success stories, though they account for no more than 10 per cent of the industry's estimated 3,000 professionals. Among those 300 are the real high-flyers. *Dragon Ball* helped make Akira Toriyama one of Japan's highest earners. Rumiko Takahashi's annual income grew so great that she ranked among the ten wealthiest people in the whole of Japan. An equivalent in America might be Charles Schulz, of *Peanuts* fame, though he was strictly a one-man operation. To meet demand, most manga creators, especially on a weekly, have to become managers running a studio and dividing up the labour and their modest page rate among a staff of between a couple and 20 or more people. The hope is that the investment pays off when royalties start to come in for the book compilations.

After the layout sketches have been approved by the editor, the mangaka draws the art boards so that they can be handed over to assistants who will carry out the subsequent stages: finishing the inking; drawing in panel

borders, balloon shapes and sound effects; adding photo-reference drawings of machinery, nature, architecture; and applying the kaleidoscope of screen tones and patterns available. The end result can make black and white art look almost more vivid than full colour. Given the scale of production, there is a constant demand for visuals of a similar nature. Out of this need for quick turnover has arisen an industry supplying a variety of standard backgrounds, skies, explosions, brickwork, flowers, etc. The master artist's finishing touches may involve giving the signature look to the faces or specifically the eyes, or no more than a perfunctory nod at the end of a production line. In America in the 1930s, with a readership of 60 million, the creator of boxing champion Joe Palooka at one stage drew little more than the faces. Today, the roll-call of collaborators on a modern American comic book can be almost as long as the credits on a movie. In manga, it's still only the mangaka who normally gets the byline; everyone else works in anonymity.

Assistants may never move on, for lack of talent, ambition, luck or because they are in such demand for their specialist skill. But becoming an assistant is one path to becoming a mangaka in one's own right. True knowledge of manga, some would argue, is like that of a martial art. You won't pick it up from any number of 'How To' manuals. It can only be handed down by studying under a *sensei*. As a humble apprentice, your training might take you from the most menial tasks to published professional status. Or, like Rumiko Takahashi, you might enrol for a course at Gekiga Sonjuku, one of the most demanding manga schools, run by Kazuo Koike, writer of *Lone Wolf and Cub*. These are paths that many still follow, the risk being that the student ends up as little more than a clone of the master. Other aspiring creators are entirely self-taught and self-directed, learning by copying or by trying for themselves. If they're talented, persistent and lucky, their personal vision may get noticed via competitions, fanzines, porno manga or experimental non-paying magazines and win them a cult following or maybe crossover success without too much compromise. Naturally there are always those who won't, or can't, fit into the commercial system. From their ranks emerge the struggling artists for whom self-publication can offer an alternative and sometimes sizeable market in itself.

A few years before his death in 1989, the originator of story manga, Osamu Tezuka, observed: 'Now we are living in the age of comics as air.' By this, he meant that manga are everywhere, permeating everyday life and almost taken for granted. But he was also warning that, like air itself, some manga might be polluting and damaging. He was speaking as someone who had devoted his adult life to the advancement of the culture.

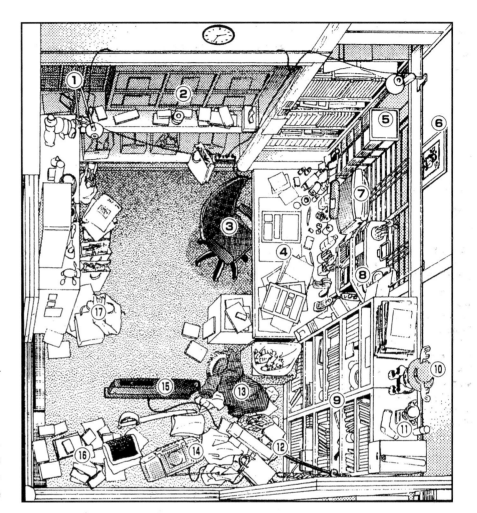

Above: All mod cons in *One Piece* creator Eiichiro Oda's studio. His assistants work in the next room.

1. About 200 American and European music CDs
2. Closet converted to magazine rack
3. Ergonomic chair
4. The dynamic drawing board
5. About 300 more music CDs
6. Prized sketch by Akira 'Dragon Ball' Toriyama
7. Air purifier
8. Sound system
9. Reference books
10. *One Piece* Chopper doll
11. One sock
12. Antique swords and flintlock
13. Coat thrown on the floor
14. Radio/cassette player
15. Heater (for the winter)
16. *Shonen Jump* and other manga magazines
17. Fan letters

Two first-generation *otaku*, or fans, raised on Tezuka's works, Kentaro Takekuma and Koji Aihara, felt that the master's hopes, and their own, for the medium were being so betrayed by the mass market that they had to respond. They did so in their 1990–92 exposé *Even a Monkey Can Draw Manga* by turning themselves into a comedy double-act. Shown sporting Tezuka's trademark berets as they pursue their dream 'to rule Japan with manga!', they conducted readers through a breezy and deliberately crass mock-instruction manual. Their painfully accurate 'lessons' tore into the crises of creativity they saw afflicting the industry: the lack of passion, risk and originality among the next generation of artists; the domination over them by editors often imposing their own pat storylines; the opportunism and cowardice of the publishers; and the complicity in all of this of the readers.

The medium will always be a fragile ecology, as Tezuka knew. Like any form of mass entertainment, it is prone to dumbness, plagiarism and formula. Fortunately, the continual demand for more and more stories makes it dependent on giving new talent a chance, on letting in that all-important breath of fresh air.

Chapter 02
Japanese Spirit, Western Learning

TO WHAT EXTENT are modern manga continuous with Japan's long tradition of narrative art? The Japanese government seems to think entirely so. Since April 2000, the new national art curriculum for junior high schools has insisted that manga be brought into the classroom. In its accompanying explanatory textbook, the Ministry of Culture and Education affirmed that 'manga can be called one of Japan's traditional modes of expression'. Art teachers are supplied with a three-page illustrated history to help them convey the uninterrupted continuity between historic picture scrolls and prints and manga. Alas, in this visual material, the portrayal of contemporary manga was limited to one wordless sequence by Tezuka and a pin-up of Dragon Ball, with not a speech balloon or sound effect in sight.

Such a view hinges on a very broad, and largely outdated, definition of manga in Japan, which embraces everything from the single-panel cartoon and political caricature to the four-panel newspaper strip, in addition to what the word now means to most people: namely, story manga and gekiga, or multi-panel comics and graphic novels. The only way to equate all of these vastly different artforms is to emphasize the purely pictorial aspects they have in common: in other words, exaggeration, simplification and movement lines. By concentrating on the obvious similarities, however, the authorities conveniently ignored the panel-to-panel storytelling and complex mingling of words and pictures that are the very keys to modern manga.

In fact, manga – that is, comics – might never have come into being without Japan's long cultural heritage being soundly disrupted by the influx of Western cartoons, caricatures, newspaper strips and comics. To deny this is to rewrite history. Manga grew out of an amalgam of East meets West, old meets new; or, as another 19th-century modernization slogan put it, it was a matter of *wakon yôsai* – 'Japanese spirit, Western learning'.

What exactly is the 'Japanese spirit' that is so apparent in manga? Some have pointed to the inherently visual nature of the Japanese written language itself, which uses *kanji*, or Chinese characters. These ideograms do not represent objects realistically but abstracted into symbols, streamlining reality into shorthand strokes of a brush or pen, in much the same way that comics do. Perhaps the way in which writing for the Japanese involves symbol-making and reading involves symbol-decoding predisposes them to accepting the symbolization integral to comics.

Another distinctive national characteristic that may help explain why manga account for nearly 40 per cent of all books and magazines sold in Japan is the people's long-standing appetite for pictorial art, which – in the manner suggested by the Ministry of Culture and Education's brochure – at times gets close to the spirit of the comic. Comics critic Fusanosuke Natsume has classifed some of this early narrative art as 'pre-manga'. Such works began with 12th-century drawings painted onto paper scrolls as much as 20 feet (6 metres) in length and placed in sequence to tell of legends, battles and events from daily life. Scrolls could be funny, too. The artist-priest Toba (1053–1140) gently mocked the priesthood by turning them into rabbits, monkeys, foxes and frogs; he also drew infamous farting contests. As on a modern computer, the readers' eyes could 'scroll' through the landscape, moving right to left as the scrolls were opened out. Perhaps that flowing way of viewing and reading survives in manga? Similarly, the way a scene painted onto a folding screen is divided into sections could be said to be echoed in the rows of frames in a manga. It is no accident that the vertical white gaps or 'gutters' between frames are frequently made to abut more closely than the horizontal gutters, in effect making each row of frames more readable, not unlike a screen.

Printed matter that was more affordable and accessible to the public, and probably closer in spirit to

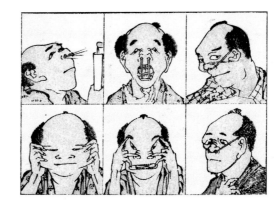

Right: Though seldom narrative, Hokusai's *manga*, or 'playful sketches', such as these facial contortions, prefigured much of the humorous draughtsmanship of modern cartoons and comics. Hokusai produced the sketches between 1814 and 1834. Opposite: Battered and bandaged but never beaten, Norakuro enlists as a dog soldier in the Japanese army. The black stray was among the first pre-war characters to be widely merchandised and have his magazine exploits compiled into hardbacks.

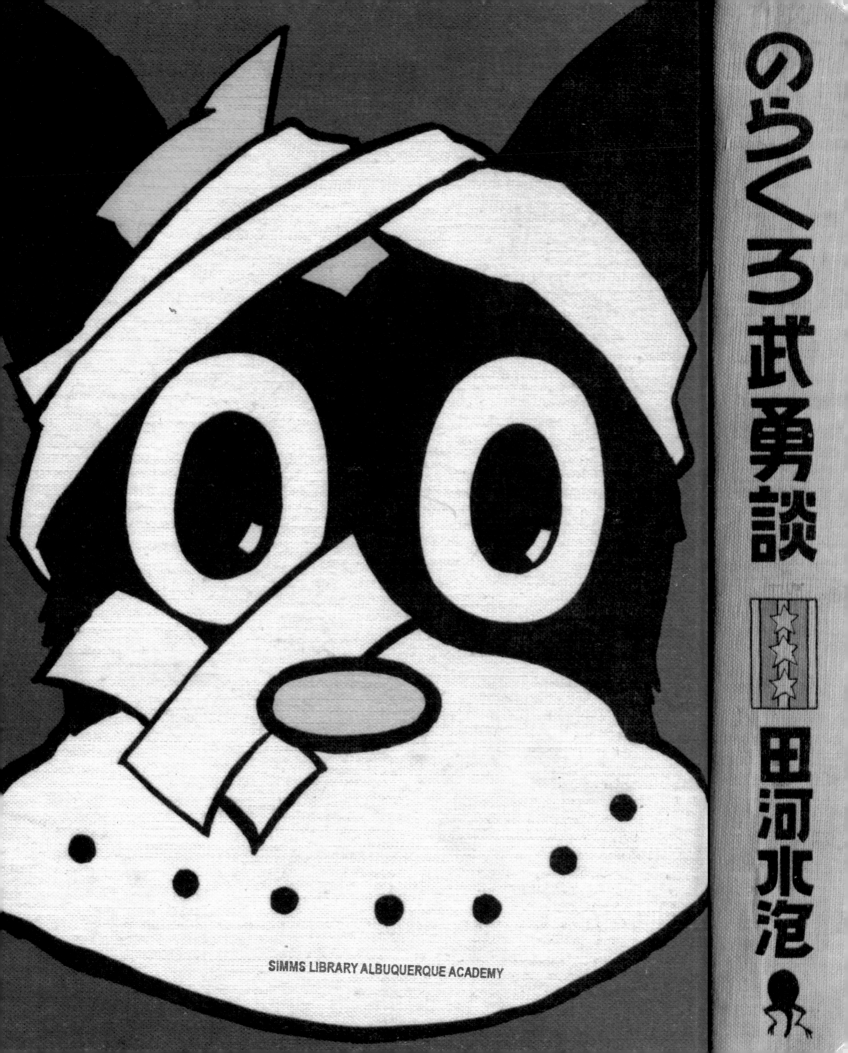

Manga: Sixty Years of Japanese Comics

Ukiyo-zoshi, or 'floating-world novels', include illustrated narrative pages that incorporate written speech and thoughts within the pictures using flattened perspective. These two examples come from *Characters of Worldly Young Men*, written by Kiseki Ejima in 1715; the artist is uncredited. Right: The son's moment of triumph. 'Shall I tame this steed for you?' he asks, as the trampled grooms cry 'Ouch!', and his samurai father looks on admiringly from the veranda: 'Wonderful!' he says. Far right: Two shop-boys raise sticks over their heads and shout, 'If you insist, sir!' Their master, who is dressed as a samurai, shouts, 'Come on! Attack me!' His fencing instructor sits in the background. Below: The English tradition of satire and caricature arrived in Japan in 1862 courtesy of Englishman Charles Wirgman and *The Japan Punch*.

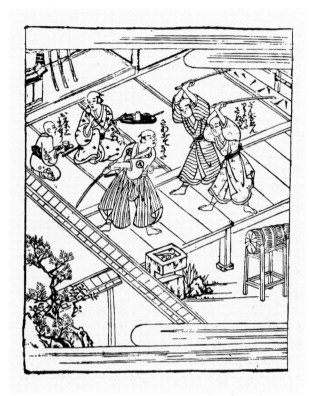

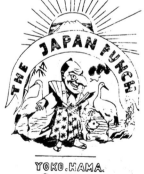

manga, included the *ukiyo-e* pictures of the entertainment quarters or 'floating world'. From the 17th to 19th centuries, these woodblock prints were produced in hundreds of copies in as many as 15 colours and portrayed all kinds of secular subjects. One print might be dedicated to a night of passion with a courtesan, another to a kabuki player's performance or a sumo wrestling bout, others to watching beautiful geishas, cherry blossoms or the shifting seasons. The contemplation of the transient pleasures of everyday life through these prints can be echoed in certain manga in the fleeting moments they capture within each panel. Other links between the old and the new can be found in the *shunga*, or 'spring pictures', from this period. Banned in 1722, their erotic exaggerations seem to recur in current pornographic manga. Similarly, several examples of the horror genre of manga draw on the demons and monstrous apparitions in *yokai* prints. The precise outlines, bold compositions and meticulous use of delicate and repetitive patterning characteristic of all these prints are not a world away from manga illustration, where dynamic line artwork is the norm and fabric and other textures are applied as flat, unmodulated tones. The relationship is even clearer in modern manga set in the distant past. In these, artists often make conscious reference to ukiyo-e and other prints; after all, this is how history looked.

Other ancestors of manga include the *Toba-e*, named after the great scroll painter. These were collections of pictures showing comical situations using visual humour and minimal text. The first were produced by Ooka Shumboku in the early 18th century in Osaka, then and now a city of entrepreneurs. Another format was the mass-produced *kibyoshi*, or 'yellow-cover books', which were full of woodcut cartoon stories lampooning figures of authority. Furthermore, there were also *ukiyo-zoshi*, or novels of the floating world, which featured pictures containing additional dialogue not found in the main text.

It was easier for pictures and words to be printed together in Japan than in the West. In books using the Roman alphabet, for example, blocks of text were composed employing a 26-letter alphabet of moveable type; any woodcut illustration would need to be made separatel, so early publishers of English books and broadsheets preferred to save trouble and expense and keep pictures to a minimum, or drop them entirely. In Japan, however, moveable type took longer to take hold because the language requires so many more letters and characters. Thus it was easier to cut the words onto the same wood block as the illustration. The upshot of this was that from the start text could be smoothly incorporated within images and the two elements conceived, printed and read together, as in the basic system of comics.

Since printed text and images developed in tandem in Japan, this created a mindset receptive to modern

Top and above: In *Jiji Manga*, the Sunday section of the *Jiji Shinpo* newspaper, Rakuten Kitazawa (1876–1955) used the full-page American-style colour format for *Donsha*, which related the adventures of a plucky street kid, and *Haneko*, whose eponymous star is here seen attempting the latest dance import, the Charleston. Left and below: From 1936 to 1971 spunky five-year-old Fuku-chan romped through the newspaper strips of Ryuichi Yokoyama (1909–2001). He was also animated for a propaganda film in 1944 and a TV series in 1982.

comics. By contrast, in Britain there developed a greater division between the verbal and visual. During the so-called 'Golden Age of Caricature' between 1780 and 1830, London's bars, coffeehouses, printshops and drawing rooms were strewn with the scurrilous prints of James Gillray and his contemporaries. These satirized politicians and other popular figures of the day and sometimes incorporated copious hand-lettered text and slanted, ungainly speech balloons. But in most early British comics speech balloons were banished, and the text was relegated outside the pictures and typeset underneath.

So what might the word *manga* have meant to print artist Katsushika Hokusai in 1814 when he invented the term? To him it meant looser, unself-conscious sketches in which he could play with exaggeration, the essence of caricature. Hokusai never dabbled in narrative in his sketchbooks but, were he alive today, he might recognize in modern manga some of the same pleasure in grotesque expressions, physical comedy and uninhibited drawing.

Manga as we know them today evolved from the efforts of a series of pioneers during the modernizing Meiji period and after, who adapted newly imported Western influences. First to arrive and be imitated were single-frame political cartoons. In 1862 British army officer Charles Wirgman launched *The Japan Punch*, based on the British *Punch* weekly magazine. It was intended for foreigners living in Yokohama and featured Wirgman's own cartoons. This uneasy marriage between Western innovation and Japanese tradition involved using the latest copper-plate techniques to print the first issues on the finest-quality soft Japanese paper. His cartoons were utterly new. Prior to this, making caricatured likenesses of actual people or critical comments about contemporary events had been forbidden in Japan under the shogunate.

Nicknamed *ponchi-e*, or 'Punch drawings', these exotic Western-style pictures gradually caught on with Japanese artists, who began to get up the courage to attack their leaders' corruption. Readers of the magazine *Marumaru Chinbun* from 1877 delighted in the clever compositions of Honda Kinkichiro, who loaded Western cartooning conventions with traditional Japanese references and puns. By the 1890s, the rather derisive term ponchi-e had been replaced by the word manga, now redefined to cover all

the cartoon arts at that time. In these periods of social unrest or dissent, the single political cartoon had some teeth, but since 1945 the medium has declined in Japan, enjoying little of the gravitas it has in America or Europe. In fact, in the last few years it is manga themselves that have taken on more politicized roles, both as opinion-forming tools and as highly critical projections of contemporary society.

It was in the closing years of the 19th century that Japanese artists began to respond to the discovery of multi-panel comic strips from Europe and America. The broad humour of one-page strips from *Punch*, French magazines *L'Assiette au Beurre* and *Le Rire*, Germany's *Bilderbogen* and America's *Puck* clearly made an impression on Rakuten Kitazawa. He began by sending up country bumpkins baffled by the big city in his first strip serial in 1902 for *Jiji Manga*, a weekly newspaper supplement. In 1905 Kitazawa unveiled *Tokyo Puck* as a colour showcase for Japanese cartoonists. He was also aware of the mischievous kids of the American Sunday funnies, derived from European cautionary series like Wilhelm Busch's *Max & Moritz*. Kitazawa invented the tomboy Miss Haneko, a thoroughly modern Japanese girl whose high spirits and enthusiasms for the latest foreign crazes regularly backfired.

American newspaper strips were very accessible, even to foreign audiences. The funnies cast a wide net and tended to be non-specific. Even when set within an Irish family, for example, a story would broadly reflect the new urban and immigrant experience shared the world over. Translations of many strips spread to Japanese newspapers in the early 1920s. Among the most influential exports was George McManus's *Bringing Up Father*, which poked fun at both the unambitious everyman and the grasping nouveaux riches by contrasting Jiggs's down-to-earth simplicity with his wife Maggie's vain social climbing. The strip also served as a catalogue of the latest Art Deco fashions and interior designs. In Belgium, it was a favourite of the young Hergé before he created *Tintin* in 1929; in Japan, it served as the basis for such variations as *Easy-Going Daddy* and *Bringing Up a Rich Man*. These and other Japanese copies tended to be limited in their ambition and length, veering only occasionally outside of mild farce and occupying only a single page of up to

Manga: Sixty Years of Japanese Comics

As iconic as Felix the Cat and Mickey Mouse, the puppy Norakuro became a mascot of Japan's militarism in the 1930s. He enjoyed a new lease of life after the war, and was later revived in 1970 in new comics and a TV series, and as part of the 1980s 'retro anime' trend. Right: Norakuro leads his canine commandos into blood-free cartoon combat in this adventure from 1938, block-printed in combinations of blue, red and yellow. Far right: Norakuro cleverly has them use a tank tread as a shield and as a walkway over barbed wire against the enemy pigs who represent the Chinese. Below: Norakuro's creator, Suiho Tagawa (1889–1989), with a canine friend.

Right: Among Tagawa's other 1930s characters was an octopus in glasses who puts two of his tentacles down each sleeve and trouser leg in order to appear human. Far right: In this patriotic scene, he has brought sailors' uniforms to recruit his fellow octopuses into Japan's navy.

eight frames. As with the political cartoon, the impact of newspaper strips in post-war Japan has also become less significant than in America or Britain.

Beyond the 'gag-a-day' ritual of humour strips, what really kept US readers loyal to a paper were the melodramatic weekly and daily serials. In Japan, serials were mainly cartoonish and confined to a few pages in new magazines aimed at children, like *Shonen Club* (1931). In their prime these monthlies were a couple of hundred pages thick, forerunners of today's massive manga periodicals. One of *Shonen Club*'s best-loved figures was the brave little stray dog Norakuro, a sort of canine counterpart to Felix the Cat. This cute-looking kiddies' entertainment soon became steeped in the militarism of the period. In pursuit of his dream of becoming a world-famous general, Norakuro enlists as an accident-prone 'private second class' in a tough dog regiment commanded by Buru, the bullying bulldog. The funny animal comedy soon gives way to heroism on the battlefield. By his perseverance and bravery, the plucky pup rises through the ranks. Compiled into hardcover books printed in blocks of bright colour, his collected adventures sold over a million copies before World War II.

Tagawa and most of his contemporaries took an almost theatrical approach to their comics. They drew characters mainly head-to-toe, rarely in close-up or from unconventional viewpoints, as if the reader were watching actors perform on stage. The clarity and calm of their pages appeal to American graphic novelist Chris Ware. 'To me, this is the course comics should've taken before they got sidetracked and transformed by movies in the 1930s.' For better or worse, that transformation would overtake manga too, but it was slower and interrupted by the war. Historically, those visual storytelling innovations that would become known as 'cinematic techniques' were being pioneered by Western cartoonists from the early 19th century, long before film directors could put them into practice. By the 1930s, heightened realism, shifting camera angles and rapid cutting became the common language of American comics and movies, but these techniques went largely unseen in Japan. Cut off and cramped by wartime restrictions, manga could only hint at the changes to come. Still, these early works provided a foundation and inspiration to their young readers. After the war, one mangaka in particular, Osamu Tezuka, would unlock the Pandora's box and throw away the key.

Above: In San Francisco in 1931, Henry (Yoshitaka) Kiyama self-published *Manga Yonin Shosei*, or 'The Four Students Comic', his bilingual autobiographical account of life in the city as experienced by him and three young Japanese countrymen from 1904 to 1924. Left: In 52 two-page episodes, drawn in the American gag-strip style of the period, Kiyama records the big events – earthquakes, riots, the flu epidemic and, here, the 1914–18 Great War in Europe – as well as smaller happenings such as instances of racial prejudice that affected the lives of Japanese immigrants, students and servants.

1 2

EPISODE 45
The Great War in Europe

The Father Storyteller

ONE EXPLANATION for the popularity of comics in Japan… is that Japan had Osamu Tezuka, whereas other nations did not. Without Dr Tezuka, the post-war explosion in comics in Japan would have been inconceivable.' This posthumous summary by the respected Japanese newspaper *Asahi* is no exaggeration of the influence of Osamu Tezuka (1928–89). It is hard to imagine how Japan's manga industry, as well as its animation industry, could have grown to their current scale and diversity without his pioneering example. So many of his innovations continue to influence both artforms to this day; he provided their blueprints, their foundations, their richest wellspring. His influence in Japan could be seen as equivalent to that of Walt Disney, Hergé, Will Eisner and Jack Kirby rolled into one, but even this comparison falls short. One critic has likened Tezuka's place in the history of manga to that of D.W. Griffith in the history of cinema. Several commentators suggested that Tezuka should be awarded the Nobel Prize for literature. He lives on as one of Japan's most remarkable 20th-century figures, celebrated in his own museum in Takarazuka, where he was raised. He is revered, if not worshipped, as the 'God of Manga'.

Tezuka's 40-plus-year career, from 1946 to 1989, is synonymous with the struggle to develop manga from slight entertainments principally aimed at children into narratives of every type for readers of all ages. Though Tezuka died relatively young, only three months or so after his sixtieth birthday, he produced enough work for several people's lifetimes. He wrote and drew a record 150,000 pages for 600 manga titles as well as some 60 animated works, and wrote essays, lectures and film reviews – and still found time to qualify as a licensed doctor in the Western tradition. Applying his medical knowledge, he pushed his own body to its limits: he often slept only four hours a night to beat looming deadlines. When he was diagnosed with stomach cancer, he of all people could understand what his system was going through and yet he chose to keep working to the end. Even on his deathbed, he urged his failing body: 'Please let me work.'

What drove Tezuka to such dedication? One explanation he gave was his witnessing of Japan's war-machine propaganda and the death and destruction of World War II. As a teenager he experienced the

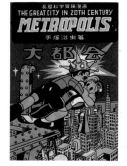

Above: Published in 'red-book' form, early post-war works such as *Lost World* (1948) and *Metropolis* (1949) established Tezuka's reputation for science-fiction dramas.

horrific aftermath of an air raid on Osaka. This fired his conviction to teach peace and respect for all life through animation and the less costly comics. He was forced to put all dreams of a career in manga on hold before and during the war, but he kept practising all the same and drew 3,000 pages of them in private. The closing scene in one of his autobiographical comics re-creates the end of the war. His jubilant 17-year-old alter ego exclaims: 'I am alive! I survived!' and 'I will draw comics! Nobody can stop me now, I will draw cartoons!' What had begun as a childhood enthusiasm grew into a consuming mission. In addition to his formidable energy, Tezuka was also driven by the belief that manga and anime should be acknowledged as valid parts of culture. He led the way in transforming manga's image through the sheer range of genres and subjects he tackled, his nuanced characterizations, his kinetic layouts and above all his emphasis on the need for a compelling story – one that was unafraid to confront the most basic human questions of identity, loss, death and injustice.

How did Tezuka arrive at this new form of comics? Part of the answer might be

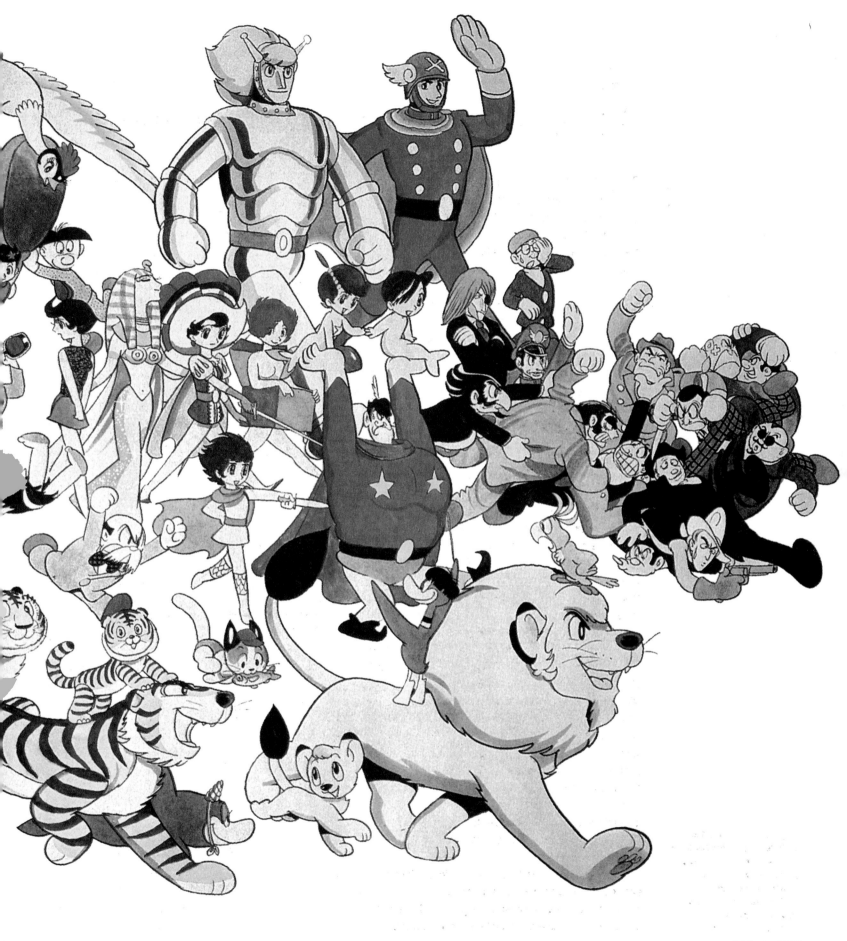

Manga: Sixty Years of Japanese Comics

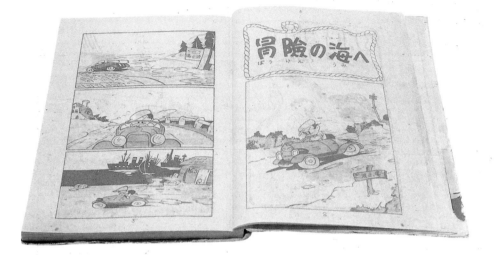

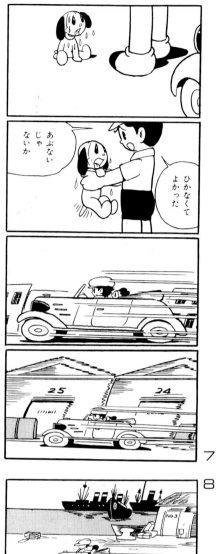

that he grew up in an unusually liberal and modern household. During his bachelor days his father had been an avid reader of imported and local comics and had tried to create them himself. Now married and well-to-do, he presented his son with a regular diet of comic-strip books, including American ones. Tezuka's mother would read the comics to little Osamu until he was old enough to decipher them for himself and began to make his own. She also took him on frequent visits to watch the local women-only theatre company in Takarazuka, which led to his participation as a student in amateur dramatics.

Though comics and theatre clearly enthused him, Tezuka's prime storytelling influence came from the cinema. He later claimed that he had seen a film every day of his adult life. The habit began in infancy, when his father took up watching, collecting and even making movies. That passion soon rubbed off on the impressionable young son. The family would go on frequent trips to the cinema, and at home they watched again and again Tezuka senior's amateur 8mm movies and collection of prints of Disney and Fleischer Brothers cartoons or Charlie Chaplin comedies. Discovering the magic of flip-book animation, young Tezuka filled notebooks with cartoons in an attempt to create the illusion of movement. As a teenager, he had already seen an impressive number of films,

including many of the Hollywood adventures, Saturday-morning serials and British thrillers that were screened in Japan prior to its entry into the war in 1941.

Not surprisingly, American and European productions were banned during the war, and cinemas had to show their quota of jingoistic propaganda. The post-war era brought about a total change. While Japan's studios struggled to resume production, American governance allowed the backlog of unseen films from the West to flood into the country. Movie-going was a persuasive medium of 'democratization' and became a national fever. It was some of the only cheap entertainment available in the pre-TV period. A freeze on ticket prices helped boost attendances in 1946 to almost double their pre-war average. The qualities of the latest adult foreign movies came as a revelation to the Japanese, and particularly to a young man like Tezuka, until then so enamoured of Disney and Chaplin. As a medical student in the early post-war era, he recorded his amazement and imitative ambition in another of his autobiographical comics after watching a recent American film: 'Why are American movies so different from Japanese ones? How can I draw comics that make people laugh, cry and be moved, like that movie?' This was the leap of the imagination that allowed Tezuka to transform Japanese comics.

Above: The influence of movies and animation on Tezuka is unmistakable from his first published hardback book of manga, *Shin-Takarajima*, or 'New Treasure Island' (1947). Right: The original layouts (re-created in 1984) show that he wanted to open with eight pages, like strips of film, of Pete hurtling in his car to the docks. Only four of these 31 panels were used in the printed version, but the book's cinematic pacing made it a runaway success.

5

6

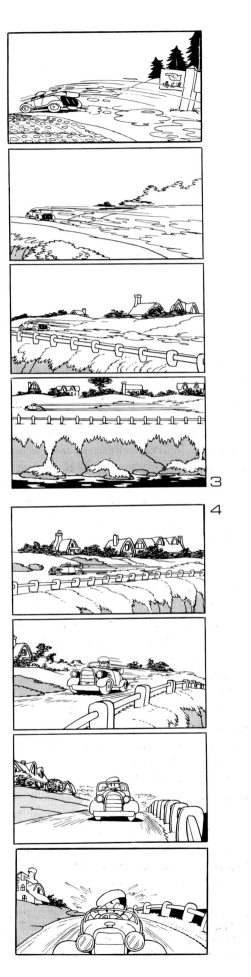

3

4

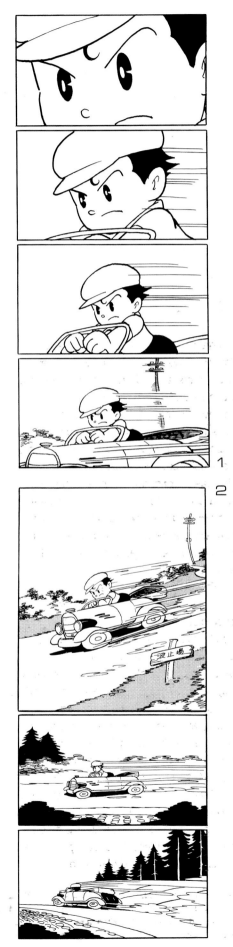

1

2

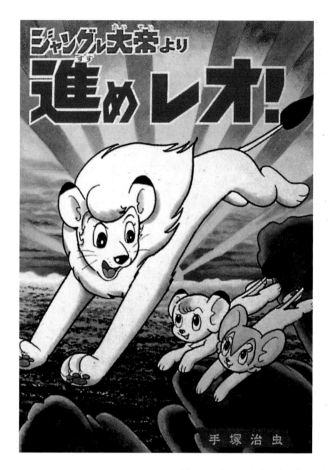

ジャングル大帝より
進めレオ!

手塚治虫

Above: Broadcast as *Kimba the White Lion* in America in the 1960s, Tezuka's animated animal TV series was Japan's first in full colour. He began it in 1950 as a manga entitled *Jungle Taitei*, or 'Jungle Emperor', which was serialized in *Manga Shonen* and then collected into books.

It is arguable that the birth of modern manga could not have occurred without the unusual predicament of post-war Japanese comics. They had been hit so hard by the war that they had all but vanished from the severely reduced pages of the daily newspapers and children's magazines. They needed to be modernized and rebuilt, like the nation itself, practically from the ground up. Even before the war, the medium's evolution in Japan had generally not kept pace with the increasingly realistic illustration, dramatic themes and faster panel-to-panel changes of 'camera angles' characteristic of American newspaper strips and comic books from the early 1930s. These new techniques influenced comics in many other countries, but much less so in Japan, which was isolated by the war. As a result, manga artists tended to stick to the older system, in which they showed characters full-figure, from a fixed distance, as if they were filming them using a static camera. No wonder Tezuka recalled that after the war 'Western comics were imported by the bushelful, and had a tremendous impact'. And yet by far the strongest influence on him in so many ways seems to have been the narrative dramas, of which American movies were the great exemplars. Above all it was the motion and emotion of Hollywood that he sought to inject into his comics.

To do this, he realized he would need space – plenty of pages and panels. But where could such a work be published, when there were no openings in the Tokyo papers or periodicals? As a beginner, Tezuka had little choice but to seek a commission from one of the modest local Osaka publishers specializing in small, cheaply printed hardback compilations of manga. These were nicknamed *akabon*, or 'red books', because of the large amounts of bright red ink adorning their gaudy cardboard covers. His first red-book commission was to draw a story by Shichima Sakai. As Tezuka began to unfold the tale, his

draft on straw paper grew to 250 pages. When it was published in 1947, *Shin-Takarajima*, or 'New Treasure Island', had been cut down to just 60 pages, less than a quarter of his original proposal, and various revisions had been made without his approval. Despite this tampering, however, the dynamism of Tezuka's sequences made the book a runaway hit that sold 400,000 copies. As the first of its kind after the war, it also started a trend for original manga stories to be issued directly in the red-book format.

From one panel to the next in *New Treasure Island*, Tezuka constantly shifted the reader's point of view, mimicking the movements of a film camera to generate a feeling of restless action and to propel the characters through the tale. At times the focus zooms in and the figures threaten to burst out of the panels. Motion lines, speed distortions, sound effects, sweat drops – the full armoury of comics symbols served to heighten the experience. Tezuka even stacked his wide, cinema screen-sized frames in vertical columns on the page to look like sequences cut from a roll of film. To eminent comics creator Shotaro Ishinomori, then a nine-year-old boy, the book was 'shockingly new' and 'probably what made me decide to become a manga artist'. Ishinomori was not alone.

Tezuka kept the shocks and bestsellers coming. Now in control of both stories and illustrations,

Above: Many thought that Tezuka's colour animated version of his 1950s jungle fable bore some striking similarities to Disney's 1994 film *The Lion King*. Of course, Disney in turn had greatly influenced the young Tezuka.

he increased the variety of his page layouts and the length and ambition of his subsequent projects. He began to reconfigure the medium to fit graphically charged, film-inspired, long-form books with variable and substantial page counts. This flexibility remained largely impossible in English-language comics until the recent advent of the graphic novel. In the wake of his success, his publisher gave Tezuka six months to create an unprecedented 160-page science-fiction red book. Although he had never seen Fritz Lang's *Metropolis*, the title and a single still of its female robot were all it took to inspire Tezuka to devise his own totally original akabon based on it. Published in 1949 as a two-colour slipcased hardcover, his *Metropolis* presented a timely warning of the dangers of unchecked technological progress. Two years later, he was allowed to stretch to a 300-page futuristic critique of the superpowers then engaged in the Korean and Cold Wars, its title derived from the 1936 film *Things to Come*.

Whether dealing with serious or tragic themes or adapting classics such as *Faust*, *Crime and Punishment* and the life of Buddha, Tezuka stayed true for many years to the cute, almost quaint artwork and rounded, rubbery unreality of the classic animation and comics he had loved as a boy. Even in some of his most dramatic later works, he might deliberately puncture the fiction with humour, exaggeration or in-jokes, or by appearing himself, often directly addressing the reader. This may have been Tezuka's way of avoiding becoming over-earnest and transmitting his creative enthusiasm. Perhaps such intrusions serve as 'private' confidences from author to audience to say that, however realistic a manga becomes, it remains after all a fabrication. This is akin to the alienation effects used by German playwright Bertolt Brecht, like Tezuka a morally concerned storyteller from a defeated post-war power. Brecht wanted to remind his audience not to lose themselves entirely in the performance, but instead always to think for themselves. Similar effects in comics can disconcert Western readers who expect serious subjects always to be served 'straight', but through Tezuka they have become characteristic of manga.

In many ways Tezuka saw himself as the 'director' of his comics. He might not have sported De Mille's megaphone or Von Sternberg's high boots, but he did like to wear his French-style artiste's black beret at work and in public. In his manga and animation productions, he operated a 'star system' and cast his stories from the paper actors in his repertory group, as if they were acting a role in a film. When producing work in such volume, why start afresh with every story when you can bring back established players, with their own style of acting and a

Dostoevsky's *Crime and Punishment* was one of Tezuka's favourite novels in his student days; he even acted in a stage production of it. Adapting it into illustrated form in 1953 pushed Tezuka to experiment with comics' psychological potential. Above: To convey the inner torment of Raskolnikov, his brooding over the murder is shown in atmospheric panels, silent save for the sound of falling rain, his figure dwarfed by the cityscape. Left: Later, to dramatize Raskolnikov's decision to confess, Tezuka draws a tall upright panel, again wordless, of him descending a vertiginous flight of steps.

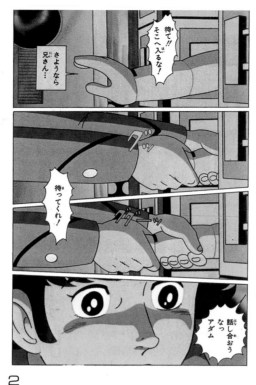

3

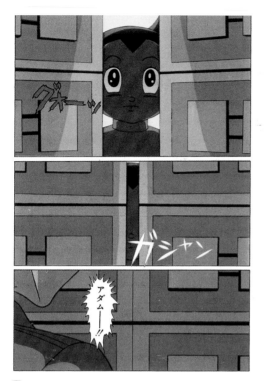

2

1

Above: A host of Tezuka's 'actors' took major roles and cameos in the movie *Marine Express*, a futuristic 1979 animated TV special. Tezuka's screenplay starts as a murder mystery on board an undersea train from California bound for Japan, but soon goes off the beaten tracks to take in time travel, alien invasion and the sea kingdom of Mu. In this sequence, Astro Boy, 'playing the part' of robot boy Adam, bravely undertakes to save the stricken locomotive.

persona already familiar to readers? There were forerunners of this idea in American newspaper strips, like Ed Whelan's *Minute Movies* and Floyd Gottfredson's assigning of Mickey Mouse and friends to assorted time periods, genre adventures and professions, but no one had taken it as far as Tezuka. It helped him to build a special relationship with his audience, who enjoyed recognizing the familiar actors' faces, now appearing typecast or 'out of character'. Tezuka made up biographies for his actors outside their appearances in the comics and wrote reviews of their performances. He even kept a ledger of what each of them 'earned'.

Film obsessed Tezuka in another way. If manga was his bride, Tezuka once confessed, then animation was his mistress. Money from his manga would finance his dream of adapting his characters for animated films. He took on more and more assignments and poured the profits into setting up his own animation company, Mushi Productions, in 1961. Through this he produced television cartoons of his manga *Tetsuwan* ('Iron-Arm' or 'Mighty') *Atom*, first broadcast on New Year's Day, 1963, and *Jungle Taitei*, the first in colour, in 1965 (they were sold abroad as *Astro Boy* and *Kimba the White Lion*). Their national and international success established the close symbiotic relationship between manga and anime that has underpinned the two industries ever since.

While further adaptations of his comics proved lucrative, his one-off, non-commercial experiments won acclaim and awards but brought meagre financial returns. For Tezuka, animation was a fulfilling but expensive affair, straining his finances to the point of bankruptcy.

Undaunted, he bounced back with animated movies made for television and 17 features for the big screen. Among the latter were *1001 Nights*, the first erotic animated film for adults, years before Ralph Bakshi's version of R. Crumb's *Fritz the Cat*, and the big-budget version of his long-running manga *Phoenix 2772*. To be a master of either animation or comics would have been achievement enough for most people; Tezuka was a master of both.

Having a story worth telling was paramount to Tezuka. He once said that a story, like a tree, needed strong roots to be compelling; if these were weak, no amount of flashy detail would hold it up. At the heart of all of his stories are questions about the seemingly eternal foolishness of mankind. Having endured the hate-filled militarism of the war years in Japan, Tezuka found in manga an accessible medium through which to convey warnings about the consequences of bigotry, disrespect for life and unchecked scientific advances. 'What I tried to express in my works can be summed up in the following message: "Love all creatures! Love every living thing!"' he said. But Tezuka was no naïve optimist or trusting humanist. He felt despair at man's continued inhumanity to man, and he understood the identity crisis facing the Japanese in the aftermath of their defeat. Addressing human issues like these is what gives his parables about a robot child, a white lion cub, a princess disguised as a man and an immortal bird such timeless resonance. They also prove his belief that 'comics are an international language that can cross boundaries and generations. Comics are a bridge between all cultures.'

アニメ版 ∝ テレビ

マリンエクスプレス VOL.1

原作 手塚治虫

Left: The relationship between manga and animation has become extremely close. Successful manga series are adapted into animated movies, TV series and specials and straight-to-video/DVD originals. From these derive 'anime comics' which collate colour 'cels' into pages of comics. This is the cover of the first volume of the 'anime comic' version of *Marine Express*, acclaimed as one of Tezuka's finest original feature-length movies.

Manga: Sixty Years of Japanese Comics

Below: On 7 April 2003, the Tezuka Museum in Takarazuka celebrated Astro Boy's official birthday by showing a replica model waking up repeatedly and speaking to the public. Astro Boy fan Natsu Onoda was among the visitors: 'The whole nation of Japan was there, I couldn't even move. I witnessed the museum staff make the decision to wake him up earlier than scheduled to appease the impatient crowd, and do so many, many times in a row. I could not even get close enough to see him until the fifth time of his awakening. The glass window went dark between awakenings, so we did not see him go back to sleep. There was music, the Beethoven they used in the TV series for the scene, and Astro woke up, then spoke: "Thank you, I was able to wake up since you have given me energy. If you have a camera, please take many pictures of me." People chuckled at this. Then the museum staff yelled, "Okay, if you have seen it, move along, move along!"' Onoda has also performed in a theatrical tribute to Astro Boy by the Chicago-based company Live Action Cartoonists.

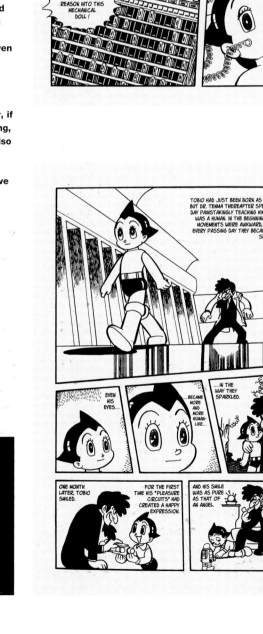

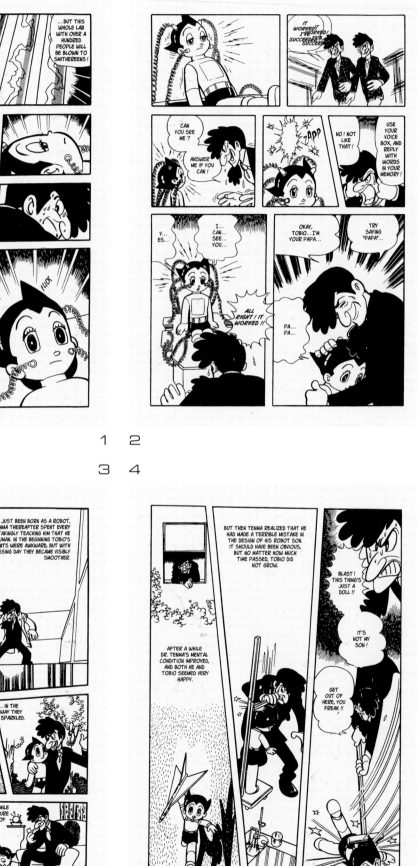

1 2

3 4

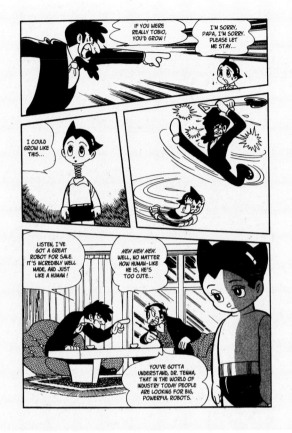

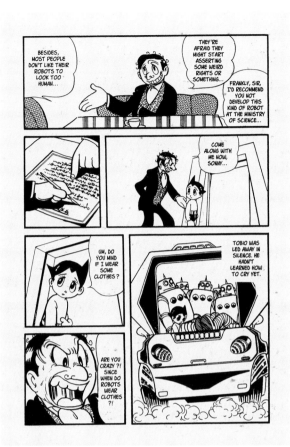

5 6

7 8

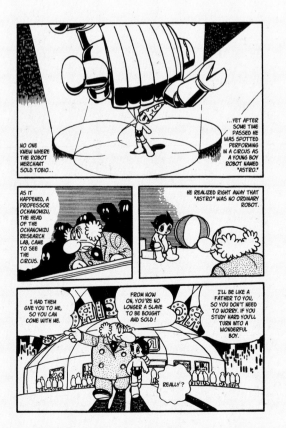

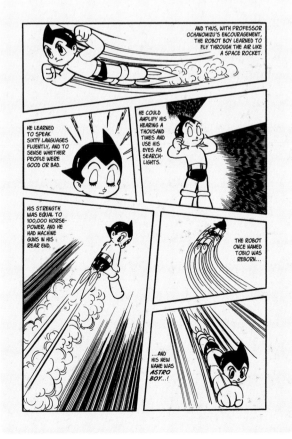

Opposite and this page: Like a science-fiction Pinocchio, Astro Boy was built by a grief-stricken industrialist in the image of his son, who had been killed in a car accident. The inventor's joy, however, is short-lived, because no mechanical boy could ever be a substitute for a real, growing child. Astro Boy is thus rejected by his 'father', but then rescued and refitted by a professor. Astro's quest to become human and to bring harmony between mankind and robots unfolded from 1951 in Osamu Tezuka's 17-year serial. The original Japanese title, *Tetsuwan Atom*, emphasizes his atomic-powered capabilities, or 'Seven Kinds of Powers and Mechanical Engineering'. During the 1950s, there was a mushroom cloud of fear surrounding nuclear energy, particularly in Japan; Tezuka's robotic friend offered a more hopeful vision of its uses.

Manga: Sixty Years of Japanese Comics

This page and opposite: In *Adorufu ni Tsugu*, or 'Tell Adolf', a daring blend of fact and fiction set mainly between 1936 and 1945, Tezuka weaves together the fates of three men called Adolf: one is Hitler himself, who according to secret documents actually has Jewish blood in him; the second is a young German Jew; and the third is his former friend, the son of a German diplomat and Japanese mother. The latter becomes a Nazi officer, shown in this harrowing scene executing Jewish prisoners but later stricken by his conscience, represented by the graphic device of the violinist's haunting music. One of Tezuka's greatest mature works in a more realistic style, this was serialized in the news magazine *Shukan Bunshun* and was the first of his epic stories to be published in English in 1995 under the title *Adolf*.

1 2

3 4

1

2

3

4

5

6

Created in 1972, the scene above sets the tone at the start of *Buddha*, an inspirational biographical tale for all ages and at nine volumes Tezuka's longest continuous storyline. A fox, a bear and a rabbit search for food for a holy man starving in the mountains. Returning with nothing, the rabbit throws himself onto the fire so that the man might live. Tezuka uses no words here, only a seamless flow of pictures and symbols to convey this moving act of sacrifice and transcendence, concluding with the full-page panel opposite.

From a Darker Place

DURING JAPAN'S post-war recovery, everyone needed a form of cheap entertainment to help them escape the poverty-stricken realities of the times. Gradually, as the larger Tokyo-based publishers got back on their feet in the late 1940s, they devoted more pages of their children's magazines to manga. But Osamu Tezuka was not the only aspiring comic artist who found it tough to break into them at first. Other untried, younger newcomers, still in their teens, were also hungry for opportunities to hone their writing and drawing skills. Rejected by the majors or unready for them, they had little choice but to look elsewhere. They turned to the cut-price and sometimes cut-throat outlets of paper theatres, novelty comic books and pay libraries. Though their earnings were not high, the compensations for total novices were regular work and few editorial demands.

By working for more marginal businesses, these young artists eventually refined a darker kind of manga known as *gekiga*, or 'dramatic pictures'. These were quite different from the period's mainstream comic titles targeted at kids – less simplistic and fanciful, their settings closer to the street and contemporary reality. Consequently, they were read by older teenagers and young adults. The term gekiga was coined by one of the genre's masters, Yoshihiro Tatsumi, in 1957. He deliberately wanted to distinguish his work from the lighter manga in the juvenile magazines at that time. Paradoxically, but happily for the manga tradition, many creators from this gekiga generation would go on to be accepted during the 1960s into these same mainstream magazines and change them forever. The doors that had once been closed to them were now open. The success story of the modern manga cannot be completely understood without acknowledging the crucial role of the compelling dramas and moods introduced by the new gekiga artists. Thanks in large part to their contributions, instead of growing out of comics, both readers and creators continued to grow up with them.

Everyone has to start somewhere. Several major gekiga creators cut their teeth in the fast and furious world

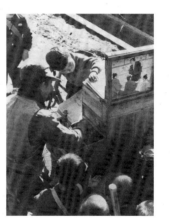

of the mobile wooden *kami-shibai*, or 'paper theatres'. Before the widespread ownership of TV sets, thousands flocked to watch these live performances, which resembled a form of street television. An actor would act out the dialogue while displaying a series of illustrated story-sheets in a TV-shaped window. Churning out these freewheeling, crowd-pleasing narratives was how many youngsters learnt to put across stories in pictures with speed, clarity and impact. The ghost stories of Shigeru Mizuki, Tatsuo Nagamatsu's skeleton warrior Golden Bat and the samurai heroics of Sanpei Shirato found their first audiences in paper theatres, before graduating into printed form.

Another route for young hopefuls was to be commissioned by canny publishers in the wholesale toy district of Osaka, Tokyo's rival and Japan's commercial heart. It was these who produced the *akabon*, or 'red books'. Tezuka recalled that 'after my *New Treasure Island* was released in 1947, the Kansai area became deluged with Osaka-made akabon manga'. He himself produced a further 36 of these books in the period to 1953, most of them issued in the red format by Osaka publishers. Hundreds more akabon by other hands were pumped out from 1947 to about 1956, a good few by uncredited illustrators plagiarizing or even simply appropriating Tezuka's artwork. Several artists brazenly imitated a bestselling manga based on imported Tarzan films, while others took as their heroes such Japanese stars as movie monster Gojira (Godzilla) or real-life television wrestler Rikidozan, in apparent defiance of copyright law.

Despite their often crude appearance, these books had a raw vitality that gave them a wide appeal. Peaking in popularity in 1948–50, the most popular titles were reprinted so often that they reportedly wore holes in the metal printing plates. To keep them cheap, the format was usually postcard-size or smaller, with the inside pages printed on low-quality paper. Costing usually between 10 and 50 yen, 90 yen (25 cents) at most, these novelties sidestepped bookstores and other official channels and were hawked via candy stores, stalls at festivals and fairs,

Right: Before television's arrival in 1953, more than 10,000 travelling storytellers would entertain nearly five million people every day with *kami-shibai*, or 'paper theatre' performances. Many stories were illustrated by future manga creators. Opposite: The gripping cover of Yoshihiro Tatsumi's 1956 gekiga crime drama *Black Blizzard*.

and by street vendors. Their wily publishers could be accused of exploiting youngsters into toiling for next to nothing. Nevertheless, they did allow Tezuka and others to try their hand at creating complete stories, many of 24 to 48 pages in length, a few of them considerably longer.

This became a problem. The publishers put out longer and longer stories to meet the demands of their young readers, but inflation pushed the cover prices beyond their reach, to 100 yen or more. Sales slumped and publishers panicked. But then children switched to hiring these comic books for only about 10 yen for two days from *kashibonya*, or 'rental libraries'. These long-established businesses allowed the public to hire out books, along the lines of Victorian 'penny libraries' or today's video stores. This new market of kashibonya helped many of the Osaka red-book publishers avoid bankruptcy. Manga became accessible and affordable for all. Sports mangaka Tetsuya Chiba, later to win fame for *Tomorrow's Joe*, was not the only beginner to get his first break drawing for the rental libraries. His parents did not initially approve, but were less opposed once he started earning money, at the age of 16, with his *Revenge of the Hunchback*.

Manga, whether in the rented volumes or in the newsstand monthlies and bookshop collections from the big Tokyo publishing houses, were still regarded as entertainments for children. This meant that there were virtually no manga aimed at older junior-high and high-school students, or graduates and young members of the workforce. When these types of readers also began to seek out manga from the pay libraries, the red-book publishers and others responded. They began catering to them with *kurai*, or 'dark' manga, in full-length books of 68 pages or more – the initial stirrings of gekiga. They altered their format to A5 (approximately 8½ inches high and 6 inches wide; 21.6 x 15.2 cm), larger than B6 or postcard size, to differentiate them from the junior red books. Publishers also offered the pay libraries monthly anthologies in hardcovers featuring a number of short gekiga stories, starting with *Kage*, or 'Shadow', in 1956 and then *Machi*, or 'Street', a year later. They would rarely print more than 10,000 copies: *Kage* reached 8,000, *Machi* 6,000. These print runs were not high, but they did not need to be. If each copy was rented 30 times, the total readership could reach 240,000 and the libraries would make a tidy profit.

Many of the young creators of these publications had much in common with Osamu Tezuka when they started out. Like him, many were born or lived in or near Osaka, where the library publishers were mostly based. The gekiga artists, however, were a bit younger and

Above: Three of the rental-library manga books by the young Tetsuya Chiba, including his very first, *Revenge of the Hunchback* (top), published in 1956 when he was only 16. The other two are historical samurai stories involving a goblin mask.

tended to come from less comfortable and cultured backgrounds. Tezuka's manga were an almost unavoidable early influence on them, but part of this new generation of artists grew disenchanted with his cartoonish, wide-eyed style and child-friendly themes. They preferred to deal with gutsier, more socially aware subjects, drawing on the themes and techniques in the latest films by Japanese directors like Akira Kurosawa and Yasujiro Ozu. The directors of American *film noir* and neo-realist cinema from Europe also provided alternative approaches. Yoshihiro Tatsumi's uncompromising, seminal short stories in *Kage*, for instance, did not flinch from exposing the scars of a defeated and deeply wounded nation. If there was any message in his subtle vignettes, it was that the process of life was to come to terms with despair and lack of fulfilment and to accept melancholia as the highest condition one could aspire to in a poetic world.

Gekiga creators also re-examined Japan's sometimes troubled history. Sanpei Shirato's carefully researched and naturalistically illustrated sagas harked back to past glories and tragedies. For instance, the spectacular splatterings of blood and body parts in his *Ninja Bugeicho*, or 'Chronicle of a Ninja's Military Accomplishments' (1959–62), predictably upset parents and teachers. What earned the series a much more appreciative following on campus was the hero's stance

against a despotic warlord on behalf of the poor and the Buraku pariahs. In Japan, this minority had continued to be subject to much discrimination and yet it was largely invisible in official histories. The extent of establishment control over the teaching of Japanese history remains an interesting and awkward subject. In 1993, the eminent historian Saburo Ienaga won a 28-year lawsuit to prevent the Ministry of Education from revising strongly worded passages in his high-school textbook about Japan's activities before and during World War II, although the court decided that the ministry did have the right in general to determine the content of history textbooks. By contrast, creators of period gekiga have often been able to relate episodes from history not taught in schools and through them strike parallels with concerns of the day. In conservative Japan, it is comics that provide a vehicle for independent and daring perspectives on the truth.

It may be no coincidence that gekiga publishers flourished during the highly politicized years at the end of the 1950s. This was a time of social upheaval and opposition to the renewal of the Japanese–American alliance, which culminated in 1960 in major riots. The general climate, however, changed during the 1960s, when the population as a whole focused their efforts on building their country into an economic superpower.

The rental libraries saw their market weaken at this time: young people had more money to spend and could afford to buy, rather than hire, manga. In addition, the libraries faced competition on the newsstands from the new boys' manga weeklies and in the home from the spread of television. As a result, by 1963 practically all of the publishers supplying the kashibonya had collapsed. A considerable proportion of the gekiga creators were forced to abandon the medium. Their stories from a darker place receded again into the shadows, at least for a while.

Nevertheless, at the same time gekiga artists were being commissioned by mass-market publishers, who saw in them a way to beef up the excitement of their weeklies. As early as 1960, Shirato had begun contributing period stories to Kodansha's *Shonen Magazine*. In 1965 Mizuki's creepy spirit world joined the line-up. By the end of the following year, the rougher, quirkier approaches of these and other gekiga creators had boosted *Shonen Magazine*'s sales to nearly one million. There was a price to be paid, though, for the incorporation of gekiga into the huge-selling manga juggernaut. Payment for pages shot up, but most artists had to knock them out in quantity to a strict weekly deadline and were subject to editorial intervention. Some artists were reluctant to put themselves through this industrialized system; to them, creative freedom was more valuable than cash rewards.

Among the latter was Shirato. In 1964, instead of entrusting his next ninja project to the established *Shonen Magazine*, he took the commercial gamble of offering it to a brand-new monthly, *Garo*. For its founder, Katsuichi Nagai, this magazine was no casual undertaking.

A gritty *noir* atmosphere pervades many gekiga short stories in the rental-library magazine *Deka*, or 'Seedy', which began to appear in the early 1960s. These extracts are from the first issue. Top left: A *yakuza* (gangster) tale by Takao Saito, later famed for his *Golgo 13*. Left: A private-eye story by Yoshiharu Tsuge. Tezuka's influence is evident here.

Manga: Sixty Years of Japanese Comics

Above: Rebel heroes of the people from Sanpei Shirato's compelling historical series *Ninja Bugeicho* (1959).

His third brush with death from tuberculosis had left him determined to focus his remaining years on his passion for manga of substance. Shirato's proposal for *Kamui Den*, or 'Legend of Kamui', so impressed Nagai that he resolved to launch a magazine to feature it and offered Shirato total editorial control, prompt payment and star billing. Together publisher and artist set up a showcase and laboratory for creator-driven manga. Its title, *Garo*, means 'art gallery' as well as being the name of a martyred warrior created by Shirato.

Kamui Den was the big reader attraction, highlighted on the cover of the first issue in September 1964, which featured a combat scene showing two bloody severed arms flying through the air. Shirato's class consciousness had first been raised by his father, a politicized illustrator notorious for his Communist convictions. Class struggle against injustice was central

to Shirato's character Kamui, a 16th-century ninja from the lowest caste in feudal Japan. In keeping with the worldwide wake-up call of the 1960s, this incorruptible people's hero was the first of a number of manga characters adopted by the protest movement. His name and image were displayed on banners when college buildings were occupied by political activists.

Shirato's presence alone would guarantee *Garo*'s finances until he left in 1971, the year of its highest circulation – 80,000 copies – still minuscule compared to those of the big players. Thereafter *Garo* had to survive on sales as low as 5,000 by operating on a shoestring and not paying its artists. Nevertheless, it provided a vital service, bringing estranged rental-library gekiga artists like Tatsumi and Yoshiharu Tsuge back to the medium and nurturing unconventional mangaka, the mavericks and visionaries essential to the continuing development of any living artform.

The innovations of both gekiga and *Garo* had not gone unnoticed by Tezuka. Approaching 40 and still keenly competitive, he realized that he could not incorporate comparable material into his commercial work. So in January 1967 he set up his own monthly magazine, *COM*, and threw down the gauntlet in the first issue's manifesto: 'Manga is said to be in its golden age today. However, how many excellent works of quality are actually being released? Isn't the real situation one in which many mangaka are being worked to death, while they are forced into submission, servitude and co-operation with the cruel requirements of commercialism? With this magazine I thought I would show you what real story manga are.'

In order to be able to produce the challenging work he most wanted to create, which would allow him to express his moral concerns, Tezuka had little choice but to publish it himself. From this point on, the more realistic artwork and dramatic storylines of gekiga began to influence his work. *COM* ran so many of his own manga that it became almost a Tezuka magazine, but he also recruited other leading professionals who yearned for space to experiment and ran competitions to find the 'best newcomers of the month', in this way launching many young artists on their careers. *COM* magazine closed in 1972, by which time it had served Tezuka's purpose of proving what 'real story manga' might achieve, notably in his continuation of what he saw as his life's work, *Hi no Tori*, literally 'Bird of Fire', but usually known in English as *Phoenix*. It is a measure of gekiga's importance, and Tezuka's openness, that they could inspire the father of story manga to rejuvenate himself, like a phoenix, and soar to still greater heights.

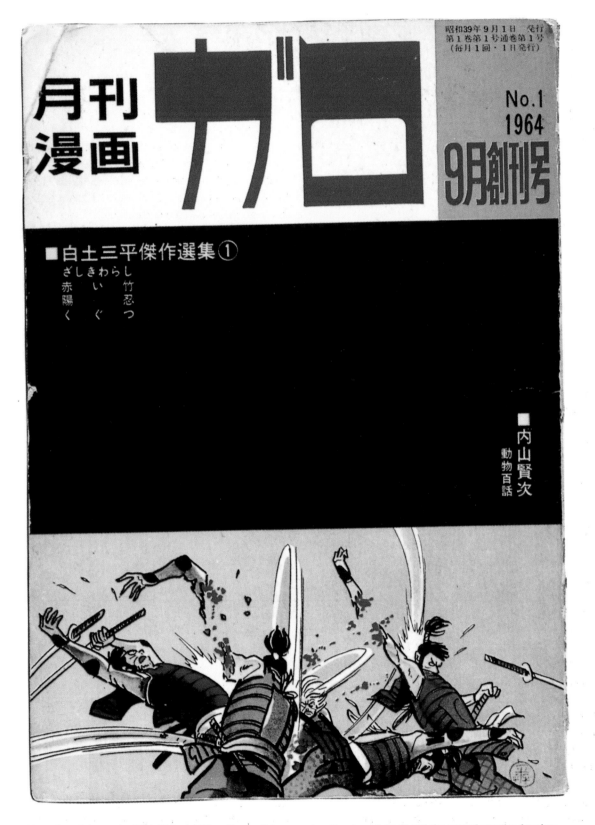

Ever since it began in 1964, Katsuichi Nagai's monthly magazine *Garo* has championed the sort of creative freedom rarely found in the mass market. Where else could Sanpei Shirato have unleashed his radical dismemberment-and-class-consciousness ninja epic *Kamui Den*? Above and top right: The covers of the first and second issues by Sanpei Shirato. Below this: covers to issues 47 by Yoshiharu Tsuge, 52 by Shigeru Mizuki (1968) and 101 (1972).

This page: Yoshihiro Tatsumi is a master of frank, unsentimental exposés of the human condition. In *Goodbye*, in which a father preys on his prostitute daughter, he evokes the dark side of occupied Japan.

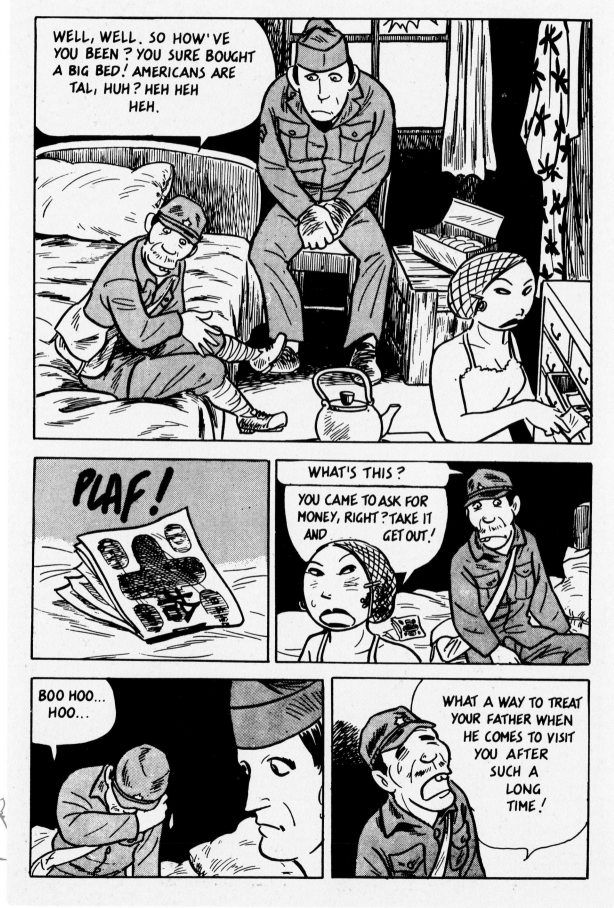

Left: Two escaped convicts handcuffed together come to blows in *Black Blizzard*, Yoshihiro Tatsumi's 128-page thriller from 1956, reminiscent of Stanley Kramer's 1958 movie *The Defiant Ones*.

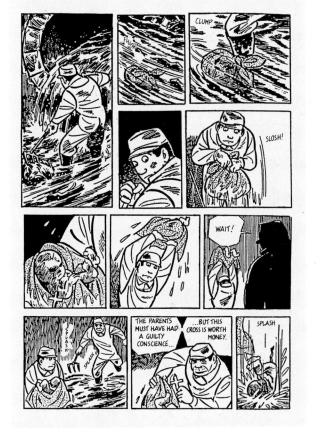

Left: In *The Sewer* Tatsumi portrays a sewer worker's selfishness, as he pressures his girlfriend to have an abortion and disposes of the child he never wanted.

Above: Brutal and balletic – Sanpei Shirato choreographs an ageing samurai's strategy to outwit a gang of assassins, despite being outnumbered six to one and cutting off his own injured foot. Taken from a short story drawn before *Garo*'s first issue.

Sanpei Shirato's *Kamui Den* from *Garo* and, shown here, its sequel *Kamui Gai-Den* from *Big Comic* helped define the historical gekiga genre. Against all the odds, the young rebel ninja Kamui combats injustices against the lower classes in 16th-century feudal Japan. Here he helps Oshika carry out a daring horseback rescue of her father, but there is no escaping their lethal pursuers.

1 2

Fascinated as a boy by the phantoms and monsters of Japanese folklore, Shigeru Mizuki began to draw them for rental-library books and paper theatres beginning in 1957. Right: A samurai who can talk to animals enters a cave of cats, from the first issue of *Garo*. Above and below: Mizuki's 1959 *Ghost Family* unveiled his most celebrated character, GeGeGe-no-Kitaro.

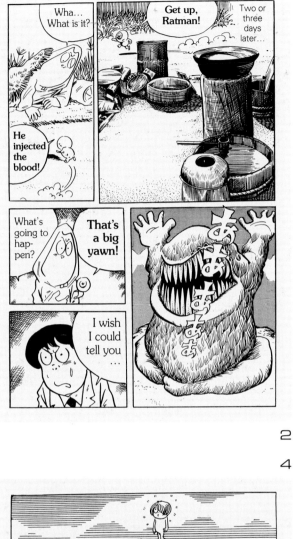

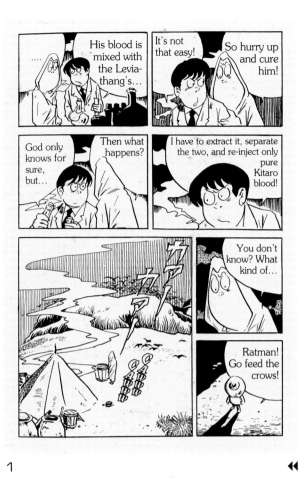

2 1

4 3

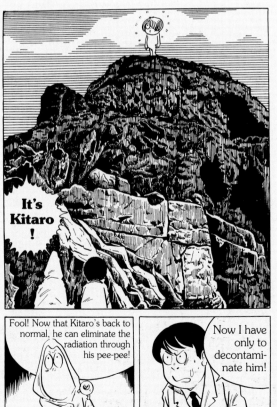

Shigeru Mizuki lost his left arm while fighting in World War II in New Guinea. He had experience there of contact with the spirit world, a source of much of his later manga stories. Assisted by his phantom family, his boy-hero GeGeGe-no-Kitaro somehow manages to resolve problems between humans and goblins. Although his father died before Kitaro was born, he returned from the dead by reanimating his own eyeball and growing arms and legs. He and Kitaro are shown on the opposite page (below) with, from left to right, the Sand Witch, Old Man Crybaby and Ratman, and Piece-of-Paper floating overhead, all figures from Japanese folktales. One of the distinctive qualities of gekiga is the setting of simplified characters within meticulously realistic decors, as in this sequence (left), where a scientist has transformed Kitaro into the 'Leviathang'.

Manga: Sixty Years of Japanese Comics

Few if any manga have matched Osamu Tezuka's epic *Hi no Tori*, known in English as *Phoenix*, for sheer scope and daring. From 1967 to 1972, Tezuka had to publish it himself in his magazine *COM*. When he first began to work on it, in 1954 and 1956–57, Tezuka was still heavily influenced by Disney; when he resumed the saga in *COM*, it shone with his new maturity and passion. The immortal bird has now been transformed into the guardian of the living universe, who renews itself across twelve books that swing between our world's ancient dawn and its end in the 35th century. Left unfinished on Tezuka's death, at more than 4,000 pages, *Phoenix* is a masterpiece that will assure its creator's immortality. The second book, 'A Tale of the Future', is part Buddhist science-fiction parable. It shows the folly of mankind's self-destructive evolution, which wilfully ignores the interdependence of all things, from galaxies to the tiniest atomic particles. Here, the Phoenix transports Space Patrolman Masato on a trip as mind-expanding as Kubrick's finale in *2001: A Space Odyssey*. All Tezuka images © Tezuka Productions. All Rights Reserved.

Chapter 05

Boys Are Forever

THE MOOD WAS sombre that day in March 1970, as hundreds of people flocked to the offices of Tokyo publishing giant Kodansha. Manga creator Tetsuya Chiba will never forget it. 'The streets were packed. All those readers were there, even though it was a weekday. People had taken time off work, businessmen, students. They were all dressed in black, they had black armbands and black ribbons on, many had brought flowers and incense.' Chiba himself almost didn't join the extraordinary gathering. 'A famous poet in Japan, Shuji Tarayama, had called for a funeral to be held, but at first I thought he was joking. I didn't believe it would happen, but it did. At the time I was working very hard, so when I was told that I ought to turn up, I thought, "No, all I want to do is sleep!" But I made the effort and decided, "Right, I guess I better dress up smart, do my collar up and put my tie on."' Chiba was going to attend a funeral service for one of his manga characters.

Only a few weeks earlier, his *Shonen Magazine* boxing serial *Ashita no Jo*, or 'Tomorrow's Joe', had featured a showdown between Joe and his arch rival, Toru Rikiishi. By submitting himself to a debilitating diet, Rikiishi had been able to slim down to Joe's bantamweight class. His body was so weakened, however, that his knockout victory over Joe cost him his life. The character's death so moved readers that more than 700 mourners joined Chiba in Kodansha's offices for a service conducted in a full-scale boxing ring by a Buddhist priest. Such an outpouring of grief for a fictional figure reveals how deeply readers can become

attached to weekly manga dramas. The public had rooted for Tomorrow's Joe, too, as he struggled to raise himself from petty criminal to world-title contender. Chiba has an idea why the Japanese took this story so much to their hearts: 'Joe is completely wholehearted, he puts himself on the line totally. He just wants to do one thing very well with his life and really goes for it without hesitation, even if it might seem impossible, despite all his limitations. Those qualities are very dear to the Japanese.'

Joe's career climaxed in 1973 with one of the most memorable finales in all of boys' manga fiction. Somehow, this ordinary Joe finds the strength to keep on fighting against the world champion through all 15 rounds. The question at the end of the story is not so much whether he has won or lost, but whether he is going to live or die. The last image shows him slumped on his stool, bruised, exhausted, silent, but with a smile across his face. Chiba and writer Ikki Kajiwara preferred to leave Joe's fate open: 'There are adults who see Joe collapsed in his corner and they assume he is dead and done for. And then the younger audience think, yes, Joe has put everything he had into that fight, but he's not finished. He's actually matured because of this experience. He is going to go on, because he is Tomorrow's Joe.' Perhaps the kids were right – after all, readers never held a funeral for Joe.

Joe's mettle stirred the nation in other ways. Years before adult boxing movies like Stallone's *Rocky* or Scorsese's *Raging Bull*, Chiba and Kajiwara crafted a manga for boys that made you feel every punch of Joe's brutal bouts. These long, unsanitized, blow-by-blow accounts added to the debate about the 'violence and coarseness' being introduced into children's weeklies by the darker and hugely popular gekiga stories. From 1967,

Below: Young Tetsuya Chiba hard at work at his drawing table. Right: Tomorrow's Joe dominates a bookshop poster promoting boys' classics. Opposite: Throughout 2003's 'Endless Summer Dream!!', *Shonen Jump*'s 456 pages for 220 yen (or $2) celebrated 35 years of weekly thrills for hyperactive boys of all ages, here cover-featuring lead story *Buso Renkin*, or 'Armoured Alchemist', by Nobuhiro Watsuki.

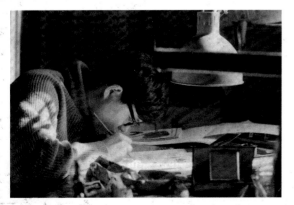

Above: What a catch! An eye-popping blue spread from Takao Yaguchi's fishing manga *Tsurikichi Sanpei*, or 'Fishing-Crazy Sanpei', featured in a 1980 issue of the weekly *Shonen Magazine*. Below: Tetsuya Chiba's baseball hero from *I'm Teppei*.

a governmental Youth Policy Unit placed any suspect manga on a 'Harmful Designation List'. Chiba has recounted in an autobiographical manga an uncomfortable visit to his studio by officials investigating *Tomorrow's Joe*. The series was deemed 'indecent', complaints were sent to the publishers, and in 1973 it was brought to its famously inconclusive conclusion.

In this tale of a Japanese prizefighter prepared to put up his fists and fight all-comers, the square ring seemed to epitomize the moral conflicts that had remained unresolved in Japan since the war. Besides concerns that the story made a virtue of violence, pressures to curb *Tomorrow's Joe* may have also been related to the character's adoption by political and terrorist groups. Like Shirato's earlier ninja, Kamui, in *Garo*, Joe quickly became an icon of rebellion for the proletariat. So much so that in 1968, the year he first appeared, hijackers from the Japanese Red Army knew that everyone would understand their motives when they stated: 'We are Tomorrow's Joes.' Soon after, the character was adopted by Japan's student protest movement, so that some branded the series 'the Bible of student extremists' and blamed it for encouraging violence during street demos against the Vietnam War and the government's support for America.

That same military power had occupied Japan from 1945 to 1952. Under the US post-war administration, there had been similar anxieties about the insidious influence of aggressive subject matter, not only in manga but throughout the Japanese media. This had prompted the American authorities to crack down on anything that smacked of Japanese war-mongering or the Bushido values of blind obedience and self-sacrifice. In 1946 they drew up a constitution to enshrine goals of democratization and demilitarization, which laid down that 'the Japanese people forever renounce war as a sovereign right of the nation' – Japan was in effect forbidden 'the

right of belligerency'. Before and during World War II, comics about samurai warriors in boys' magazines had disseminated ideals of patriotism and militarism; to root out such tendencies post-1945, samurai tales were outlawed, as were judo, karate, sumo wrestling and other sports. The ban applied both in print and in practice; indeed, it prohibited competitive sports of any kind. General MacArthur finally lifted it in 1950, realizing that if the Japanese were no longer to be allowed near the battlefield, it would be wise at least to let them back onto the playing field. To restore morale and instil hope for a new Japan, the defeated nation needed to learn about winning again.

Uplifting manga stories about sports of every kind, from national favourites baseball and sumo wrestling to fishing and motor racing, soon caught on in early 1950s magazines for boys. To this day, manga are recognized for their role in motivating youngsters to take up sport. At the time soccer was not played professionally in Japan, but Yoichi Takahashi was so impressed by his experience of the 1978 World Cup in Argentina that he set about popularizing the sport through his hero Captain Tsubasa, who rose from child prodigy to become national youth team captain. Several of Japan's World Cup players in 2002 cited this manga as having had a life-changing influence on them. No doubt future table-tennis pros will be saying the same about Taiyo Matsumoto's *Ping Pong*, which has been adapted into a hit live-action movie.

Everyone knows that in the end a sports manga hero is bound to win, or lose well, so the thrill comes from reading how he overcomes all challenges with determination and honesty. A baseball or basketball game can stretch to hundreds of pages, every move broken down and its impact maximized through jarring layouts, speed lines and sound effects, and blurred and foreshortened figures. The genre's winning formula consists of following an unlikely but gifted novice, often the underdog or little guy, through the rigours of training under a master and on against all odds to eventual triumph. Indeed, this formula has been applied to manga set in all kinds of different worlds, from martial arts, fantasy and science fiction, to big business, power politics and even the manga profession itself.

After the war, being a mangaka represented an entirely new competitive field and a creative alternative to the factory floor or office desk. During the first eight months of peace, the number of book and manga publishers grew from around 300 to over 2,000. The market for boys' manga appeared ripe for exploitation and appropriately aimed tales gradually started to occupy more space in the monthly newsstand magazines which multiplied in number

ART and STORY by **INOUE TAKEHIKO**
SLAM DUNK

Will Sakuragi get to start in his very first game?

EPISODE 26: THE SECRET WEAPON

ON SALE JUNE 18!

Slam Dunk Graphic Novel Volume 1

FOR MORE DETAILS, SEE PAGES 3-4.

Above: Yoichi Takahashi's Captain Tsubasa, from boy prodigy to 2002 World Cup star. Left: *Jump* sportsman Sakuragi, reluctant, red-headed basketball player in *Slam Dunk* by Inoue Takehiko.

Below: In boys' manga, everything can be competitive, even Chinese wok cookery, as in *Iron Wok Jan* by Shinji Saijyo.

from the late 1940s, the period when the foundations of the burgeoning mass-market manga industry were laid. While still a medical student at Osaka University, Osamu Tezuka seized every opportunity to sell his characters to the different periodicals. By 1952, after only five years, he was leading the field. To give some idea of Tezuka's productivity and the booming market: that year his New Year's greeting card showed him in a 'group photo' of his characters from at least seven concurrent serials in seven different magazines, not counting those from his red books. No wonder his style became dominant so quickly.

Not every storyline by Tezuka was proving very popular, though. He was disappointed with reader response to his new feature *Ambassador Atom* for the monthly *Shonen*, in which the future Astro Boy had debuted in April 1951 as a 'bit player' and an unfeeling robot. Tezuka was called in for a meeting with the magazine's editor-in-chief, a Mr Kanai, who gave him some advice. He forecast: 'The magazines today have got to get beyond gag strips. I think that works with a stronger narrative element are going to become more and more popular.' How accurate that prediction would

prove to be. Kanai told Tezuka that in his view readers of manga magazines were not the same as those who read akabon red books – they wanted heroes. It was this far-sighted editor who spotted the potential of Tezuka's robot child. To appeal to readers, Kanai urged him to turn Astro Boy into a hero fighting for justice and to make him warmer, a more emotional and human figure. Tezuka realized that what Astro was missing were parents. Their creation formed the story for the first episode of Astro's own serial, the meteoric success of which gave Tezuka the courage to give up his career as a doctor and follow his dream.

The teenagers who had grown up reading, re-reading and copying his work dreamt of following in Tezuka's footsteps. With opportunities improving in this expanding field, Tezuka moved to Tokyo to be near his publishers. He set up a studio in the drab but affordable Tokiwaso apartment block, a building that was typical of the period's rapid reconstruction programme. Aspiring cartoonists flocked to the capital to seek out the master. The building became a magnet for 'wannabe' comics creators, some of whom started out as his assistants

Towering robots began as remote-control clunky machines like Tetsujin 28-go, or Gigantor (below right). Go Nagai revolutionized the genre with the pilotable Mazinger Z and Grendizer (right), which led to the high-tech designs of *Gundam* (opposite below).

Below: The rivalry begins as *Shonen Magazine* and *Shonen Sunday* unleash a new era of boys' manga weeklies in 1959.

before growing up to become his rivals. Owing to the much-loved manga creators and characters associated with this address, the building has now acquired almost mythical status: it is visited by tourists, dramatized in manga and film, and was even re-created in a Tokyo Tezuka store as part of Astro Boy's birthday festivities. What could be a more appropriate site for the birthplace of post-war manga than this ordinary place of work?

Starting in 1959, 20 years after the birth of *Batman*, the Japanese comics industry experienced a remarkable period of growth. This was fuelled by the dynamic expansion of the economy and the increase in the available audience, when the children of the post-war baby-boom generation reached manga-reading age. Radio and television in the home were competing for kids' attention by adapting several successful comic characters into serials. A weekly live-action TV version of *Astro Boy*, for example, was broadcast in 1959. It dawned on publishers Kodansha and Shogakukan that a month had become a long time in a child's life. On TV and radio, a mere seven days separated one episode from the next. So the two publishing companies set about launching Japan's first manga weeklies for *shonen* ('boys'): Kodansha's *Shonen Magazine* and Shogakukan's *Shonen Sunday*. So zealous was their rivalry that they tried to beat each other to the newsstands with their first issues. Both were eventually released ahead of schedule on the same day, 17 March 1959. They even vied with each other to have a photograph of the same famous baseball hero on their front cover; in the end, it was *Sunday* that secured his sales-boosting smile.

Readers quickly came to prefer a weekly 'fix' of manga excitement, so monthlies fell out of favour. The battle of the boys' weeklies heated up during the 1960s, as new, English-sounding titles like *Champion*, *King*, *Ace* and *Jump* entered the fray and circulation figures shot up. For manga creators, shifting gear from monthly to weekly publishing schedules quadrupled their workload; the whole working process had to be restructured. To cope, many set up studios and took on assistants. There were no recognized qualifications in this field, and social status or family connections counted for little. Hence the medium was open to anyone who had talent, luck and drive. There was good-natured but intense competition between the studios – and not just on the printed page. Taking a break from their drawing boards, several studios played baseball against each other. In 1960, for instance, Tetsuya Chiba formed his 'Whites' team, only to be promptly beaten 8:2 in their first game by Tezuka's 'Gamma' boys. So began a long-running sporting rivalry between the studios.

Above: The guy in the white sweater is Koji Kabuto, who as a boy was the original pilot of Go Nagai's Mazinger Z. Here, by popular demand Koji returned to drive Grendizer in 1975.

Japanese boys' manga, the bestselling sector of the market, share most of the action and comedy themes common to post-war boys' comics worldwide, with a few exceptions. The genre of cowboys and Wild West folklore, still popular today in France and Italy if not in America, is probably too rooted in American history to be transplanted easily into manga. Besides, Japan had no need to import the western when it already had its own samurai warriors and a rich legacy of folk tales and legends. Crime-fighting costumed superheroes, often humans transformed by accident, design, tragedy or mutation, have dominated American comic books since the 1960s. Few American superheroes have made much impact in Japan, however, whether

in their limited translations or in original manga adaptations. Japan's unlikely champions are mostly aliens and androids, like Ultraman, Eight Man and Muscleman, and uniformed, masked teams, from the Kamen Riders to Power Rangers.

The Americans and British went on for years fighting and winning World War II in their countless war comics. Understandably, in Japan, the painfulness of the subject and the restraints on promoting militarism under the occupation and new constitution meant that hardly any modern war stories were produced. A resurgence of chauvinism in the early 1960s led to a fad for glamorized war manga for boys, a tendency that deeply disturbed Tetsuya Chiba. 'They presented war in a very aggressive light, as if soldiers were real superheroes. I felt that showing how we killed the enemy is not something splendid. War is a disaster and that was the reason I wrote *Taka of the Violet Lightning* in 1963.' Chiba researched his portrait of a fighter pilot thoroughly. 'I studied volumes of archived letters from pilots and spoke with people who had lost sons and brothers in the war. I learnt that petrol was sometimes so short, pilots had to be sent off with only half a tank in their plane.' The inclusion of true incidents like this made Chiba's serial unusually authentic and affecting.

By the age of six, Keiji Nakazawa had lived through the horrors of war and, with his mother, had survived the atomic bombing of Hiroshima in 1945. Growing up, Nakazawa wanted to forget his past. He became a manga artist, concentrating on creating sports and science-fiction stories. He was forced, however, to confront the bomb after his mother's death. 'Usually the bones remain after cremation, but radioactive caesium had eaten my mother's bones away and they turned to ash. I felt as if my mother were telling me to convey the truth about the bomb to the people of the world.' There was no better way for him to bear witness than through his comics. In his acclaimed *Shonen Jump* serial *Barefoot Gen*, Nakazawa transcribed not only his experiences of the immediate ghastly aftermath, but also his family's wartime opposition to ultra-nationalist propaganda and their post-war deprivations under the American occupation. He hated America for dropping the bomb, but he was even more furious about the lack of accountability of Japan's leaders, from Emperor Hirohito, who had driven his country to war, down. Nakazawa was allowed, in fact encouraged by his editors, to address such charged topics in of all things a boys' weekly comic. Compared to other Japanese media, manga offered an almost unique opportunity to speak the unspeakable.

Is it human nature, if not a human right, to go to war? How does a nation deal with being forbidden to do so again? There are no restrictions in manga on fantasizing about waging and winning a war in the future using one of the country's greatest assets: advanced technology. Dreams of scientific wonders defeating the enemy had been expressed on both sides during World War II via the opposing nations' patriotic comics. Thanks to American laboratories, a weedy specimen could be injected with a serum and rebuilt as super-soldier Captain America, while teen pilot Airboy could rule the skies in Birdie, his revolutionary, bat-winged fighter plane. By contrast, in one famous militaristic manga in 1943, Japanese scientists had favoured non-human intervention and constructed a huge spike-booted Science Warrior to flatten New York.

This wartime fantasy seems to be a major source of the giant-robot phenomenon in manga and anime. The notion was revived in the 1956 series *Tetsujin 28 go*, or *Gigantor*. The first true giant robot in manga was the twenty-eighth member of a battalion of metallic warriors designed to save Japan during the war. Its construction was interrupted by the American bombings. When it was completed and revived years later, its mission, like that of post-war Japan, was no longer fighting but instead keeping the peace, and its might was employed to thwart assorted criminals and aliens. Granted no identity or intelligence of its own, Gigantor was a clunky prototype for many Japanese giant robots. Typically, these are conceived as tools or weapons for humans, often youngsters, to drive like a vehicle or operate by remote control, or to wear as suits of armour. Robots in manga who have their own personalities tend to be small and friendly, like Astro Boy and Doraemon, the robot cat from the future. By and large, the bigger the robot, the less likely it is be independent or individualized.

While Japanese technology was advancing the miniaturization process of electronic goods, scientists in manga were unleashing a proliferation of massive mechanized beings. The genre was reinvigorated by Go Nagai and his Dynamic Productions in 1972 with *Mazinger Z*. This was the first manga to play out the power fantasy of piloting a towering miracle of engineering, built of the

Above: Boys' SF manga stretches from kids' toy-robot fantasies such as *Playmodel Kyoshiro* by Koichi Yamato to the likes of sexy space opera *Cobra* by Buichi Terasawa.

Above: Hard man Ken takes bullets on his chest and masters the splatter martial art of *Fist of the North Star*, a massive *Jump* hit from 1983 by Tetsu Hara and Buronson. Right: *Cocona* by Hiro Mashima is a recent *Shonen Magazine* success.

Below: The dumb and dumber boy and his dad, 'The Genius Bakabon', helped redefine nonsense comedy manga in *Shonen Magazine* from 1967.

indestructible metal known as 'Japanium', from within the machine's brain. The *Mazinger Z* manga and its spin-offs provided a foretaste of an increasingly convoluted and maturing subculture of *mecha*, as in high-tech mechanics. *Macross*, *Gundam*, *Patlabor* and several other sagas of transforming robots and extravagant bodysuits were born as anime movies or television shows and later adapted into manga.

These manga and anime war stories, with their advanced military hardware, technical specifications and battle logistics, can be seen as a way for the Japanese to simulate scenarios, on a grand, even intergalactic scale, in which superior technology and strategy conquer all. At times, the future becomes barely distinguishable from the past, as the elaborate designs of robot heads, bodies and weapons recall samurai helmets, armour and swords. But these sagas are often as much about relationships, human and otherwise, as they are about combat and machine design. These fantasies, and the related dramas about humans rebuilt as cyborgs, or androids taking on human form, dare to address the interdependence and fusion between humans and machines. It should come as no surprise that many of the scientists and designers at the forefront of Japanese robotics research grew up on robot manga and anime – nor that they commissioned *Patlabor* artist Yutaka Izubuchi to design the final outer body of Japan's 'Promet' humanoid, unveiled in December 2002. Comics and animation are preparing us all for how robots will look and interact in reality in the future.

Equally enjoyed in boys' manga are the mischief, mayhem, knockabout pranks, and bad and mad behaviour that make kids laugh in comics the world over. Certain Japanese creators, however, pushed this genre into unfamiliar territory in the late 1960s. Gag manga had grown rather safe and stale and thoroughly benefited from being re-booted by the 'extremely foolish' comedies of

Fujio Akatsuka. His insane 1967 family sitcom centred on an idiot-father, Tensai Bakabon, or 'The Genius Bakabon', who managed to be even dumber than his dumb son. Japanese patriarchy had never been ridiculed so ruthlessly and kids loved it.

Surpassing that affront, the following year came Go Nagai's provocative *Harenchi Gakuen*, or 'Shameless School', in *Jump*. Parents and teachers were outraged, but pupils lapped up his anarchic satire of Japan's high-pressure education system, in which male students and teachers alike are fixated not on study, but on drinking, gambling and above all on ogling girls. Hardly explicit, it provided a welcome challenge to authority and the cramming regimes many youngsters had to endure. Nagai's publishers Shueisha, however, were taken to task by the government's Youth Policy Unit for publishing such 'harmful' classroom antics. Nagai eventually decided to wind up the series, but not before taking his revenge. Portraying the storming of the school by opponents of his series, he had the latter perish in a massacre that left no survivors. Though undeniably silly and juvenile, series such as this permitted some expression in Japan of the spirit of rebellion gripping the youth of the world at the time.

Bizarre flights of the imagination also raised the stakes, and raised some concerns, in other boys' genres. For instance, in the 'sports-guts' variety of hot-blooded baseball manga, there had never been such a deliriously implausible team as in Ikki Kajiwara's *Astro Kyu-Dan*. Thanks to their incredibly wealthy owner, they trained in a state-of-the art stadium and travelled in their own Concorde. Several players had unusual skills: for instance, there was a blind man with fine-tuned hearing, and a giant who was able to hurl his Tom Thumb-sized brother to catch high-flying balls in mid-air. Never one for doing anything by halves, Kajiwara made a guilt-ridden cheat commit seppuku, or hara-kiri, and made the pitch after one losing game resemble an infamous wartime naval defeat. Similarly, martial-arts manga had never been so surreally gory as in *Fist of the North Star*, in which the touch of a single finger could trigger unmentionable bodily explosions.

What also hooks millions of Japanese males, and females too, on boys' manga is that hardly a day goes by without one or several animated adaptations of them being

broadcast on television – you couldn't buy that kind of prime-time advertising. You can't always judge a manga by its anime, though. It is not uncommon for the story to be changed, and important details can be lost in the leap from printed page to small screen. Take the case of *Dragon Ball*. Creator Akira Toriyama has observed that 'the problem is, one anime episode can typically cover three manga episodes, so anime can easily outpace the speed of manga. So the anime is stretched out by adding more combat.' In the process, the less spectacular strengths of a manga story can be diluted by the animators' need to fill airtime by dazzling the eyeballs with fighting and effects. *Yu-Gi-Oh!* escalated into a card-game craze and related anime series, which missed out some of the qualities of the heartwarming original manga about how a shy, timid schoolkid makes friends and finds the courage to stand up for them against bullies and tricksters.

So why are so many readers of boys' manga adult men? Are these stressed salarymen, husbands and fathers, escaping into a second childhood? Or perhaps they have never truly left their first childhood and prefer to remain 'like a boy of twelve'? Nostalgia undoubtedly has its attractions, but the enduring allure of the boys' weeklies may not be their denial of adulthood or responsibility, but rather the positive values they promote. As editor of *Shonen Jump* Hiroki Goto explained in 1991, the weekly magazine 'shows that if you work hard you can accomplish anything. That's what our stories are saying. And that philosophy appeals to both children and adults.' What seems to sell *Shonen Jump* and other titles to boys of six to 60 is their values of friendship, perseverance – and winning. In weathering the struggle of rebuilding their country since the war, and now of reviving their economy since the recession, the Japanese have continued to find inspiration and solace in shonen manga heroes. It's somehow fitting that the word *shonen* not only means 'boy', made up of the characters for 'few' and 'years', but also 'pure of heart'.

Left: Akira Toriyama's *Dragon Ball* debuted in 1984 and helped *Shonen Jump* achieve the highest-ever sales of any of the top four boys' weeklies. A recent *Jump* cover appears on page 53, while covers from the other three competitors are shown below.

Within its 486 pages, this 1 July 2003 issue of *Shonen Magazine* offers 22 stories, including *Reservoir Chronicle* by all-woman studio Clamp, *Samurai Deeper Kyo*, magical fantasies *Magister Negi Magi*, *Rave* and *Cocona*, plus three baseball serials, basketball, cars, golf, mahjong and a pop starlet photoshoot: www.shonenmagazine.com.

The 468-page *Shonen Champion* for 18 September 2003 marks the thirtieth anniversary of Tezuka's *Black Jack*. Grappler Baki, hard man Switch, the explorers of *Unknown Kingdom,* cycling, soccer, magic training, boxing, three baseball stories and more make up the other 23 strips, plus film and music news and pin-ups: www.akitashoten.co.jp.

Among the 22 manga in the 438-page 24 September 2003 *Shonen Sunday* are favourites Gosho Aoyama's *Detective Conan,* Rumiko Takahashi's demon Inu Yasha and Mitsuru Adachi's boxer Katsu, plus soccer, basketball, speedboats, circus training, baseball, lots of wild fantasy battles, and a cover star pin-up section: http://websunday.net.

In the pummelling final round of his bantamweight world-title fight, Tomorrow's Joe pushes himself as never before against title-holder José Mendez. Tetsuya Chiba, shown above, had been independently researching a boxing story when sports-manga writer Ikki Kajiwara heard of an editor who was interested in running a story about boxing and who suggested they work together. Joe has remained popular in the 30 years since the publication of this powerful conclusion, adapted into animated films and TV series, live-action movies, plays and even a musical.

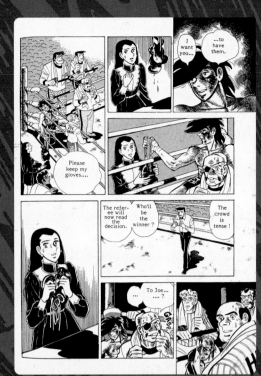

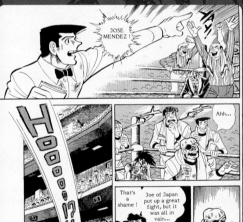

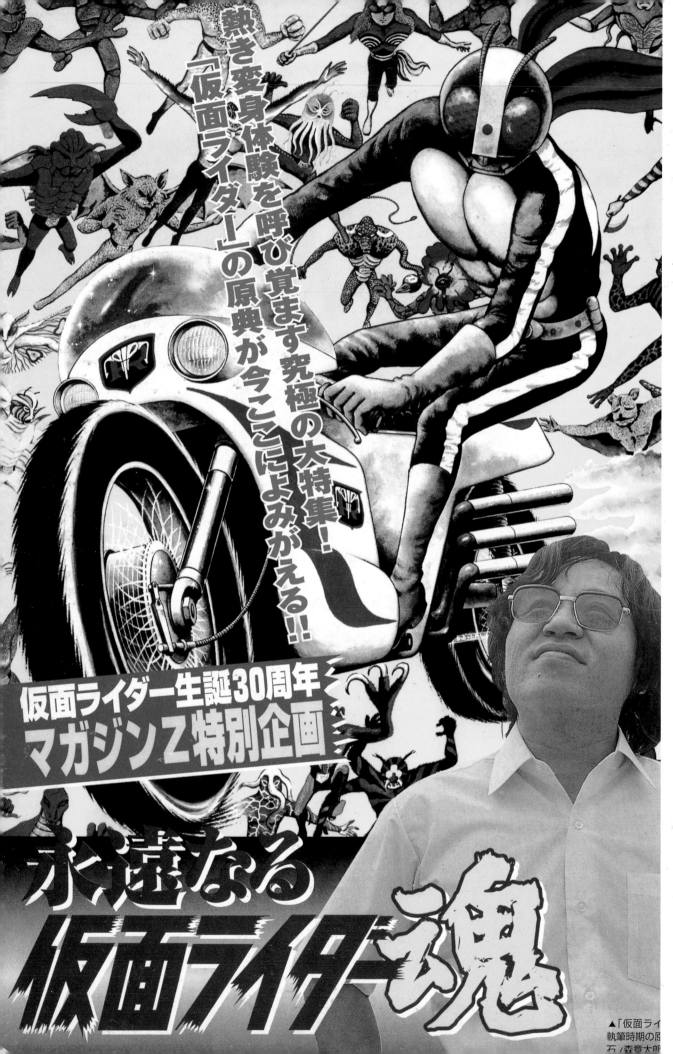

熱き変身体験を呼び覚ます究極の大特集！

「仮面ライダー」の原典が今ここによみがえる!!

仮面ライダー生誕30周年
マガジンZ特別企画

永遠なる
仮面ライダー魂

▲「仮面ライ
執筆時期の原
石／森章太郎

Japan may not be overrun by superheroes in quite the same way as America, but there's still no shortage of costumed heroes, aliens and androids in manga. Left: A perennial favourite created by Shotaro Ishinomori (1938–98) is Kamen Rider, or 'Masked Rider', in his insectoid helmet. He debuted in 1971 in manga and a Toei Productions live-action TV series; new shows and movies are still being made today. Ishinomori had wanted to be a novelist, but working as a teenager as Tezuka's assistant convinced him to pursue manga instead. Below: After the Cuban missile crisis, ardent pacifist Ishinomori sought to expose the military-industrial complex which he believed conspired to keep the world in 'a war without end'. In 1964 for *Shonen King*, he imagined the next stage in warfare using cybernetically enhanced humans. A brown-haired, half-Japanese delinquent becomes Cyborg 009 and leads a multiracial team against their makers.

Left: Ultraman is a skyscraper-high alien champion from the planet Ultra. He and his many Ultran cohorts first battled evil monsters in an influential live-action TV series in 1966. Below left: Among the manga adaptations is *Ultra Brothers* by Noboru Sakaoka. This is from a 1982 issue of *Shogaku Ninensei* for eight-year-olds, a tie-in with a series screened contemporaneously on NHK TV. Above: Another cross-media success is the alien wrestler hero Kinnikuman, aka Muscleman, created for *Shonen Jump* by Yudetamago in 1980. Shown here is Kinnikuman II, his son, who starred in *Ultimate Muscle: The Kinnikuman Legacy*, a recent 'Second Generation' revival to celebrate sales of over five million copies of the series.

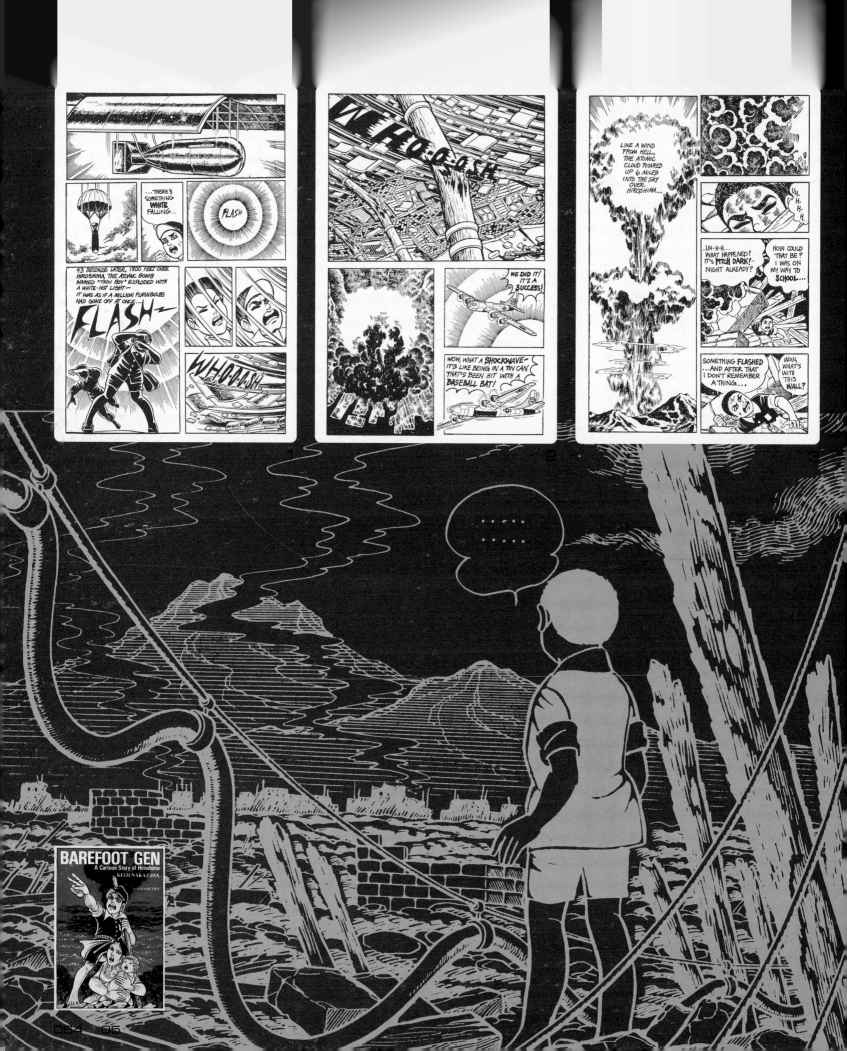

1 2 3

4 5 6

This page and opposite: For years after, details of the effects on human beings of the bombings of Hiroshima and Nagasaki were largely suppressed in the Western media as too shocking. Survivor Keiji Nakazawa translated his own harrowing experiences into the semi-autobiographical *Barefoot Gen* from 1972. Pronounced with a hard 'g', *gen* is a Japanese word meaning 'root' or 'source'. As Nakazawa explained: 'I named my main character Gen in the hope that he would become a root or source of strength for a new generation of mankind – one that can tread the charred soil of Hiroshima barefoot, feel the earth beneath its feet, and have the strength to say "No" to nuclear weapons.'

Manga: Sixty Years of Japanese Comics

Right: Having scandalized parents and teachers with his deliberately provocative *Shameless School* classroom farce, Go Nagai followed it up in 1972 with monstrous horrors and scantily clad females in *Devilman* and other supernatural horror series for *Shonen Magazine*. His *Devilman* saga expanded into a complex universe of demonic characters battling for good or evil. These pages come from *Susano-Oh*, the name of the ancient god of Japan. © 1979-1981 Go Nagai/Dynamic Planning Inc. All Rights Reserved.

2 1

Many manga characters are in the traditions of farting and penis humour found in historical prints. Right and below: Crazy kids like Kazuo Umezu's Makoto-chan revel in bodily functions and humiliation, as in this swimming race, where he swallows a granny competitor's false teeth. Far right: Tatsuhiko Yamagami's demented boy policeman Gaki Deka, naked save for his cap and tie, flashes his phallic udon root vegetable.

This is my house 10 years ago.

Left and above: An ordinary desk drawer houses the time-travel machine that first brought blue robot cat Doraemon from the year 2112 to the home of Nobi Nobita. In this extract, they go back to the hospital on the day Nobi was born. Doraemon's name derives from the word *dorayaki*, the name of a favourite Japanese sweet, and *mon*, which means 'monster', as in *Pokémon* and *Digimon*. Doraemon's lack of ears is explained by the fact that they were chewed off by a rat while he was sleeping. Doraemon can retrieve a seemingly infinite variety of astonishing gadgets from his 'fourth-dimensional' tummy pocket, from a computer pencil that gives you the right answers in exams to a camera that produces miniatures of whatever it has photographed. Below: Doraemon's creator 'Fujiko F. Fujio', alias Hiroshi Fujimoto (1933–96), seems to have perfectly understood the daydreams and anxieties of everybody's childhood.

With his facial scar and shock of white in his hair, Osamu Tezuka's Black Jack is an uncannily gifted doctor who has been blacklisted by a jealous medical profession. He becomes an unlicensed surgeon-for-hire with strong principles and a mysterious past, a hint of which is revealed in this extract. His huge fees pay for his private island, far from civilization, where he cultivates every kind of plant and animal. His six-year run in *Shonen Champion* from 1973 led to live-action and animated movies and a musical version performed by the all-female theatre group in Takarazuka. These pages demonstrate one of the distinctive traits of manga, the fact that 'big-nose' cartooning can sit happily alongside the most convincing realism. Tezuka, a qualified doctor, illustrates each episode's operation like a medical manual – it's not for the squeamish. Notice too how he changes all the panel layouts to diagonals as soon as the surgery begins on page 3, as if he is 'cutting up' the pages. And, as so often with Tezuka, the story provides a thought-provoking lesson about the value of life. All Tezuka images © Tezuka Productions. All Rights Reserved.

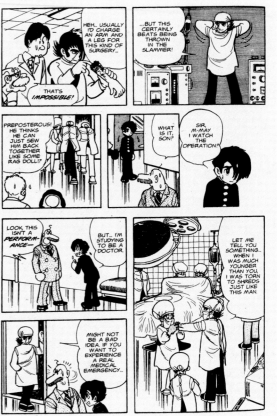

1

2 3

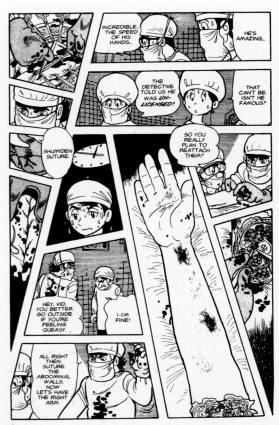

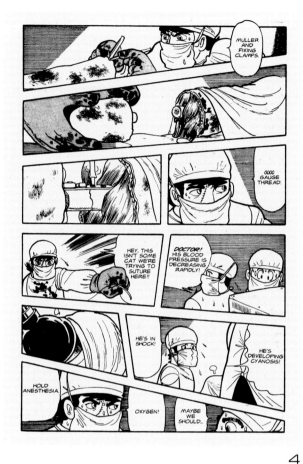

4 5

6 7

Have scalpel, will travel. His unique surgical skills take Black Jack all over the planet. On one trip, he finds himself stranded in the Australian outback and has no choice but to operate on himself to extract a tapeworm from his own stomach, while fending off a pack of wild dogs. No matter how bizarre they become, Tezuka's medical qualifications lend even his most extravagant scenarios a certain plausibility. For example, Black Jack's little friend and confidante Pinoko is actually a diminutive mature woman who had survived for years inside her unsuspecting twin sister. Pinoko was only discovered and rescued when Black Jack operated on her twin to remove what was thought to be a tumour.

Manga: Sixty Years of Japanese Comics

The Monkey King of Chinese legend is thoroughly updated by Akira Toriyama as orphan boy Son Goku, trainee martial artist and owner of a magic Dragon Ball, one of seven that can grant a wish when they are reunited. On their quest to find the others, he and his friends are imprisoned. But how will he be affected by a full moon?

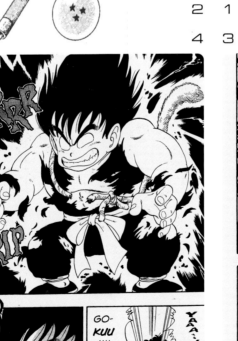

2 1

4 3

Above: First broadcast in Japan in April 1997, *Pokémon,* as in 'Pocket Monsters', is a TV cartoon, a cardgame, a manga, a toy, a movie and a marketing dream. It baffled Western parents while turning on a generation of kids to Japanese pop culture.

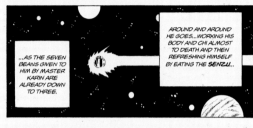

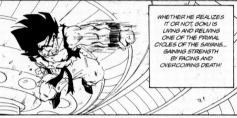

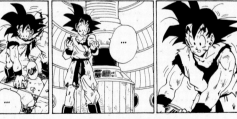

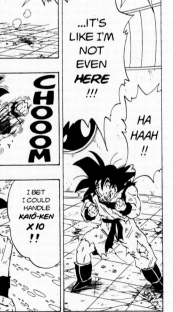

2 1

4 3

Left: Now with a wife and son, the adult Dragon Ball Z learns that he is a Sayajin, a member of a destructive alien race. Much training and battling ensue as he sides against them to protect his adopted planet.

Manga: Sixty Years of Japanese Comics

Right: He's a link between this world and the next and can allow ghosts to possess his body and take on their powers. Like GeGeGe-no-Kitaro before, Hiroyuki Takei's Shaman King taps into Japan's rich world of spirits. Though the rest of the pages are in black and white, certain chapters in boys' manga can open with colourful title-pages and spreads like this.

Below: another recent *Shonen Jump* star is Kazuki Takahashi's bullied schoolboy who can take revenge as the 'King of Games' Yu-Gi-Oh.

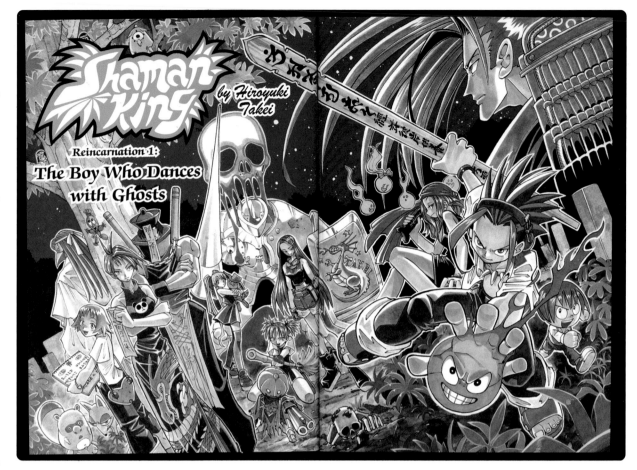

2 1

NARUTO ナルト™
by Masashi Kishimoto
1: Uzumaki Naruto!

Left: Orphan and outcast Naruto is the attention-seeking class clown in a school for ninjas, despised by classmates and tutors alike. Unknown to him, behind this contempt lies the secret that at birth he was made into a living vessel to imprison an evil fox spirit. There is nothing to beat rooting for the underdog in boys' manga. Above: Eiichiro Oda's rubbery teen pirate Monkey D. Luffy from *One Piece*.

2 1

Left: What began as a truly strange animated series from cult studio Gainax has become a manga drawn by Hajime Ueda. *FLCL*, or 'furi curi', might come from 'Flictonic Klipple', the syndrome giving high-school nothing Naota a monster-channelling horn on his forehead. But should he trust alien Vespa-rider Haruko? As she says: 'Accept things as they are. That's the *Newtype* way of life.' *FLCL* almost reads and looks like Naota's pubescent dream journal.

Chapter 06

Through a Woman's Eyes

LITTLE MACHIKO Satonaka adored her *shojo* (girls') manga and dreamed of having her own stories published. But women did not write and draw the girls' comics she read; they were produced by men and their contents were based on what men thought preteen girls wanted to read, or ought to read. Perhaps that's why Machiko-chan found their half-hearted sentimentality lacking in something that as a young woman she might be able to bring to the genre. As a result, in 1964 she entered a talent competition in the new girls' weekly *Ribon*. She won and debuted at the age of 16 with her vampire comic *Portrait of Pia*, heralding in the process the arrival in the shojo manga market of a bright young generation of hard-working women who would claim it as their own during the early 1970s, when the field blossomed with fresh genres and a new sophistication. Shojo manga publications currently employ an estimated 400 women mangaka, among them some of the industry's most successful creators. Girls are no longer their only audience; stories by women are reaching across age differences and the gender gap. Only in Japan have women been been able to cultivate comics into the country's most empowering forum for female communication.

That they can enjoy such creative independence and success may come as a surprise to people accustomed to thinking that all Japanese women are and always have been submissive subjects of an oppressive patriarchal system. This impression was fixed in Western minds in the 19th century, when courtesans and geishas were celebrated abroad in prints, books and exhibitions in a wave of 'Japonisme' and in such Westernized male projections as Gilbert and Sullivan's *The Mikado* and Puccini's *Madame Butterfly*. Not only is this impression of Japanese women outdated today, it also ignores their broader historical status and role in Japanese society.

Several empresses reigned in ancient Japan. Admittedly, between 770 and the present, only two women have ascended the throne, briefly and ruling in name only, but every emperor has claimed descent from the sun goddess, Amaterasu. The latter is still revered as the great-great-grandmother of the nation's first ruler and as the mother of the Japanese people. Amaterasu is one of myriad female beings in the Shinto pantheon. These deities and their priestesses are sources of the numerous women characters in manga with magical or spiritual powers.

In early times, a Japanese daughter or wife tended to work the rice paddies or run a business side by side with the men of the family and could exercise authority in business and village affairs. It was only later, starting in the Tokugawa period (1600–1868), that this relatively egalitarian respect accorded to women was challenged by the Confucianist doctrine of female subordination. Under this, a woman had to live a life of total obedience to her parents, husband and sons, and ultimately to the emperor. The shogun applied these principles to the lives of the women of the elite, but the movement was never populist and proved impractical for widespread introduction among the lower classes.

Strict subordination was only imposed on women of all classes starting in the Meiji era in 1868. The imperialism and militarism of the 1930s further eroded the rights of women, and indeed of almost all citizens. These Confucianist extremes were discredited after the war but vestiges lingered on. In 1947 the American-imposed constitution met the demands of the pre-war suffrage movement in granting women equality and the right to vote. Even so, they were still discouraged from the workplace because they were supposed to be home-makers and child-rearers. Male artists reinforced these limited expectations with their stories about wise mothers and dutiful daughters in girls' manga. As in other countries, male-dominated hierarchies would take time to change.

A millennium ago, modern Japanese women's ancestors had pioneered the new literary form of the novel. Around 1004, Murasaki Shikibu, a lady-in-waiting to

Below: Courtly passions from a millennium ago adapted into the manga of *The Tale of Genji* in 1993 by Waki Yamato. Right: *Futsu jan!* or 'Ordinary, Isn't It?' by Mihou Kotou from *My Birthday Comics*. Opposite: Naoko Moto's *Lady Victoria* is set in 19th-century England and is serialized in the monthly magazine *Princess*. This image comes from the February 2002 instalment.

Manga: Sixty Years of Japanese Comics

the empress, filled the hours between court ceremonies by writing what many claim is the world's first psychological novel and the greatest work of fiction of the age, _The Tale of Genji_. Rather than risk writing in the complex Chinese script reserved for aristocrats, priests and government officials, she used the simplified _hiragana_, or 'unofficial' script. Her book helped establish it as the _onnade_, or 'women's hand', accessible to women and men alike. Across _The Tale of Genji_'s 54 chapters and one million and more words, Murasaki described the love affairs and innermost feelings of her 'Shining Prince'. She also crystallized the aesthetic of _aware_, the acute perception of the impermanent but intense beauty of human beings and the natural world. Other women began to write, and feminine sensibilities found expression in their own

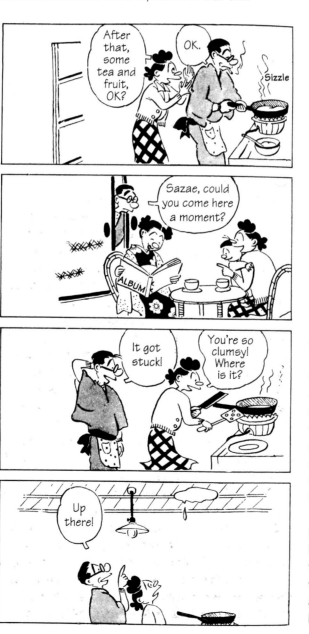

literature. Just as these authors had refined the written word, so their modern counterparts would eventually enrich manga, Japan's popular literature, with a similarly heightened sensitivity.

Before the Sixties, however, shojo manga were created by men. Their stories and style sprang out of the passive shojo ideal promoted to girls through illustrated novels serialized in monthly magazines starting with _Shojo Kai_ ('Girls' World') in 1902. Shojo novels were loaded with the ideological policies of the period, emphasizing that a girl, no longer a child but not yet a grown-up either, should aspire only to refinement, romance, marriage and motherhood. The illustrations combined Japanese concepts of beauty with the latest European commercial art styles and imported fashions to produce the typical shojo look seen to this day in manga: enlarged eyes and pupils, with long lashes; long and thin arms and legs; and petite noses, mouths, breasts and hips.

After the war, only around 10 per cent of the pages in these magazines were given over to comics, but the quantity increased from the late 1940s. Up to the 1960s, they were produced pretty much exclusively by the same male artists who worked on the boys' titles. Although women had barely any presence in manga magazines before the 1960s, Machiko Hasegawa (1920–92) had managed to carve a career for herself. Aged only 14, Hasegawa had started as an assistant to Suiho Tagawa on short comics for the girls' magazine _Shojo Club_. In 1946, she went solo and sold her vertical four-panel daily gag strip to a newspaper. At first she drew her character Sazae-san as tall and graceful, then when she got married shrank her into a plain but cheery housewife coping with her extended family. For decades Hasegawa's affectionate, unglamorized portrayal of an everywoman's good humour and quiet strength (based on the mangaka's own life) conveyed the sort of feminine insights that would have probably escaped most male cartoonists altogether.

One male cartoonist, the American Chic Young, proposed a much more aspirational domestic lifestyle in his newspaper strip _Blondie_. Promptly installed in 1946 in the daily _Asahi_ newspaper, Young's beautiful blonde was very much the master of her hapless husband, Dagwood, and the Bumstead household and expected to enjoy the latest fashions and labour-saving appliances. Virtually a

guide to consumerism, the *Blondie* strip and its spin-off books and movies had an undeniable influence, instilling in its readers the desire to share in the middle-class American dream. It also provided a means of brushing up one's English by reading the original dialogue that accompanied the translated speech balloons. It may have been no mere coincidence that, within days of General MacArthur's recall to America in 1951, *Asahi* dropped *Blondie* and replaced it with the homegrown *Sazae-san*.

Girls reading *Shojo* magazine from 1949 to 1955 were being tempted by an even grander life of luxury than Blondie's. Living in a castle with her royal family, scrumptious foods and sumptuous outfits was the thoroughly modern medieval princess Anmitsu-hime ('Princess Beanjam'). She was literally sweet, as her name and those of her family and friends were all derived from tasty desserts. The series lifted sales of the magazine to 700,000 copies. Canny male cartoonist Shosuke Kurogane knew how appetizing this confection would be to girls enduring food and clothing shortages.

A feistier princess starred in Osamu Tezuka's first long-form story for girls, serialized from 1953 in *Shojo Club*. A girl named Sapphire is born with both a girl's and a boy's soul, but to take her place as heir to the throne she has to disguise herself in public as a prince. She becomes known as Ribon no Kishi (literally 'Knight in Ribbons') or in English by the appropriate title of Princess Knight. By obliging her to conceal her feminine nature and her love for a dashing prince charming, Tezuka created an exquisite world of indecision. He seems to have understood the thrill many girls must have felt from this princess passing herself off as a strapping young man. In his fairytale ending, though, Tezuka has her male soul removed, so that as a 'total woman' she can marry her prince and live happily ever after. His Princess Knight was no feminist rebel after all – but she was a prototype for the magical girls and the sexual ambiguities that would become central to shojo manga.

So where did Tezuka's gender sympathy stem from? As a child, he was taken on frequent visits to the local Takarazuka theatre by his mother, who knew several of the performers. In this famous all-female company, women cross-dressed to take the male parts. Their colourful extravaganzas drew on elements of traditional male-only Kabuki and Noh theatre, but glamorized them by introducing the spectacle of Parisian and Broadway revues and Hollywood musicals. These shows had a lasting effect on Tezuka, as he explained: 'Naturally in my youth I imbibed the romantic and flamboyant atmosphere of this world. My characters' costumes as well as the scenery that surrounds them owe much to the theatre.

More importantly, the spirit of nostalgia toward Takarazuka pervades and infuses my work.'

Tezuka's fondness for these performances also influenced his habit of showing female characters with very large, sparkling eyes, often welling up with waterfalls of tears. These became characteristic of shojo manga. Tezuka got the idea for large eyes partly from Westernized cartooning and animation, but he had also been mesmerized by the Takarazuka players. As a child he would look up into the actresses' eyes, heavily highlighted with mascara and twinkling with the reflections from the bright spotlights. He found that this stage technique for projecting emotions through the eyes also worked in manga. Your gaze is instinctively drawn to those cartoon eyes, as big as windows, that seem to follow you around the page. Tezuka also understood that, in the unspoken affairs of the heart, the eyes are the prime communicators of feeling, our first language.

The girls' comics market expanded still further with the arrival of *Nakayoshi* ('Good Friends') and *Ribon* ('Ribbon') in 1955. These monthlies have become national institutions; more than half of all young Japanese girls have grown up following one or other of them. Naturally, demand for artists to fill their pages increased, but it was still men who were commissioned. Tetsuya Chiba was only 19 when he debuted in *Nakayoshi* in 1958. He later

Right: Luna the cat helps Sailor Moon discover her magic powers and her role as leader of a colour-coordinated girl septet. Naoko Takeuchi revitalized the magical-girl genre in the monthly *Nakayoshi* magazine. Below: Long-running shojo manga favourite *Mask of Glass* by Suzue Miuchi charts a young woman's determination to become an actress.

recalled: 'It was difficult for me to write for the girls' magazines, because I am a man, and I had only brothers, no sisters. Even my mother was quite like a man. Girls' manga at the time were real tear-jerkers. I thought if that's what they want, I should do the same.' Chiba and his peers started out producing sentimental weepies about orphans, ballerinas and violinists which reinforced the sensitive, unassuming shojo stereotype. 'I reached a point where I had been working on sad stories where you lose your mother, your father, you're being bullied, and I thought I can't stand this anymore. I wanted to portray something more positive.' Chiba did this in *Miso Curds* in 1966, a serial about a latch-key city kid who finds new friends and confidence when she moves to the country. But once he began making his name in boys' comics, Chiba, like Tezuka and other male mangaka, turned away from the girls' market.

Of those men who kept a foot in both camps, two in particular laid the ground rules for what would become the massive 'magical girl' genre. Fujio Akatsuka's *Secret Akko-chan* in 1962 set up the formula of the normal girl who is granted powers by a special object, in this case a spirit in a mirror. Mitsuteru Yokoyama's supernatural heroines from other worlds first appeared in the form of Little Witch Sally in 1966 and the slightly older housekeeper Comet-san in 1967; both were inspired by the imported American TV sitcom *Bewitched*. *Little Witch Sally* was animated for television from 1966 to coincide with its serialization in *Ribon*. This truly magical cross-media synergy became a standard tactic and helped boost *Sailor Moon*, *Pokémon* and other hits.

Finally, in the early 1960s, female mangaka brought much-needed fresh voices to the growing mainstream girls' press. Some graduated from working on gekiga for the declining rental-library publishers; others were 'discovered' through contests run in new weeklies, led by *Shojo Friend* and *Margaret* from 1963. Young women, who would have found it tough to start their careers writing or directing for film or television, seized the

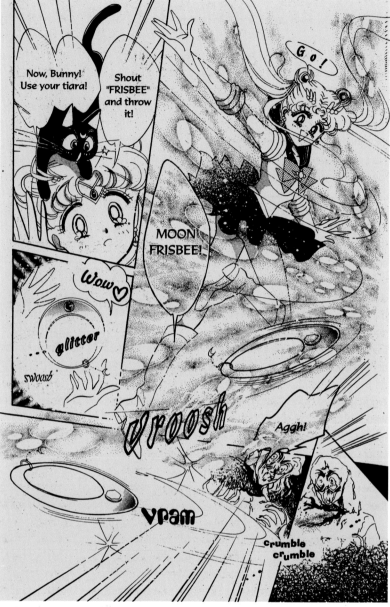

chance to apply their storytelling gifts to shojo manga. They shared their readers' taste for imported pop music, fashions and films, and reflected the mood of the Swinging Sixties in the exploits of blue-eyed Western blondes that they began to relate in their fanciful visions of life in foreign countries. They also turned ordinary Japanese girls into manga heroines, creating more interesting and convincing female characters than the shojo paper dolls typically created by men.

In the early 1970s women mangaka were becoming the majority working on the shojo titles. Five notable independent creators, Moto Hagio, Riyoko Ikeda, Yumiko Oshima, Keiko Takemiya and Riyoko Yamagishi, came to be identified as a group. Their admirers called them 'The Magnificent 24s', after the year Showa 24, or

1949, when most of them were born. The '24s' all broke into shojo manga in their early twenties, having grown up reading Tezuka's work. Building on this, these women took the medium into uncharted regions and between them helped transform the entire shojo page surface, turning it into a canvas of the heart.

Men's logic and linearity were overruled. This generation of female mangaka unchained their panels from the uniformly regimented rectangles and rows beloved of male creators. They gave their panels whatever shape and configuration best suited the emotions they wanted to evoke. They softened the ruled borders outlining their panels, sometimes breaking them up, dissolving them or removing them altogether. They overlapped or merged sequences of panels into collages. A borderless panel could now permeate the page, often beneath flotillas of other panels sailing across it, or it could expand or 'bleed' off the edges of the printed page itself and imply an even bigger picture beyond the paper. Thus time and reality were no longer always locked up inside boxes and narratives could shift in and out of memories and dreams. Characters too were no longer always contained within panels, but could stand in front of them, sometimes shown full length, making them more vivid and showing off their body language and fashions.

As well as using bold facial expressions, comics can also communicate feelings through abstract symbols. American cartoonist Mort Walker once jokingly catalogued some of the medium's long-established Western 'emanata' that had been adopted by the Japanese: the precise number of perspiration drops or 'plewds' required to indicate feelings ranging from anxiety to sheer terror; a coiled spring or 'spurl' for confusion or intoxication. Women manga artists in the 1970s massively enhanced this repertoire. Flowers in particular became much more than merely decorative elements. Symbolic blossoms unseen by the characters themselves identifed the story's heroine, reflected a scene's mood or conveyed a character's feelings. Bouquets bloomed like passions, petals and leaves fell when romance faded. In this language, each flower has an individual meaning: for example, daisies usually denote simplicity, chrysanthemums sensitivity, and roses sensuality.

In addition, women manga creators would leave background décors empty but decorate the area around characters' heads with a plethora of expressionistic effects and textures: lightning bolts of shock, flames of anger,

wispy embers of despair, crumbling boulders of anguish, sparkles and glows of affection, cross-hatched storms of turmoil. It was as if these women artists were photographing their characters' psychic auras. Artwork would disappear altogether from certain panels to focus attention on the dialogue balloons. By combining these techniques, female mangaka succeeded in making readers respond to internalized emotions in as involving a way as the explicit action and spectacle in boys' manga. In fact, the '24s' and other women went further by considering some of life's biggest philosophical questions, examining Japanese and Western history, the genres of horror and science fiction, social problems and other subjects that were finally open to women.

Their exploration of the fluidity of gender boundaries and forbidden love, in particular, allowed them to address issues of identity of deep importance to them and their readers. In this respect, Riyoko Ikeda's *The Rose of Versailles* set the benchmark in 1972. Ikeda contrasted the lives and loves of two women during the French Revolution, both of whom sacrificed their true feelings for the sake of duty. One is Queen Marie-Antoinette, married as a child to the Crown Prince but who now longs for a dashing Swedish count. The other is Ikeda's creation, a girl raised as a nobleman to satisfy her father's wishes for a son. The cross-dressing Oscar rises to become Captain of the Royal Guard, desired by women but secretly in love with her admirer André, a family servant beneath her station. Ultimately, Oscar renounces her rank and privileges to follow her heart. She joins André in the fight for the people's freedom and amid the storming of the Bastille is killed. To growing girls dealing with the demands of femininity, Ikeda showed Oscar as a girl who had

Left: When it comes to boys, Takao Shigemitsu's young heroine can take her pick in *Three Metres to the Sun* in *Princess* magazine. Below: Gallant Oscar is the cross-dressing, sword-wielding heroine from *The Rose of Versailles* by Riyoko Ikeda, a creation very much in the tradition of the Takarazuka players and Tezuka's Princess Knight.

Above: Among the *June* titles devoted to 'beautiful boys' love stories is *Roman June*, which mixes manga and illustrated fiction. Below: *Princess* magazine has been spun off into a smaller-format sister monthly publication, *Princess Gold* (opposite top). Right: The latter features such magical fantasies as Riho Sachimi's Wagnerian *Silver Valkyries*.

been denied the outward trappings of her sex, but who finds the courage to be her own woman and relate to her man as a true equal.

In the frissons between Oscar in male disguise and André, Ikeda hinted at homosexual attraction. Two other women from the '24' group dealt aesthetically but directly with this subject, previously avoided by male artists. Breaking with the convention of portraying only heterosexual love in their manga allowed Moto Hagio and Keiko Takemiya to confront a spectrum of other personal and political concerns. For their settings, Hagio and Takemiya initially chose boys-only boarding schools in a make-believe European past. Their deeply moving melodramas had male leads, in fact an all-male cast, although they were rather feminized, often androgynous-looking with long hair and eyelashes. Passions ran high and there was everything from sex scenes, always artistically depicted whether motivated by lust or more romantic feelings, to deeply affecting declarations of pure love. Assorted tales of *shonen ai*, or 'boys' love', grew into a staple of commercial manga for girls and became the focus of specialized magazines, starting with *June* in 1978. Women, and a few men, have since developed this genre in various directions, from the tragic to the trashy: immortal adolescent vampires; atmospheric, *Solaris*-style science fiction; the unrequited love of a camp millionaire superthief; gritty New York police procedurals; unsensational docu-dramas about AIDS; madcap satire about a gay James Bond-type bodyguard; intrigues in meticulously researched revisionist retellings of Japanese history. By incorporating it into a boys-style drug-war thriller, one woman, Akimi Yoshida, kept guys as well as girls reading for ten years with her gay male romance *Banana Fish*.

Why do these homosexual boys and young men appeal so strongly to Japanese girls? The reasons seem to be as varied as their readers. One of the latter, Kazuko Hohki, a member of the Frank Chickens rock band, has a theory that women in Japan 'are disillusioned (and bored) with male–female relationships where the sexual roles are

still very fixed. They are seeking a new romance in which neither partner has to pretend to be weaker than the other. Also Japanese women have a less womanly and more boyish figure than Western women, so it may be a kind of protest against the usual Japanese male sexual fantasy about the glamorous Westernized woman's image with big tits and all that.' After talking with readers, researcher Megumi Yoshinaka concluded that the appeal of shonen ai 'may be related to the excessive fastidiousness of adolescence. Often girls are disgusted with boys and men in general during puberty. Girls' manga show asexual or "perfect" characters. In terms of "perfection", girls prefer flawless, hairless and beautiful boys.'

Others have suggested that these boys provide an unthreatening way for Japanese girls to fantasize about

愛と禁断のファンタジー が始まる…！

恋愛が苦手な女の子・琉花の周りで

起こり始めた不思議な現象

それは彼女を夢の世界へと導く…!!

新シリーズ!! 巻頭カラー50P

銀のヴァルキュリアス

the opposite sex without competing with another female presence. In the manga stories, one male partner is often more effeminate than the other and some girls may choose to identify more strongly with one or other role. Yet another interpretation suggests these boys are really seen as girls in drag, like the Takarazuka actresses, and so permit readers to fantasize safely about same-sex feelings. There is also the appeal of doomed love and seeing men suffer. Until recently, a good many 'boys' love' dramas ended unhappily, perhaps in a reflection of their female authors' secret feelings about male gay relationships. Ryoko Yamagishi, for one, admitted as much when she realized in hindsight that in her epic set in ancient Japan she had been unable to envisage her gay prince finally

finding happiness. The popularity of the genre does not mean that female creators or readers are necessarily well disposed towards the realities of homosexuality or see the genre as making any positive public commentary about them.

Boys' love stories are only one of many genres and styles of shojo manga that cater to the diverse tastes of readers of many ages. What they frequently have in common is their enlightening fictions about the pressures and pleasures of individuals living life in their own way and, for better or worse, not always as society expects. The search for love is still a pervasive theme, but many women mangaka have transcended simple-minded romanticism and boy-meets-girl conformity. The apparent delicacy or cuteness of some of their illustrations often belie the questions they are examining about identity and self-acceptance, personal fulfilment, families and friendships, ageing and dying. Levels of meaning can be found in the most unpromising material. In *Planet of the Cotton Country*, for example, by portraying a little kitten's difficulties in understanding everyday events and her human keepers, Yumiko Oshima cleverly investigates the concerns children face when growing up. What looks like yet another ballerina story in Yamagishi's *Arabesque* becomes an uplifting account of a determined young woman's spiritual growth. Tales of schoolgirls unlucky in love can veer into heartfelt and ultimately life-affirming exposés of bullying, depression, lesbian attraction, self-harming, parental abuse and divorce, pupil–teacher scandals, suicide attempts, even conspiracies to blow up the school. Not the sort of subjects you might expect Japan's sweet, innocent-looking teenage girls to be consuming when they pick up their comics.

This audience know what they like. From an early age, a shojo manga reader can grow attached to her favourite artist, more so than to a character or magazine, and follow her output devotedly, sharing this perhaps with her schoolfriends, sisters, even her mother. A shojo manga author will often write and draw notes in the margins of her serialized stories, for instance detailing information about her health, her holidays, her hectic schedule or how she feels about her characters. Readers are encouraged to write in with queries and suggestions, to which they may receive a response in print or by letter. This interaction

forges a feeling of confidentiality and involvement, almost a sisterly bond, that can last into a reader's adulthood and throughout an author's career. It's not unusual for women, only half in jest, to identify themselves and each other according to the comics they grew up reading. Among the Japanese manga readers I spoke to while researching this book, several confided to me that their engagement with certain shojo manga could be intense. One of them, Mitsuba Wajima, a talented amateur manga artist herself, felt that the series she read by Moto Hagio and others, sometimes a hundred times, helped give her the courage to leave Japan as a single woman and start a new life in London. She told me: 'Shojo manga showed me people who were brave enough not to follow the same path everyone else does, people not fitting into the system. For me their stories were lessons that you can think of your life in another way.' Perhaps it's because at their core shojo manga are about people's emotional lives that they can have this sort of life-changing impact.

After being all but excluded for decades, women creators have brilliantly transformed shojo manga into an unusually expressive medium and created new markets of comics for adult women, female office workers and housewives. Women have also now broken into the boys' and men's magazines, formerly the preserve of male mangaka. By confounding and confusing sexual stereotypes, the love comedies Rumiko Takahashi produced for boys' weeklies in the 1980s came to fascinate readers of both sexes. Takahashi runs a studio staffed entirely by women. Also all-female is the collective Clamp, whose principal members adopted this group pen name in order to be able to divide up their workload anonymously. Their combined speciality is sexy and powerful 'magic girls', who appeal to males as much as to girls looking for heroines. Furthermore, with men contributing again to the girls' sector, at least among the manga profession and readership the gender divide is continuing to blur.

Below: How was school today? In Miwa Ueda's love comedy, everyone thinks Momo is a bubble-headed 'Peach Girl', just because she tans so easily.

Manga: Sixty Years of Japanese Comics

Right: A narrow escape for quick-change artist Princess Knight, as she loses her wig and switches to her manly persona. Osamu Tezuka's fairytale, first seen in *Shojo Club* (1953–56) and then in *Nakayoshi* (1958–59 and 1963–66), established manga serials in girls' monthlies. Here, right, Tezuka plays with the comics medium, for example on the fourth page where the guards burst through the panel borders to escape. The star-spangled glow around the princess in the open frame harbingers the arsenal of emotional auras to be used in shojo manga. Opposite: The title-page of the second compilation. In 1967 Tezuka's Mushi Productions turned the story into 52 animated colour episodes for TV. All Tezuka images © Tezuka Productions. All Rights Reserved.

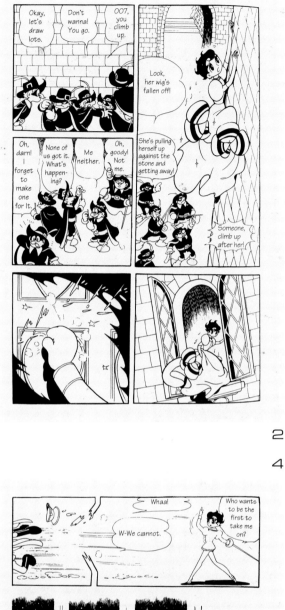

2 1

4 3

Right and below: What is a girl to do when she's always being ignored by her mother or upstaged by her older, brainier sister? Asari-chan puts all her energies into trying out every kind of sport and driving her family crazy. Mayumi Muroyama created her in 1977 for the kids' comic *CoroCoro* and 60-plus volumes later Asari-chan is still a shojo favourite.

あさりちゃん

一九八二年は テレビでも がんばるわ!!

テレビ アニメ化決定!!

室山まゆみ

(25)

タタミ

あさりちゃん

Left: Sweeping melodrama in ancient Egypt in *Oke no Monsho*, or 'Pharaoh's Seal', by Chieko Hosokawa from *Princess* magazine. Far left: Big eyes, big hair, big fun-fur fashions and big emotions in this tale of puppy love, *Maiko no Uta*, or 'Maiko's Poem', by Kimiko Uehara. Below far left: Thirteen-year-old Lili magically transforms herself into Detective Spica and relies on astrology to solve mysteries and catch criminals in Natsumi Ando's *Zodiac P.I.* Below left and above: In *Bow Wow Wata*, Kazumi Umekawa, a certified vet, tackles realistic pet problems and medical issues as well as young romance between pretty dog-loving Misato and Tasuke, a vet's son who has inherited his fox-spirit father's gift for conversing with animals.

Fictionalized passions and power plays at Louis XVI's court in pre-revolutionary France unfold in *The Rose of Versailles*, a 1,700-page historical romance created by Riyoko Ikeda (above) for *Margaret* magazine beginning in 1972. It confirmed Ikeda's arrival as an outstanding storyteller. She recounts the life and loves of Queen Marie-Antoinette, shown right with her dashing commander of guards, Oscar. As the unhappy wife of Louis XVI, Marie is smitten by Count Von Fersen. Oscar, meanwhile, comes to the aid of poor Rosalie with help from his trusty companion André. To complicate matters further, Oscar is actually a girl raised to be a man and is admired and desired by women and men alike.

Louis XVI

Count Von Fersen

André

Rosalie

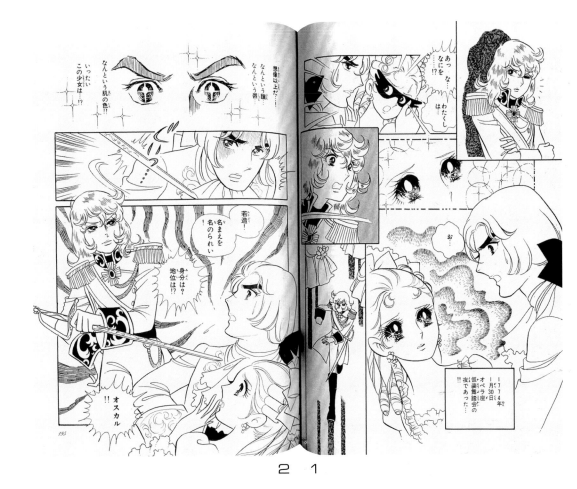

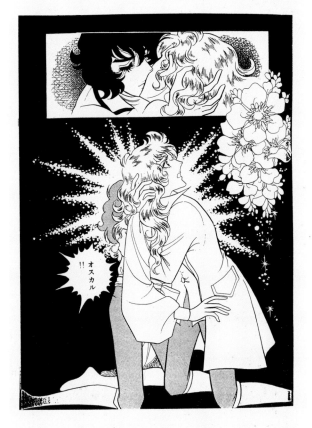

Left: The first encounter between the young princess Marie-Antoinette and handsome Swedish aristocrat Von Fersen is electric in this scene. Below left: Meanwhile, the attraction between the lowly André and his master Oscar, secretly a woman, proves too strong on these pages. *The Rose of Versailles* has sold over 12 million copies in Japan and has been made into a musical performed by the Takarazuka players, an animated TV series and a 1978 live-action film shot in Versailles. More recently, creator Ikeda revealed: 'I've long wanted to make an opera out of *The Rose of Versailles*.' Her plans call for the opera to be over three hours long; the text would also be in Italian. She is also designing the costumes and soliciting compositions based on her libretto, such as a duet by Oscar and André and a Marie-Antoinette aria:.

Moto Hagio is the acclaimed pioneer of boys' love stories in shojo manga. First came her 1971 short story *The November Gymnasium*, and then her 1974 450-page graphic novel set in a German boarding school, *Toma no Senzo*, or 'The Heart of Thomas'. Hagio does not shy away from the sexual and violent emotions of adolescence. *Toma no Senzo* opens with the suicide of 14-year-old Thomas, whose love has been spurned by his senior classman Juli. Behind Juli's rejection lies his trauma after enduring a gang rape. The death of Thomas haunts Juli in dreams but also in the flesh, when Thomas's doppelgänger Erich joins the school. Right: Here, in the graveyard the dark-haired Juli first spots Erich through the railings. Below right: In her gothic horror masterpiece *The Poe Clan*, Hagio considers mortality through the bond that grows between two 14-year-old boys, and the lives they touch across more than two centuries as vampires in an eternal adolescence. In this early scene, the still-human Edgar is yet to find out that the Poes, his adoptive family, are vampires, as Alan tries to get a first taste of his blood. Hagio published the stories between 1971 and 1976 in *Bessatsu shojo komikku* ('Special Edition Girl's Comic').

2 1

2 1

Left: Young Serge's emotions and memories are refracted through the panels that surround him as he sits in a confessional and unburdens his confused feelings about his vampish roommate Gilbert Cocteau. *Le Poème du Vent et des Arbres* ('The Poem of the Wind and Trees') is set in a French boarding school for boys in 1880. Author Keiko Takemiya (above) conveys frankly the contrasts between cheapened sex for money and pure love between boys. She caused a sensation when the story was serialized in *Shojo Comic* from 1976. Below left: Takemiya, like Moto Hagio, has also written science fiction, most notably *Toward the Terra* from 1977, originally for boys. Earth is in ruins and a computerized dictatorship is wiping out any telepathic young adults. In these anime comic pages, below left, from the 1980 movie adaptation, telepath Mu uses a dream to reach one of the oppressive human elite in a bid for help to rescue the ruined planet.

The shonen ai genre of girls'
manga presents a wide
variety of approaches to
'beautiful boy' love stories.
Right: The blond lead in spy
spoof *Love from Eroica* by
Yasuko Aoike is modelled on
1970s rock star Robert
Plant. After a break-in at the
Vatican to steal some
microfilm, Eroica reveals he
has also smuggled out the
Pope himself. Far right: Male
artist Mineo Maya's *Pataliro*
was the first to present
homosexuality in TV
animation. Disguised British
agent Jack Bankolan
regularly falls for his
gorgeous enemies. Below
right: In this interlude from
New York drug thriller *Banana
Fish*, creator Akimi Yoshida
deepens the relationship
between charismatic punk
Ash and his Japanese admirer
Eiji. Ozaki Minami has a cult
following in *Margaret*
magazine for her prolonged
erotic psychodramas, most
famously *Zetsu ai 1989*, or
'Desperate Love', below far
right, about a footballer's
longing for a fellow player,
loosely based on characters
from the *Captain Tsubasa*
boys' comic.

2 1

As a young teenager, Marimo Ragawa entered talent-search contests run by manga publishers. Finally, her perseverance paid off and she was selected by the publishing house Hakusensha. In 1998, her moving 700-page melodrama *N.Y.N.Y.* was published. It follows the lifelong relationship between Kain Walker, a New York cop who has hidden his homosexuality, and his younger blond boyfriend, Mel Frederics, an orphan with a troubled past (below left). Ragawa portrays the strength of their devotion to each other as they face the challenges of coming out, of sexual jealousy, and of living as an openly gay couple. The story becomes a thriller when Mel is kidnapped by a disturbed serial killer. Through the traumas and tears, the couple end up moving in with Kain's parents. In an unusually happy ending, they adopt a little girl and spend the rest of their days together. Usually any sex between men in girls' manga is more subtly sensual than explicit, as in this shaving scene (above left) in which Mel proposes marriage to Kain. Then again, the guys in *Be x Boy* (above) often go a bit further.

Plunge into the glamour and melodrama of the stage in *Mask of Glass*. Suzue Miuchi has been crafting this serial for the magazine *Hana to Yume*, or 'Flowers and Dreams', since 1976. Aspiring starlet Maya (below) is trained by her stern tutor Chigusa (shown right in a flashback). In the scene reproduced below right, an older Chigusa looks on approvingly as another pupil auditions for the role of a wolf girl. The blank eyes indicate that a character is acting.

Through a Woman's Eyes

Rarely has any graphic artist captured the movements and music of a ballet performance so exhilaratingly as in this climax of kaleidoscopic double-page spreads by Kyoko Ariyoshi in her 21-volume classic *Swan*, which first appeared in *Margaret* from 1977 to 1981.

2

4

1

3

Teen anguish was once a staple of many 1970s British girls' weeklies that have now completely vanished. In contrast, girls' manga thrive because authors are not prevented from confronting difficult issues, like Setona Mizushiro in *X-Day* from 2002. Life sucks for Rika, an injured high-jump star dumped by her boyfriend. Depression, rejection and low self-esteem bring her into a group of troubled students who plot via the internet to blow up their school.

SOMEONE TAKES THEM.

...STARTED LIKING SOMEONE ELSE.

THIS GUY I WAS GOING OUT WITH...

...EVEN THOUGHT ABOUT ANYTHING LIKE THAT BEFORE.

.....

I HAD NEVER...

THINGS YOU LOSE...

...DON'T JUST DISAPPEAR INTO THIN AIR.

Left: Marmalade Boy discloses the secrets of two entangled families, whose parents both swap partners and live together. It gets more complicated when love blooms between a son and daughter. In this scene, Wataru Yoshizumi applies assorted abstract textures to represent the confusion Miki feels as she learns that Yu, the boy she loves, is her half-brother. Below left: In the story 'The Door' from *Confidential Confessions*, Reiko Momochi takes a hard look at the pressures that drive teenagers to self-harming and suicide, her jarring page layouts mirroring their emotional strain. Not every girls' manga comes with a happy ending.

Developing Maturity

NO MATTER WHERE you sit or stand, it's hard not to notice them, floating above your head, fluttering in the breeze next to open windows and ceiling fans in summer – the flocks of wide advertising posters that hang in pairs down the centre of a train or subway carriage. Changed every few days, many of the most eye-catching ones trumpet the day's latest manga releases. The big publishers advertise here, because they know that manga have come to serve as a survival kit in the 'transportation hell' that millions of commuters endure in trains overcrowded to as much as five times 'normal capacity'. Monday to Friday would be bad enough, but working a six-day week was common in Japan well into the 1970s. Reading manga offers one way of defining your private space during journeys lasting up to two and a half hours. The frenetic pace of daily rush hours on mass transit systems and bullet trains becomes less dehumanizing if you let yourself be transported simultaneously by the flow of manga stories' imagery and emotions, their speech balloons and sound effects playing in your head. You can make one or more thick magazine or graphic novel last a whole trip; a chapter almost seems designed to fill exactly the time taken to travel from one subway station to the next.

The path from boyhood to manhood is seldom easy and, in Japan, old certainties have begun to evaporate during the protracted post-bubble recession. Cramming to get the best grades and dedicating yourself to the company no longer guarantees steady advancement and a job for life. Are you tough enough to work all hours, stay out late for some hard business-drinking in a hostess club and still struggle into the office on time early the next morning? How important is crawling to your boss to secure promotion? Is it more important than finding some quality time with your wife and kids? Are you fulfilled being just another cog in the machine? Samurai warriors, sportsmen, yakuza, assassins, womanizers, rebels living by their own rules, charismatic mavericks – these are some of the defining images of masculinity in manga, which people millions of

men's daydreams during their meal breaks or long commutes to the office and home again each day.

As male teenagers raised on 1950s and 1960s boys' comics graduated to become first students, then corporate warriors, publishers deliberately targeted them with new older teens' and young men's magazines otherwise known as *seinen* manga. In *Young Comic* and *Manga Action* in 1967 and the waves of other titles that followed, mangaka could deal directly with the sort of subjects that had previously been possible only in rental-library gekiga or experimental magazines like *Garo* or

COM. Creators of newsstand manga and their readers were maturing together. A case could be made that Japan's efficient office hierarchies have been underpinned by the safety valve provided by seinen manga for the frustration and testosterone of hard-working 'salarymen' ground down by the cogs of big business. No matter how humiliated you had been by your boss, you could always imagine yourself as the wronged samurai avenger Lone Wolf or the ruthless assassin Golgo 13, both hard men and utterly independent loners. If your love life was not going much better, you could unwind with the womanizing escapades of master thief Lupin III or contemplate defying convention by living together instead of marrying, like the trendy couple in *The Age of Cohabitation*.

A core captive audience for manga is virtually guaranteed by the sheer volume of rail commuters with journey time to kill. The high cost of city housing means that most workers live in suburban sprawls. Some 27 million people, more than the entire population of California, live within a 30-mile (50 km) radius of Tokyo. Compared to Americans, who typically make long car commutes to and from urban jobs, the Japanese rely far more on the railways. This makes sense in the busy cities, because all but the major streets tend to be former footpaths, cramped further by pedestrians, delivery trucks, storefront displays – in short, an obstacle course even for one-way traffic. The introduction of elevated expressways has helped, but in many cities buying a car can be difficult because you first have to prove that you have off-street

Opposite: To hyper-advanced cyborg Motoko, the physical world and the world of information are both reality in Masamune Shirow's *Ghost in the Shell 2*. Meanwhile guns and girls are the main currency for the smooth operators of *Lupin III* (right) by Monkey Punch and *City Hunter* (below) by Tsukasa Hojo.

Above (from top): Fiercely masculine imagery from three men's magazines – *Morning* shows off the posing 'Iron Man', *Big Comic* caricatures Prime Minister Junichiro Koizumi as a samurai, while *Comic Ran* devotes all of its pages to famed warriors from the past. Right: A beautiful but deadly woman can be both lover and target for reluctant assassin Crying Freeman. The series was written by Kazuo Koike and drawn by Ryoichi Ikegami.

parking for it – which can cost more to rent than your apartment. Why not turn instead to manga to get an adrenalin rush akin to the one you get from being behind the wheel, or in any high-velocity scenario? With their fast cutting, speedlines, screaming sound effects and 'subjective motion', as Scott McCloud termed it in his book *Understanding Comics*, manga can almost put a reader in the driver's seat.

It's the whole gamut of manga's virtual, big-screen sensations and emotions that have addicted so many Japanese adults to these magazines. In many ways, readers turn to manga for the sorts of vicarious experiences and solid visual storytelling that people in the West expect from the movies. It may well be more than coincidental that in the period that comics consumption and television viewing rocketed, cinema attendances in Japan plummeted: by 1972, they were one-sixth the level of their 1958 peak. They have barely recovered since. A recent survey found that on average there is only one, sometimes quite run-down cinema for every 68,000 citizens in Japan. Some have dubbed manga the 'poor man's film industry'; frankly, it might be more accurate to call Japanese movies a 'poor man's comics industry'. During the 1990s, manga generated three times as much profit as cinema. Indeed, some of this profit derived from the licences and royalties paid by the studios to adapt manga stories into films; the most common sources of inspiration for movies are pre-tested hit comic serials. Anime versions have generally proved more popular than live-action ones, especially as their special effects can outdo even the most lavish American blockbuster, and at a fraction of the price. Animation, in the form of adaptations of *Akira*, *Ghost in the Shell* and other manga, as well as the biggest-grossing original features by Hayao Miyazaki, often accounts for over half of the film business's annual revenues. Hollywood itself has now started licensing manga and financing live-action adaptations of *Akira*, *Monkey Punch* and *Lone Wolf and Cub*.

Cultural historian Tomafusa Kure has suggested that manga for adults may have also helped to fill the void left by some of modern Japanese literature's abandonment of more direct, story-driven fiction. A vogue among more intellectual novelists since the Meiji period has been to veer away from narrative clarity to concentrate on

psychological states, in particular the 'I-novel' form with the author as the main character. In Kure's view, this literature 'by the 1970s had lost vitality, and readers – including intellectuals – had lost interest. Meanwhile, manga offered a new form of expression, as they fashioned even basic human emotions into dramatic stories.' Manga now include every type of prose fiction, from pure pulp and broad satire to refined lyricism. The literary establishment may blanch at the idea, but not only have manga been acknowledged as an influence on a number of contemporary writers of 'J-literature', notably Banana Yoshimoto and her 1987 novel *Kitchen*, but they have also snatched prizes away from their prose-only peers, for example in 1983 when Katsuhiro Otomo's *Domu* manga won Japan's Grand Prix for the year's best science-fiction novel.

Manga were also much admired by the right-wing writer Yukio Mishima (1925–70). Predictably, his preference was for the *jidaigeki*, or historical dramas, which re-create chivalrous heroics and glorious deaths in battle from nearly nine centuries of pre-modern Japanese history. Mishima's disgust with his once-great nation's moral decay drove him in 1968 to form a paramilitary youth group and two years later to commit 'warrior's suicide' after a failed coup d'état mounted in the emperor's name. Mishima took his nationalism to an extreme, but his pride in the past and his idolization of Bushido, the samurai warrior's moral code, infused the appetite for the jidaigeki genre sweeping men's manga in this period. Mishima singled out the meticulous realism of mangaka Hiroshi Hirata for praise and also wrote a strong defence of these manga when critics railed against their unsanitized violence, if not their seeming militaristic leanings.

The ongoing success of jidaigeki manga today suggests that, while samurai no longer have a place in the modern nation, their lives and legends answer a yearning for continuity with Japan's unWesternized heritage. It hardly seems to matter if these tales fluctuate from the factually faithful to the wholly romanticized, from the freewheeling flamboyance of real 16th-century maverick Keiji Maeda to the nihilistism of punk warrior Manji, who is cursed with mystical healing bloodworms that keep his body immortal. Spectacles of wholesale butchery in manga are no bloodier than many popular samurai prints from

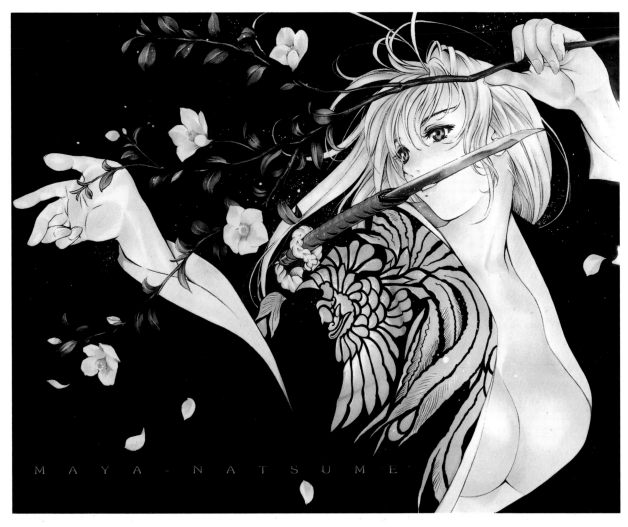

MAYA · NATSUME

Left: In many stunning-looking fantasy series for men, the varying appeals of a ravishing beauty, a vulnerable girl and a fearsome glamazon can all be wrapped up in one dream female, as is the case with Maya Natsume in *Tenjho Tenge*, or 'Above the Heavens, Under the Heavens' by the creator known as 'Oh! Great!'. Below: The inevitable 'panty shots' also cater to the male gaze.

the past. Just as *chanbara*, or 'swordplay dramas', began losing popularity among younger readers in the late 1990s, Takehiko Inoue's energetic interpretation of the feats of master swordsman Musashi Miyamoto has reinvigorated the genre for men and women all over again. In these manga and the film and TV spin-offs – there is even a dedicated satellite channel – history can be retold in endless variations.

As you would expect, to appeal to young and adult men in the new seinen magazines, mangaka soon started exploring sexual themes, taking both humorous and more serious approaches. Comedies in a cartoonish style might involve little more than low-key titillation such as panty and cleavage shots, blushing embarrassment and the occasional mild sex scene, or fixate on mostly unrequited lust, such as U-Jin's high-school farce *Angel*. On the other hand, slow-burning attraction has been handled sensitively and responsibly in several serials, notably the long-running *Maison Ikkoku* and *Tokyo Story*. The tawdry sensationalizing of a lot of Western reporting has given the distorted impression that sex is everywhere

in manga. If you go to the pages of leading men's manga magazines like *Morning* and *Afternoon*, the *Big Comic* range and the various *Young* titles expecting them to be overrun with porn, however, you will be sorely disappointed. What you will find instead are satisfying, well-told stories and plenty of humour for adults, in a range of genres and styles, and with no qualms about depicting sex and violence but rarely gratuitously. The really explicit material tends to be confined to magazines from smaller publishers specializing in eroticism, often with limited circulations and poor newsstand distribution, or to the even smaller print runs of self-published amateur magazines, or *dojinshi*.

It should also be remembered that, though images of violence and sex in manga are not governed by the sort of puritan code imposed by the American comic-book industry, they are far from unregulated or out of control. It's hard to see why this unavoidably graphic art form should not be granted the same freedom from censorship enshrined in Japan's constitution as all other media. In fact, manga have been subject to various forms of

Five examples of the ploys devised by artists in men's comics to show sex without showing sexual organs. From video censorship comes the pixellation effect (above). Rather than hiding genitalia with black shapes, leaving them blank invites readers to use their imaginations (left). An eggplant and swords are among the substitute symbols (below).

the definition of 'indecency', beyond saying that publications should comply with generally accepted standards, a clause that has been interpreted as forbidding any realistic representation of adult genitalia and pubic hair. In one sense, these restrictions have only drawn more attention to the censored areas. Manga artists devised cunning ploys to get around these prohibitions by obscuring the offending details with shadows, black shapes, pixellated video effects or white spaces, sometimes inviting readers to fill in the blanks. They also came up with a lexicon of symbols. They replaced the vagina with flowers, seashells and the like, and the penis with snakes, fruit, vegetables, baseball bats and other phallic objects or drew an amorphous but unmistakable outline or silhouette. Article 175 has probably also helped to make manga more sensually expressive. Its restrictions may have encouraged artists to venture beyond standard representations of sexual intercourse to explore all manner of sexual gratification and to situate sexuality not solely in the characters' genitals but in their whole bodies, their clothing and general environments.

It may come as a surprise then that, despite the sexual and violent aspects of a proportion of manga, Japan has a mere fraction of the total rapes and murders per year committed in, say, America. For example, in 1992 the number of reported rapes per 100,000 people was only 1.4 in Japan, but 37.2 in the United States, nearly 27 times higher. Not only does this dramatic contrast demolish any argument that consuming 'irresponsible' manga is bound to stimulate readers to commit imitative crimes but, as Frederik Schodt has suggested, their cathartic fantasies may help reduce crime figures.

Crimes against the person may be low in Japan, and the rate of juvenile crime only one-tenth of that in the United States. However, crimes against property, in particular vehicle theft, have lately risen in number. One theory goes that, as parents, squeezed by the recession, find it harder to support their growing sons, more unemployed young men aged 15 to 25 are resorting to stealing in order to be able to live out the lifestyle they aspire to. These disaffected youths can be seen in the motorcycle gangs roaring through the streets of *Akira*'s Neo-Tokyo, or the streetwise delinquents operating at Be-Bop High School. In *Great Teacher Onizuka* a wild, out-of-work

national and local legislation, and are monitored and restricted in their contents by various interested agencies and citizens' groups. The public are able to register complaints against any manga they consider 'harmful', a conveniently all-purpose description. The offending titles may then be put on a blacklist by the government's Youth Policy Unit and removed from sale by local councils. These watchdog activities provide a constant check, and tend to rein in creators more harshly whenever they push beyond accepted limits or whenever under-age kids need 'protecting', because their parents or teachers have caught them picking up adult comics not intended for them.

Up until the early 1990s, portrayals of sex in manga also had to conform to article 175 of the National Penal Code. This law can be used to apply pressure on retailers and, through them, publishers and creators by imposing heavy fines on stores for distributing, selling or displaying 'indecent' printed matter. What it leaves rather vague is

Right: Who better to win over unruly rebel kids than a wild former gang leader who has now become the unlikely Great Teacher Onizuka (GTO)? Tohru Fujisama's edgy comedy has sold 37 million copies worldwide.

In other futures, recurrent settings of catastrophic destruction and apocalyptic dystopias tap into the traumas of the atomic holocausts of 1945, as well as the real risk of another earthquake on the scale of that of 1923, which virtually wiped out Yokohama and much of Tokyo. From an early age, kids are trained how to react using convincing earthquake simulators. Life may seem more impermanent when the ground beneath your feet perches on a fault line and is shaken each year by several thousand earthquakes. Admittedly, no more than a dozen tremors do more than rattle the nerves, but about once a year a quake is severe enough to cause visible damage. This sense of vulnerability, even fatalism, may be echoed in the speculative stark visions of natural and technological devastation of manga such as *Akira*, *Evangelion* and *Dragonhead*, and of environmental disaster in *Nausicaä*.

The maturing of manga's audience coincided with the economic bubble of the 1980s. As a consequence, the annual total print run of magazines published for adults rose from just over half of that for boys' and girls' titles in 1983 to exceed the children's circulation level in 1991 by over 100 million copies. The adult sector has since subsided, but it remains about as large as the juvenile market and has many more different titles. Although no individual adult periodical has reached the lofty multi-million sales of the big four boys' weeklies, *Big Comic*, *Morning* and others comfortably shift over a million copies every issue; up to one-third of their readership can be women.

The ways in which seinen manga for adolescents and adults are constantly evolving will probably always spark protests in Japan, from mothers, PTAs, feminist groups, anti-racism movements – whoever feels the medium is going too far. Nevertheless, what typically results is debate from all sides and eventual compromise, so that consensus is restored once again. Manga have so far prevailed because there has long been a broad tolerance extended to the popular arts in Japan. The occasional series may overstep the mark, but sweeping censorship is likely to be avoided, because Japanese comics have proved that they can be a fully matured medium.

ex-gang leader takes up teaching to meet more girls and finds his background handy when dealing with troublesome pupils who are only a few years younger than him. Adult manga do not shy away from chronicling all strata of criminality, from Osaka loansharks and the sometimes glamorized yakuza underworld to political and corporate corruption at the highest levels. The electorate, deeply disenchanted with the government and Japan–US relations, have responded to mangaka who have elaborated headline-making hypotheses grounded in international politics and latent nationalism. What if Japan's first popularly elected president could act to liberate the country from its ineffectual bureaucracy and security treaty with America? What if a Japanese commander of a nuclear submarine turned anti-nuclear terrorist to challenge the USA and Russia and enforce world peace? What if a Japanese-American campaigned all the way to White House?

Left: Famed for his centuries-spanning *Jo-Jo's Bizarre Adventures*, Hirohiko Araki branched off into eye-popping body weirdness with his spectral *Deadman* manga in *All Man* magazine. Below: Chinese Chen Weng, another virtuoso draughtsman, provided the cover for *Morning*'s spin-off *Open* special.

Manga: Sixty Years of Japanese Comics

Right: Jet-setting gentleman thief, womanizer and master of disguise Lupin III is the Japanese grandson of French burglar Arsène Lupin. Since 1967 he has been cocking a devil-may-care eyebrow as he outwits the law and has his way with every buxom babe. What makes up for the Bond-like sexism is creator Monkey Punch's zany sense of comedy, the ingenious plot twists and the presence of foxy *femme fatale* Fujiko – sometimes Lupin's friend, sometimes his foe, but always unpredictable.

Above and right: Takao Saito adapted Ian Fleming's James Bond novels into rental-library gekiga before creating his yakuza killer-for-hire Golgo 13 (the name is derived from Golgotha and the unlucky number) in 1969. Beyond all morals, this stony-faced pro will kill anyone if the price is right.

Left: A friendly yakuza warning. Two refugee boys from Kampuchea are determined to carve their way to top in Japanese society, one in the underworld, the other in government, in *Sanctuary* written by Sho Fumimura and drawn by Ryoichi Ikegami. Below left: Cornered but not captured, Naoki Urasawa's Monster is a sweet-faced demonic killer who should never have been born. Above and below right: In *The First President of Japan*, have the Chinese launched a nuclear missile or are they calling the president's bluff? Tense global politics written by Ryuji Tsugihara and drawn by Yoshiki Hidaka.

Writer Kazuo Koike made his name on *Lone Wolf and Cub*. A true epic at over 8,000 pages, it was co-created and drawn by Goseki Kojima from 1970 to 1976. It combines extraordinary violence and tender tranquillity, contrasting the slashing swordsmanship of the 'wolf', Itto Ogami, a former royal executioner bent on revenge for the murder of his wife, with the innocence of his top-knotted 'cub', his surviving baby son Daigoro. Together the pair take to the road, the father wheeling the boy in a wooden carriage (right) or strapping him onto his back. Itto, stoic in his inner torment, earns his living as a swordsman for hire (opposite). He is so driven by vengeance that he can appear remote, even strict towards his son, but there is a powerful bond between them.

Manga: Sixty Years of Japanese Comics

Right: In *Lone Wolf and Cub*, artist Kojima captures the physical exertions of the duellists and the dynamic thrusts of their swords as they slash near little Daigoro. Writer Koike has said, 'I am writing about Bushido, in a period when the most important thing was to take responsibility for your words and actions. But politicians and leaders today don't have this spirit.' **Below:** Two examples of more fantastical yarns from history. In her adaptation of Baku Yumemakura's novel *Omiyoshi* (left), Reiko Okano illustrates the creature hunter's encounters with legendary beings like river-rat master Kurokawanushi. Swordsman Manji (right) pays the price of immortality when poison infects his wounds in Hiroaki Samura's *Blade of the Immortal*.

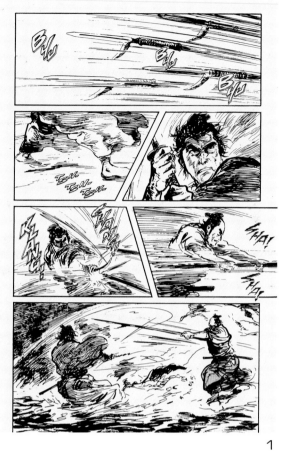

1 2

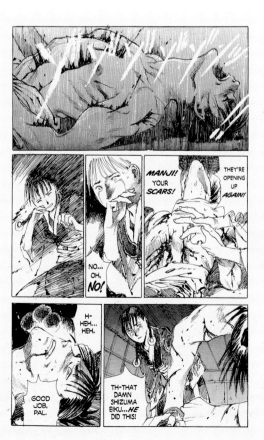

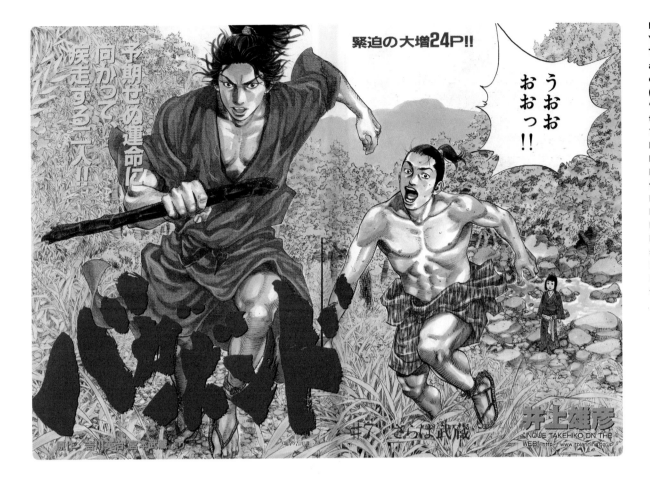

Left and below: Based on Eiji Yoshikawa's novel *Musashi*, Takehiko Inoue's *Vagabond* is a fictional account of the life of Miyamoto Musashi (1584–1645), the revered 'sword-saint' and author of the famed strategy manual *The Book of Five Rings*. Below left: Another historical biography, *Ikkyu*, charts the life of the illegitimate son of the emperor Gokomatsu. Ikkyu was a real man who lived from 1394 to 1481. Hisashi Sakaguchi completed his sensitive 1,200-page study of this Buddhist monk in 1995, only a short while before his premature death at the age of 49.

2 1

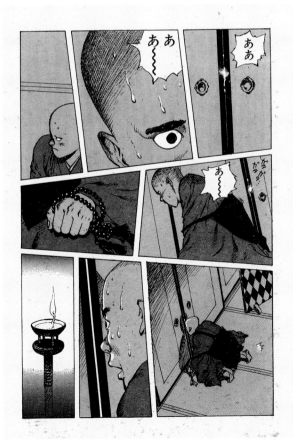

Post-apocalypse now. The future belongs to a new type of human being who is able to harness unprecedented inner energies in *Akira* (above and right), or pilot gigantic cybernetic organisms to defend the planet in *Neon Genesis Evangelion* (below). Made into anime movies, each of these sagas galvanized a generation. One of the original anime designers, Yoshiyuki Sadamoto, adapted *Evangelion* into comics.

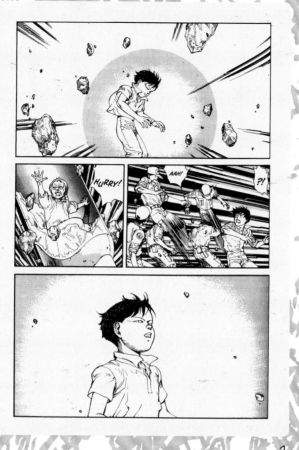

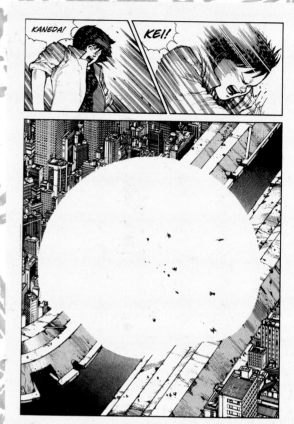

1 2

1 2

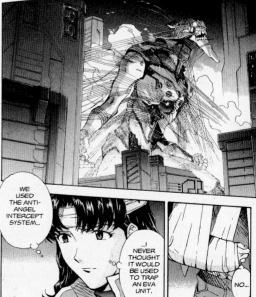

Right: Uncontainable psychic forces, urban destruction and physical deformations surge out of control through the pages of *Akira*. The sheer intensity and precision of Katsuhiro Otomo's graphic storytelling raised the benchmark in manga's expressive potential. Before completing his dystopian epic, Otomo directed an animated movie version in 1988 which introduced many in the West to his Neo-Tokyo nightmare. He then resumed the manga, expanding it to fill six large-format volumes of over 400 pages each.

Manga: Sixty Years of Japanese Comics

A pair of sexy sci-fi fantasies. Right: Blushing teen paranormal Sunao has to hold on tight when he rides with attractive and deadly UN super-agent M-Zak in *Seraphic Feather* by Hiroyuki Utatane and Toshiya Takeda. Below: In *Chobits* by the all-women Clamp studio, young master Hideki rescues a discarded, deactivated *persocom* or personal computer built in female form. Eventually he finds how to turn her on, but can a human being and computer really fall in love?

1 2

2 1

Two sexy romantic comedies. Left: So what was it that first attracted seductive Aya to student and multi-million-yen inheritor Suekichi? Naoki Yamamoto's *DanceTill Tomorrow* unravels their steamy, and often stormy, relationship. Below: Over the course of the 14 volumes of *Maison Ikkoku*, what began as lightly humorous tale develops into a rewarding story of a grieving widow who learns to love again when a young student falls in love with her and comes to understand her. Rumilo Takahashi deftly suggests the depths of two people's growing affection for each other.

1 2

1 2

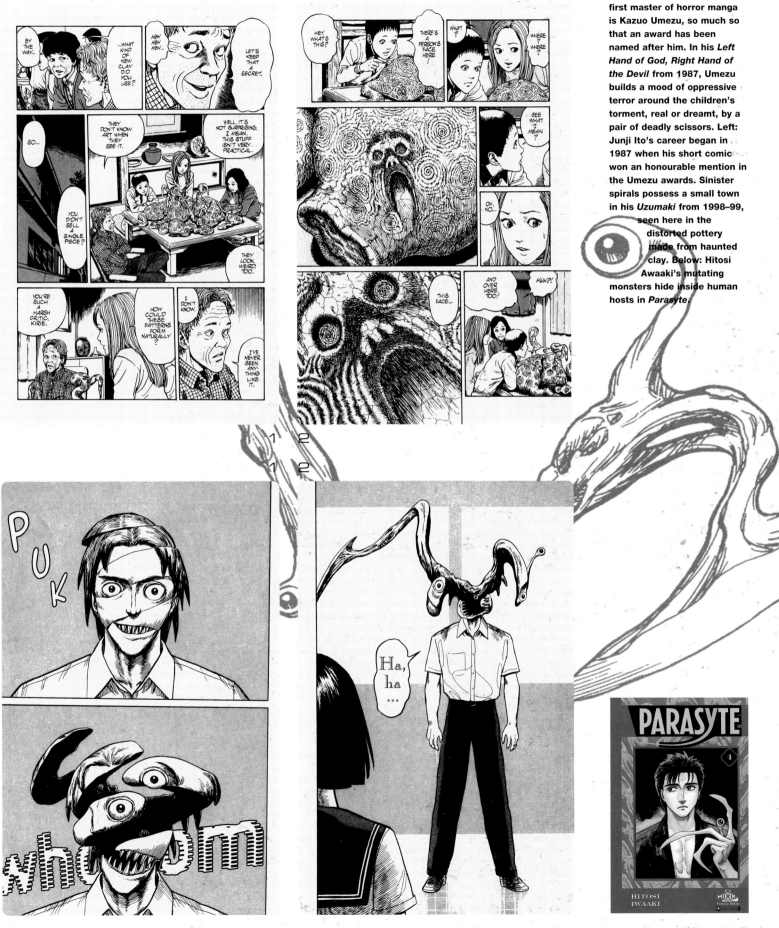

Opposite: The undisputed first master of horror manga is Kazuo Umezu, so much so that an award has been named after him. In his *Left Hand of God, Right Hand of the Devil* from 1987, Umezu builds a mood of oppressive terror around the children's torment, real or dreamt, by a pair of deadly scissors. Left: Junji Ito's career began in 1987 when his short comic won an honourable mention in the Umezu awards. Sinister spirals possess a small town in his *Uzumaki* from 1998–99, seen here in the distorted pottery made from haunted clay. Below: Hitosi Awaaki's mutating monsters hide inside human hosts in *Parasyte*.

The natural world as you have never seen it before. Meet Gon, a lone survivor from prehistoric times. With jaws of steel, this unstoppable baby dinosaur bites the big bullies and protects the weak. Masashi Tanaka's intensely rendered panels dramatize the animal kingdom's survival instinct without a sound.

Hayao Miyazaki is best known as an Oscar-winning animator, but for *Animage* magazine from 1982 he drew an ecological and spiritual science-fiction fable, *Nausicaä of the Valley of Wind* (which he also made into a movie). In a devastated environment, a princess communicates with the plants and animals and tries to understand how the eco-system can recover. Miyazaki's warning was inspired by a real disaster in Japan, the mercury-poisoning of Lake Minamata.

The All-Encompassing

NATURALLY, NOT everyone in Japan reads manga. They are hard to avoid completely, though – they pop up in newspapers, sports, finance and fashion magazines, in the form of four-panel strips, short comedies or informative and dramatic stories. Reading manga is generational. Older Japanese, those born before and during World War II, often find it hard to comprehend, let alone condone, the comics consumption of their children, many of whom now have kids of their own. A good few of the vocal minority opposed to manga belong to this senior group. On the other hand, a great many baby-boomers born after the war connected with manga in their childhood and schooldays. As teenagers and students in the 1960s, they rejected their parents' values, including their distaste for manga, and carried on reading them. The saying went that students at that time had in their left hand the liberal news magazine *Asahi Journal* and in their right the boys' manga weekly *Shonen Magazine*. These are 'the manga generation'. It is their interests, and their lack of contempt for the medium, that have fuelled much of its growth and change. Shrewd publishers know it makes commercial sense not to lose these ageing devotees, who constitute the largest proportion of Japanese society, while at the same time wooing each new generation and demographic that comes along in their wake.

The low status, wages and expectations of the 'pitiful salaryman' had long been the butt of cartoonists; indeed, this rather obvious humour still sells. By the late 1970s, however, when the generation of thirty-something baby-boomers began moving up into the middle ranks of companies, the salaryman stereotype no longer fitted them. The media nicknamed them 'the new breed', because they did not subscribe to their parents' work ethic and had a different sense of priorities regarding the balance between their job and the rest of their life. Among the first manga to reflect this shift in attitude was *Diary of a Fishing Freak* in 1979, a fantasy sitcom in which a good-natured but wholly unambitious salaryman obsessed with fishing somehow manages to endear himself to his colleagues, superiors and clients. Another, far more realistic series, *Human Crossroads*, examines the anxieties of a young businessman, worried that he is repeating his father's life of quiet desperation and thwarted ambition. On a more upbeat note, in the eponymous strip, Section Chief Kosaku Shima is the model company man, eager for recognition and popular with the ladies. Mired in middle-management and office politics, he proves himself to be hard-working, capable, dedicated, whatever his assignment – to the point that the character also lent his name to a series of inspiring 'Formula for Success' guidebooks.

Another vast demographic that publishers had hardly catered for before was adult women. All that changed when the generation whose tastes had been formed by the great shojo classics of the early 1970s entered the job market a decade later, only to find that equal-opportunity legislation was ineffectual and sexual discrimination remained the norm. Many of these young 'Office Ladies' might be poorly paid and unfulfilled in the workplace, but outside of it they decided to live their single lives to the full, in ways their mothers had never imagined. The OLs postponed marriage, stayed in their jobs and continued to live with their parents. After work they could enjoy a double life of nightclubs, fashionable parties, dating and perhaps real love in Japan's high-flying 1980s economic bubble. Commuting from the suburbs, these secretaries, receptionists, nurses and shop assistants, often single and lonely, as well as bored wives left alone by their salarymen husbands, proved a ready market for their own kind of manga.

Women's general magazines since the 1960s had flirted with manga by including a few pages of serialized comics. Attempts had been made to attract an older female audience, such as in Tezuka's experimental publication *Funny* in 1969 or *Josei Comic Papillon* in 1974, but both folded within a year. It was not until 1980 that Kodansha found success with *Be Love*. Other publishers quickly jumped in, first with *For Lady*, *You* and *Bonita*, then from 1985 with a bewildering array of 'ladies' comics', or *redikomi*. The majority of these are created by women, some of them newcomers, others former shojo manga artists who might have been expected to retire into domesticity by their thirties. Redikomi deal with adult women's lives and dreams. Within the romance genre, the sweet, ordinary heroine almost always gets her perfect man in the end. These slushy, rose-tinted love stories are rarely more stimulating than your average Harlequin novel; in fact, Ohzora publishers are adapting the original

Opposite: What woman doesn't want to *Feel Young*? This chic cover girl was created by George Asakura (a female pen name) for one of the new aspirational 'ladies' comics' promising sex, love and designer labels.
Below: Salarymen, meanwhile, might emulate Kenshi Hirokane's upwardly-mobile manager Kosaku Shima.

FEEL

Cool + Lovely* Comics for all Women!

YOUNG

平成15年10月1日発行 毎月1回1日発行（通巻156号）
平成3年9月30日 第三種郵便物認可

フィール・ヤング

オール読切スタイル

オール読切スタイル

10

2003

370YEN

Cover Illustration ジョージ朝倉

大反響企画！
**現金5,000円が
100名に当たる!!**
ご愛読御礼
ナンバーくじ付き

魚喃キリコ
三原ミツカズ
南Q太
宇仁田ゆみ
内田春菊
やまじえびね
有間しのぶ
安彦麻理絵
IKARING
伊藤理佐
堀内三佳
いわみちさくら
こいずみまり
朝倉世界一
青木光恵
斎藤綾子
まついなつき

巨弾連載スタート！
**「新・花のあすか組！」
高口里純**

大人気シリーズ！
**安野モヨコ
「東京番外地」
桜沢エリカ
×
寺門琢己
「ボディ＆ソウル」
西村しのぶ
「RUSH」**

a Piece of Cake

［ピース オブ ケイク］
失恋直後の志乃を待つのは…!?

巻頭カラー
ジョージ朝倉

フィール・ヤング

FEEL YOUNG

FEEL YOUNG

2003 **10**

新連載！
**ジョージ朝倉
「ピース オブ ケイク」**
新・花のあすか組！
高口里純

大人気シリーズ！
**安野モヨコ
「東京番外地」
西村しのぶ
「RUSH」**

大反響企画！
ご愛読御礼
ナンバーくじで
**現金
5,000円
プレゼント!!**
SHODENSHA

Manga: Sixty Years of Japanese Comics

Above, from top: Stimulating monthlies like *Anklet* and *Huge Love for Women in their 30s* are the comics counterparts to *Cosmo* and *Playgirl*, while *Forbidden S&M* is part of a range of sex manuals starring Mr Sex Hero. Right: Working girl Haruo Hattori lands a job in one of Tokyo's hottest hostess bars in *Club 9*.

American tales for use in a *Harlequin* magazine and a line of over 250 manga books.

Certain ladies' comics, however, permitted women creators the sort of freedom to show sexuality that they had been denied in girls' comics, although there was still article 175's ban on the depiction of genitals and pubic hair to get around. By the late 1980s, almost a quarter of ladies' comics presented so-called *hentai* content. Otherwise known by the initial 'H', which is pronounced 'etchi', this is a fairly broad label covering anything from the fairly kinky to the seriously perverse. In monthlies like *Aya*, *Rouge* and *Comic Amour* women's depictions of erotic liaisons between a secretary and her married boss, a student and her teacher, an under-appreciated housewife and her boyfriend, or other combinations, are as uninhibited as anything in men's sex manga. The only distinction might be the inclusion of a little more plot and foreplay. Considering how demure and conservative Japanese women are perceived as being, these 'H' manga came as something of a shock. They were not such a surprise to Takeshi Oshima, a male mangaka who works for *Amour*. To try to understand what women want, he consults them via internet chat rooms. 'I can understand their fantasy completely. You have several feelings inside of you. Sometimes you are innocent; sometimes indecent – it is part of being a human being. A magazine like *Amour* throws a light on the dark side of these ladies, because even a sophisticated lady likes to be a slut in certain situations.'

Between their sexual explicitness and their romanticized exaggerations, how empowering these ladies' comics are for their readers has been debated by female critics. Miya Erino, a specialist in women's studies, painted redikomi in 1993 as 'a world where narrow-minded women, fixed in their thinking, waste their time becoming artists and readers, while publishers following male principles reap the profits'. There are some female editors, but the publishing business itself remains very much male-controlled. Erino also argued that ladies' comics seldom advocated any feminist questioning of the limits imposed on women by Japanese society but instead reinforced its conservative values. Sociology professor Kinko Ito concurs that many of the images of women, especially in some erotic redikomi, represented what Japanese men want women to be, perhaps as a result of male editors' influence on creators. Despite this, Ito acknowledges that there are ladies' comics (and adult male manga) that depict women

more positively. 'In many redikomi stories classified as pornographic, Japanese heroines learn to become independent-minded and assertive in terms of their sexuality. They are no longer sexual objects and toys played with by men, but legitimate owners of their bodies and sexual pleasure.'

Though redikomi are mostly consumed by women aged 19 to 29, their readers can be as young as 15, adolescents curious about their future. Karen Eng of the American magazine *Ben Is Dead* canvassed a high-school class of girls all aged about 17 for their opinions of the sex they had read about in juvenile and adult manga. Many of their responses revealed the role manga play in a society where girls do not always receive sex education in school or at home. Typically, one wrote: 'Japanese parents are ashamed about sex and don't tell us about venereal disease and contraception. So we learn them from comics. I think we need such comics.' Another pupil wrote: 'In Japan, there are less sex educations [*sic*] than other countries. But in comics we have more bed scenes than other countries. I think, as we have little chance to hear about sex, we rely on comics. And we get some knowledge about sex from them.'

A lot more can be learnt from reading redikomi. A large proportion are about coping with often serious family or relationship problems. From spicing up your love life with counsellor Mr Sex Hero to confronting adultery, abuse, incest, impotence and divorce, these dramas are sometimes based on readers' experiences and as such are a kind of equivalent of an agony aunt's advice column. One common situation, as housing is costly, is for a young wife to have to live with her husband's parents. The stresses this can cause on all sides and the need to resolve them have given rise to another of Ohzora's themed magazines entitled *Truly Horrifying Mother-in-Law and Daughter-in-Law Comics*. Similarly, the strains that money worries can put on a marriage are tackled in another of Ohzora's magazines, *Paying the Bills*. Many salarymen husbands work so hard and so late in the city, and then drink after work and play golf at weekends, that they are too exhausted to communicate with their wives in the suburbs or help them look after the home and kids. Readers of ladies' comics can discover how characters overcome all kinds of crises and usually reach a happy conclusion. As Kinko Ito sees it, they benefit not only from an optimistic catharsis but from practical advice as well.

Women in their forties and older, mothers and mothers-in-law themselves, also read redikomi. This age

group were unlikely admirers of the satirical *obatalian* craze. Supposedly aimed at men, the name fuses *obasan*, or 'aunt', with *Batalian*, as in 'battalion', the Japanese title of the American zombie movie *The Return of the Living Dead*. There was no stopping these chubby, henpecking housewives-from-hell from bagging the best bargains in a sale or the last seat on a train. This unflattering parody became popular with mature women, who claimed to use them to sharpen their wiles.

By the early 1990s, women could choose from 60 or more different 'ladies' comics', whose total annual sales in 1995 exceeded 100 million copies. *Feel Young*, one of the smartest of the newer titles, is reaching a younger crowd with its fresh take on their lives and loves by female mangaka from the same age group. There are gems among this 'chick-lit', ranging from manic searches for Mr Right, part *Sex in the City*, part *Bridget Jones' Diary*, to unpredictable psycho-dramas often drawn in a cooler 'clear line' minimalism akin to chic fashion illustration. The variety of redikomi is as great as that of women's glossy magazines. Some magazines offer guidance in manga form about weddings, pregnancy, health and child-rearing, others motivate via accounts of small-screen glamour (*Women on TV Variety Shows*) or of careerwomen climbing the corporate ladder.

Comics have long been known to be an appealing and highly effective vehicle for carrying information. Instead of a dry instruction manual, American Will Eisner took a humorous and sexy approach to equipment maintenance in his life-saving strips for the US army. In 1948, three million free copies of a comic-book hagiography of Harry Truman undoubtedly helped secure his surprise presidential victory. Mangaka have been equally adept at making education entertaining and publicity persuasive. Early-learning and school textbooks are available in manga form, as are study and revision guides for college students. You can learn about almost anything via manga. Cartoon chefs demonstrate how to make elaborate dishes, while seasoned sports pros show you how to improve your fishing or golf. The declining popularity among the young of the ancient board game Go was reversed almost overnight in 1999

by the hit manga series *Hikaru no Go*. For some adults, reading mahjong comics is actually better than playing the real thing, because you can do it alone, anywhere, any time, at little cost, and can always imagine yourself as the winner. Within a year of its publication over half a million people had bought Shotaro Ishinomori's 1986 manga explaining Japanese economics. It proved how receptive the public was to getting information and ideas from comics. It also explains why the Aum Shinrikyo cult responsible for the subway gas attack of 1995 was able to convert so many through their comic-strip tracts, and why a graphic novel was the medium of choice in 1999 of nationalists keen to resuscitate their claim that preventing white people from colonizing Asia was Japan's main motive for its engagement in World War II.

The relationship readers form with characters can be lifelong; like members of the same family, they grow old together. For example, thousands of salarymen empathized with 34-year-old Section Chief Kosaku Shima and followed him through his foreign postings, divorce and affairs into middle age and promotion to Division Chief. Over the decades they have watched youthful baseball player Abu-san grow up, marry and raise a son, who now plays in the same professional league as his 50-year-old father. They can also find respectful portrayals of senior citizens in new, so-called 'silver' manga, in which they are no longer reduced to the clichés of either wise elders or grumpy old fools. *Like Shooting Stars in the Twilight* is the metaphorical title of one series, in which protagonists in their sixties and older are shown still enjoying romance and sex to the full. Another called *Retired, No Boss, No Work* indicates that retirement can bring a new lease of life. Mangaka have shown great sensitivity, for example handling the effects on a family living with their grandmother as she grows senile or the needs of people facing up to dying. 'The Seven Ages of Manga' now span all of life, from the cradle to the grave. Japan's population is ageing and living longer – a recent survey confirmed there are now 20,000 Japanese over 100 years of age. There looks like being no shortage of readers for the 'greying' of manga.

Left: Every week for more than a decade Tochi Ueyama's Cooking Papa has served up succulent cartoon cuisine in *Morning*. Below: Another regular since 1989 is Risu Akizuki's 'Office Ladies' strip *Survival in the Office*. As Akizuki has said: 'The reason young OLs feel it's "better to enjoy yourself while you're young" is that it is difficult for them to have any dreams for the future.'

Chameleon ①

Right and below: Watch out, Bridget Jones. Single, 24 and man-hungry, Shigeta always seems to wind up with Mr Wrong in the 'chick-lit' romp *Happy Mania* by Moyoco Anno. **Below right:** When her devotion to Saki proves to be unreciprocated, Minako starts playing mind games with her uninhibited friend and her lovers in Erica Sakurazawa's intriguing *Between the Sheets*.

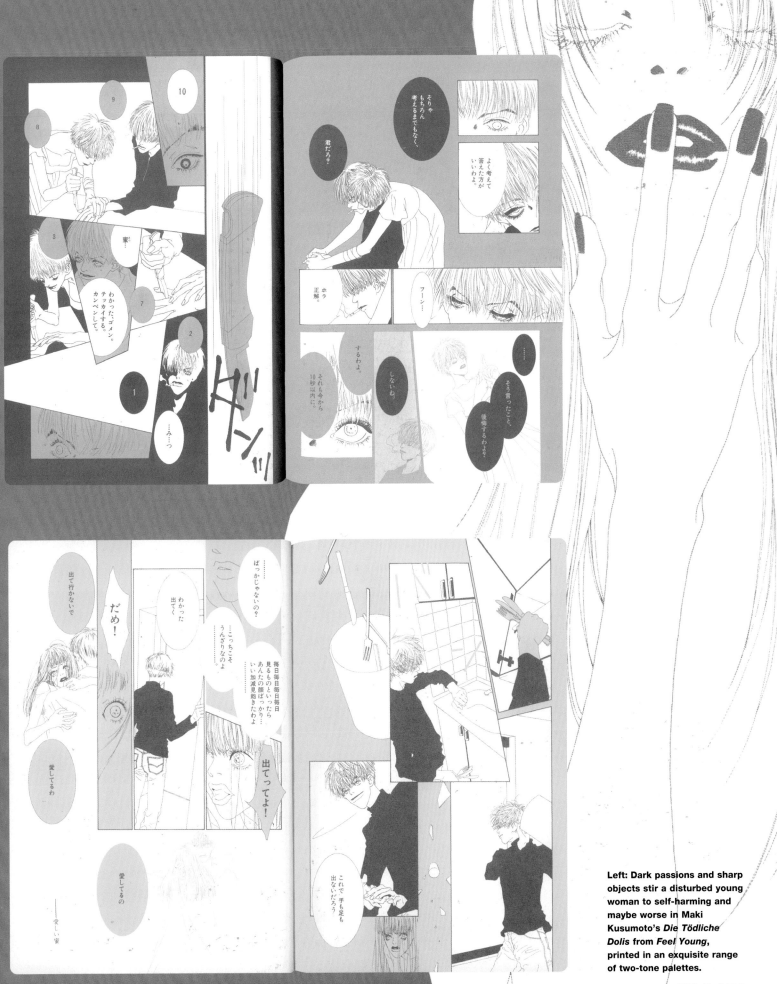

Left: Dark passions and sharp objects stir a disturbed young woman to self-harming and maybe worse in Maki Kusumoto's *Die Tödliche Dolis* from *Feel Young*, printed in an exquisite range of two-tone palettes.

Manga: Sixty Years of Japanese Comics

Right and below: A pep talk and the company pledge inspire our idealistic young salesman in *Notes from the Frantic World of Sales*, written by Jiro Gyu and drawn by Yosuke Kondo. **Far right:** In contrast, Hamasaki has no ambition beyond being a 'Fishing Freak'. A hit with salarymen, this dreamer appears in over 40 books by Juzo Yamasaki and Kenichi Kitami and several live-action movies. Here he is drinking with his chief, after both answered back to an arrogant client and fishing snob.

Right: A far from common sight, from Kazuyoshi Torii's *I'm No. 1!* To win over a sexist big head, a female section chief of a corporation gives an impressive demonstration of saleswomanship.

1 2

1 2

Left: A country girl and college student newly arrived in Tokyo, Haruo, or 'Miss Hello', picks up the tricks of the trade of entertaining executives and celebrities in the exclusive, expensive Club 9. This is a witty and sympathetic sitcom by Makoto Kobayashi set in a hostess bar.

Left: Saucy Keiko sends more than the ratings shooting up when she enlivens her weather forecasts in Tetsu Adachi's sexy satire of media ambition and TV banality, *Weather Woman*, which was adapted into a soft-core film musical.

The Man Who Walks is also a man who stops and stares at the natural world in a dappled grove. It's a hot summer's day to be carrying a rolled-up sun-screen home. Jiro Taniguchi brings a vibrant clear line and a contemplative calm to his collection of vignettes, as his nameless, affable wanderer takes time to pause and appreciate the light, the wildlife, the weather and chance encounters in a modern Japanese city.

Manga: Sixty Years of Japanese Comics

Above: Married with kids? Robot cat Doraemon's first career was as a friendly teacher in the magazine *Shogaku Ninensei*, or 'Second-Grader'. Right: Here he is seen explaining bodily functions to his pupil Nobita. Below right: First-time parents have their hands full with Crayon Shinchan, let loose in a unisex hot springs. Yoshito Usui's wild child out-menaces Dennis the Menace.

1 2

Left: In her semi-autobiographical *Homebuilding* sketches, wife and mother Shungiku Uchida shares her travails with her in-laws with *Feel Young* readers. While she is out, her husband tries to cope with the kids and is not helped by the teasing of his visiting parents. Below left: Despite appearances, Hajime Furukawa's wacky *I Don't Like Friday* was never aimed at children, but ran as a spoof sex-education English course in *Business Jump*. Below right: He may only be three years old and hardly able to speak, but Hideki Arai's Ki-Itchi has a fierce personality and won't stand kindergarten bullying. But will his mother and teachers understand?

Manga: Sixty Years of Japanese Comics

Right: By demonstrating abstract principles at work in a realistic Japanese automobile company, Shotaro Ishinomori's *Japan Inc.* helped explain the country's economy and its relationship to that of the world as a whole. The book's success in 1986 prompted a boom in information manga, such as Yumeji Tanima's guide to women's sexology (below left) and advice about AIDS (below right).

1 2

Left: Every tense moment of bluff and strategy can be recorded in the gaming manga about pachinko, mahjong or, as shown here, shogi, a sort of Japanese chess, by Nojyo Junichi. Below left: Chef's techniques and picture-perfect food shots in *Cooking Papa* by Tochi Ueyama. Below right: The arrival of Admiral Perry's black ships, from Minamoto Taro's *Funnjitachi*, a factual yet gag-laden textbook covering three centuries of Japanese history in more than 30 volumes.

コン コン

先手9六歩だ

……!!

……どうした？

9四歩や。

後手

事故処理班 ただ今 帰りました

どうも スンマセン でした～

じゃあ 始めよう みんな お待ちかねだ

おまえの 歓迎会 だよ

おう

え

ビール 買って きました

お部屋の 準備も OKです

ごくろう

梅田宅

ドサ

板良敷雲上の堂々たる方針に薩摩在番もホッと胸をなでおろした……

通訳が

とはいえ琉球を日本進出の拠点とするペリーの方針は変わるはずもなく

ペリー日誌で6月9日サスケハナとサラドガの二隻が小笠原諸島へ旅立った

1 2

Manga: Sixty Years of Japanese Comics

While older women have been represented satirically as unstoppable *obatalian* battleaxes by Katsuhiko Hotta (above), Shungiku Uchida's vision is a more sympathetic one. Her Chocho is a spirit who takes possession of an ageing, overweight woman taxi driver to enable her to have sex with one of her young male fares, (right). To represent the worldview of a grandmother succumbing to senility and the way she is perceived by the rest of the family she lives with, author Fumiko Takano portrays her sensitively as a little girl out of an old-fashioned colouring book in a story from *Zettai anzen kamisori* ('The Absolutely Safe Razor') (below right).

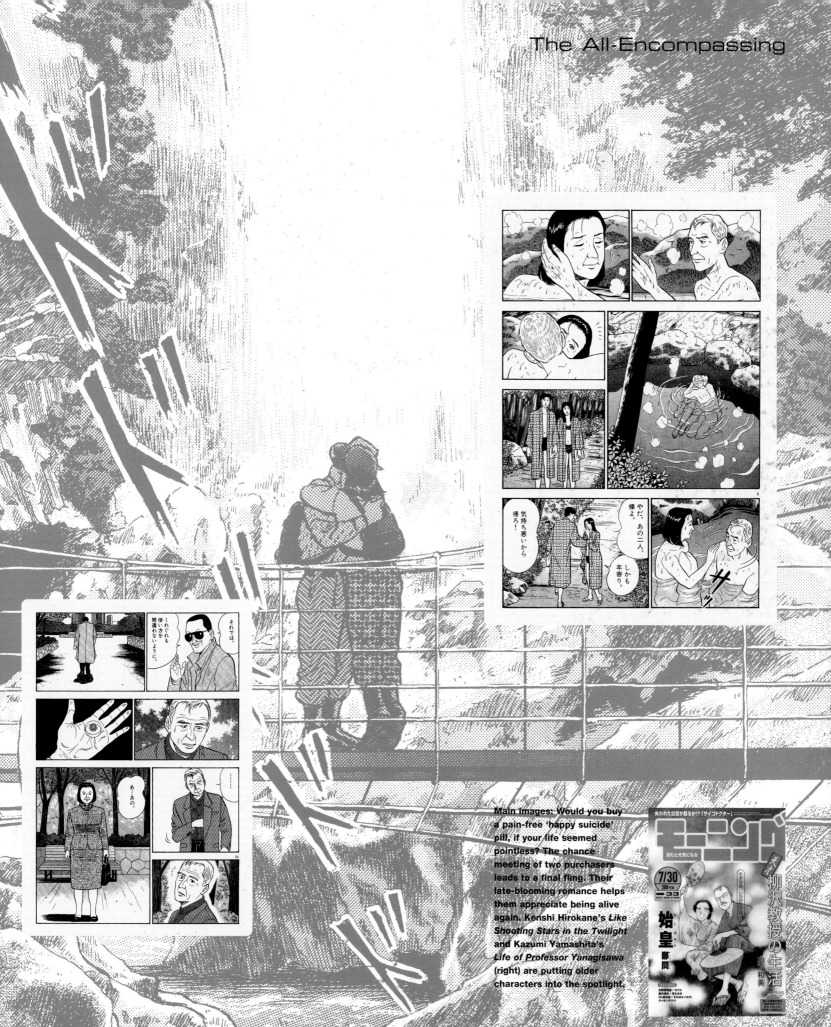

Main images: Would you buy a pain-free 'happy suicide' pill, if your life seemed pointless? The chance meeting of two purchasers leads to a final fling. Their late-blooming romance helps them appreciate being alive again. Kenshi Hirokane's *Like Shooting Stars in the Twilight* and Kazumi Yamashita's *Life of Professor Yanagisawa* (right) are putting older characters into the spotlight.

Chapter 09

Personal Agendas

NOT ALL MANGA are at the mercy of high-speed, high-volume output, targeted audiences, editors' diktats and readers' whims. In the more marginal sectors of comics publishing – in assorted specialist and adult magazines and books, and the proliferating *dojinshi* or fanzines – have sprung up all kinds of singular visionaries driven to create manga as only they can. Some of these mangaka might be given the Western label of 'underground' because of their opposition to, or lack of interest in, mainstream acceptability and their unapologetically personal approaches. In Japan, however, the border between 'mainstream' and 'underground' tends to become rather blurred because of the size and range of available opportunities within manga publishing. The most unlikely candidates can become cult icons, even commercial successes, without compromising their visions. Regardless of whether their self-expression pays the bills, many feel compelled to create comics their own way.

One impoverished mangaka lacking commissions and with a wife and child to support set up a business selling aesthetic natural rocks, or *suiseki*. Unfortunately, he found few treasures in the local riverbed. These stones had once been prized by collectors, but the trade was a treacherous one for beginners and was in decline in the 1960s as Japan pursued all things modern. Despite his efforts, after two years his enterprise had come to nothing. Facing ruin, his distraught wife scolded him: 'The only thing you can really do is manga. I beg you, go back to manga. The important thing is that you draw! You can be so stubborn, stubborn!'

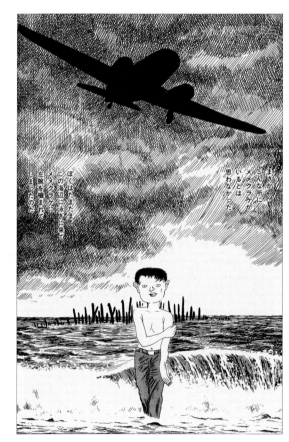

This scene in the bittersweet graphic novel *Muno no hito*, or 'Man without Talent', seems at least obliquely autobiographical. Its author, Yoshiharu Tsuge, faced similar crises in his life. He was so poor he had to sell his blood, so depressed that he could not draw and attempted suicide; his younger brother Tadao, also a struggling mangaka, actually did kill himself. For Yoshiharu, an intensely shy, self-conscious teenager in the 1950s, sitting alone at a table at home and creating gekiga for the rental-library magazines was one way of bringing in a little money without having to deal with other people. By the early 1960s, though, when the library market was floundering, Tsuge felt unwilling or unable to compete in the weekly mainstream arena. Approaching 30, disenchanted after years of doggedly working in the thriller and horror genres, and plagued by depression, he decided to disappear. For every superstar career, there is a mangaka who, by choice or not, eventually gives up the struggle and quits the profession.

Tsuge might never have been heard from again had word of his situation not reached Katsuichi Nagai, editor and publisher of the new small-circulation magazine *Garo*. With no other way to reach him, Nagai printed an appeal in *Garo*'s pages in 1965—'Yoshiharu Tsuge, please get in touch!' Contact was established and, through Nagai's introduction, Tsuge was taken on as Shigeru Mizuki's assistant. So began Tsuge's association with *Garo*, probably the only periodical able at that time to give him the liberty to experiment. In 1966, Tsuge's breakthrough came when he created the idiosyncratic

Right: This historic, iconic full-page panel opens Yoshiharu Tsuge's *Nejishiki*, or 'Screw-Style', from *Garo* magazine in 1968, a 22-page dream-fable laden with potent symbols and lyricism. Opposite: *AX* magazine has been carving out the wildest frontiers of manga since its first issue in 1998; cover by Siriagari Kotobuki.

マンガの鬼AX ビックリするほど良くキレる！

アックス VOL.1

マンガ執筆陣

根本 敬　花輪和一　近藤ようこ　東陽片岡

しりあがり寿　川崎ゆきお

特別インタビュー　竹熊健太郎

スーパー対談　林 静一×みうらじゅん

巻頭カラーイラスト　友沢ミミヨ

鈴木翁二

コラム執筆陣　南 伸坊　高杉弾　湯浅学　蛭子能収

いむらじゅん　Super!

漫画評論　小野山理絵

大越孝太郎　菅野修　アヤナアキコ　丸山玉子　本秀康

キクチヒロノリ　井口真吾　Q.B.B　逆柱いみり　河井克夫　安斎肇

定価：本体933円＋税

青林工藝舎

Manga: Sixty Years of Japanese Comics

short piece *Numa* ('Marsh'). In his mind this was 'a liberating work that got me out of entertainment manga, where the story takes precedence over everything else'. Brooding, unresolved, this and subsequent works baffled readers looking for a familiar beginning, middle and end, but came to fascinate others precisely because of their distinctive ambience and ambiguity.

Tsuge helped to free manga from the strictures of narrative and sought a more poetic grammar for them. He shifted from manga's characteristic film-influenced quick-cutting roller-coaster fluidity to a more measured, reflective style that allowed for the subtle unfolding of emotional states. To invite the reader to slow down, he often shrank his plain, simply cartooned players within expansive, richly detailed scenery of disappearing rural neighbourhoods or the wild outdoors. Rendered like etchings, these panels crystallize an uncanny sense of place and time which evokes the characters' innermost feelings.

Nothing like his 22-page dream journal *Nejishiki*, or 'Screw-Style', in *Garo* in 1968 had been seen in manga before. From the start, the reader is ensnared in the unnerving puzzle of a nightmare. Remote and staring as if in shock, a shirtless boy walks ashore clutching at a jellyfish bite on his right arm. Overhead in the storm clouds looms the shadow of a plane, perhaps a B-29 bomber. On the second page, only a bleached animal skull caught on a branch and birds circling in the sky are shown. These deathly symbols underscore the boy's detached description of the blood pouring from his cut vein. In the next panel, the boy is shown again, this time surrounded by drying laundry, white shirts with any stains washed away. His search for a doctor takes bizarre detours. Finally, while he is having sex with a female gynaecologist, she fits his wound with a mechanical screw.

Our instinct is to look for sense or pattern, because we are used to pictures and words seamlessly supporting each other to relate a clear story. Instead, in *Nejishiki* Tsuge's visual and verbal flow, though broken and disjointed, sets up fields of resonance within and between the panels. The work provoked even the most typically aloof of critics to concede that manga might indeed be 'art'. Whatever its meanings to

Tsuge, or to Japanese readers swept up in the social turmoil of the 1960s, *Nejishiki* is timeless and human in its exposure of the raw nerve of alienation.

Tsuge's new comics were not produced to order, on deadline, on a conveyor belt. From his surrealistic allegories and reflections on the pain of day-to-day existence to his first-person travelogues through vanishing districts, his manga are profoundly intimate and very demanding to create. Like his 'Man without Talent', Tsuge has renounced manga several times and for long periods. 'It's very hard for me to adjust to the world, and I'm just trying to figure out how to exist, so that I can be different without feeling insecure about it,' he has said. To his surprise, his small body of work has achieved a disproportionate national status, been hailed by the intelligentsia and adapted into films and television dramas, and is now regarded by his peers and successors as a precious beacon of meaningful self-expression in the medium.

In his footsteps a trend for 'auteur' manga creation took hold in *Garo*. The magazine's falling sales might mean that it could not afford to pay them, but that has never deterred those who saw their works not as a crowd-pleasing product or auditions for the big time, but as a necessary, unmediated outlet for issues arising from their private experience, for a catharsis not unlike that provided by 'outsider' art, from saying

whatever they needed to say. *Garo* might not have been started intentionally as a laboratory for such works, but from the late 1960s it increasingly welcomed 'eccentric' and experimental voices who might never have been heard elsewhere. These one-of-a-kind 'auteurs' also broke into manga via *COM*, *Comic Baku* and other seminal if short-lived anthologies. Some creators began to put themselves in the unflattering flesh or as cartoon alter egos into the panels of autobiographical 'I-comics'. They might use the form like a touching home movie or a guilt-ridden confessional, perhaps to filter memories of a harsh wartime childhood or record their immediate impressions of life in prison.

Stylistically, anything seemed possible. Some superbly gifted illustrators referred back to earlier styles of Japanese draughtsmanship. What others lacked in finish was more than made up for by the energy and urgency of their work. Design 'guru' and mentor Teruhiko Yumura, alias 'Terry Johnson' or 'King Terry', formed a group of *Garo* artists known as Tokyo Funky Stuff. Like him, they adopted American pen names and an abrasive, almost punk wildness. As Emiko Shimoda, renamed Carol, later recalled: 'We were all frustrated that, even in the art world, there was the idea that "art" must be pretty and well-drawn. So we decided to get together with King Terry and be a force to change the trends we hated.' Their approach, known as *heta-uma*, or 'unskilled/skilled', injected much-needed exuberance and subversion into Japan's graphic landscape. Several cited as their master the largely forgotten mangaka Shigeru Sugiura, whose freewheeling, unclassifiable children's fantasies and peculiar, painterly compositions provided an alternative to Tezuka's entrenched cinematic system.

The appearance of this conviction that anything could be the subject of a manga, regardless of social expectations or taboos, coincided with parallel global movements hatched during the unrest of 1968. Something of the same spirit spurred anti-establishment Japanese students and radicals, most of them male, to found small publishing companies in the 1970s, and to challenge conventions by putting out magazines of 'ero-gekiga', or sexually charged dramatic manga, that the major companies would have found it impossible to publish. First *Manga Erotopia* (created in 1973), then *Erogenica* (1975), *Alice* (1977) and others, regularly ran foul of the authorities and concerned citizens' groups, such face-offs serving to enhance their rebel credibility. Their stance paved the way for other smaller-scale publishers, who diversified into all kinds of niche adult content areas.

The most unrestricted expression in manga is probably found in some of the thousands of privately

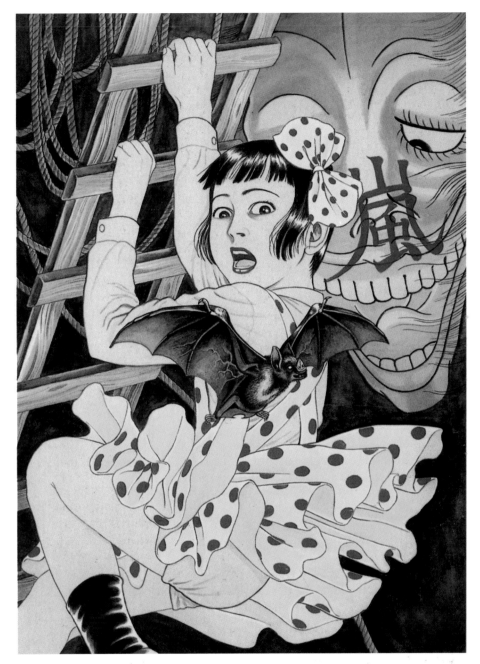

published manga *dojinshi*, literally 'same-people-magazines' but probably best translated as fanzines. Far from being poorly drawn or cheaply photocopied, these can be extremely well-produced and resemble expensive artist's books, with copies appearing in anything from small limited editions to much more sizeable print runs. Manga fanzines and fanclubs had been around since the early 1960s, but the more progressive dojinshi really started in 1976 at a small-scale Tokyo gathering of a few hundred creators and their readers called 'Comiket', short for 'comic market'. Year on year, this non-profit organization expanded, playing an essential role in the 1980s in bringing together a young generation of *otaku*, or intensely dedicated fans.

Above: Suehiro Maruo draws on the style of commercial illustration of the 1920s to make the mood of his manga more decadent and unsettling, as in this image from his 1984 *Shojo Tsubaki* ('Mr Arashi's Amazing Freak Show').

Manga: Sixty Years of Japanese Comics

These otaku became typecast by the press as disturbed, stay-at-home nerds. In fact, many had chosen to drop out of ordinary society because they preferred to belong to the huge and highly creative community of manga and anime fans. In the media, the most visible of the otaku community at Comiket are the ten thousand or so *cosplayers*, or costume players, four out of five of them women, who pose outside the halls dressed up as their adored manga characters. Nonetheless, these represent only a tiny percentage of Comiket's visitors. Inside Tokyo's gargantuan Ariake Big Sight venue, nearly half a million people flooded into the 63rd Comiket in summer 2002. Why do manga seem to encourage readers to immerse themselves in them so deeply, to study and analyse them, to imitate and parody them and to create their own? It seems manga are not merely products created to be consumed. This is perhaps why Comiket has grown into the biggest cultural gathering in Japan.

At Comiket people can survey and purchase under one roof a staggering range of hard-to-find products, offered by as many as 35,000 different exhibitors over the three days. Day one covers manga, anime and science fiction for a general audience; day two focuses on characters from all kinds of games and on variations of the shojo manga genre of homosexual 'boys' love', from the

Above: Comiket is an enormous marketplace for *dojinshi*, literally 'same people magazines' or self-published fanzines and books. Thousands of exhibitors are indexed in the 1,400-page catalogue (top). Held twice a year in Tokyo, this three-day event attracts almost half a million visitors, the largest public gatherings in Japan. Right: Mimiyo Tomozawa's fairytale folk look sugary-sweet but get up to crazy and unpredictable pranks in her 2001 *Mushroom Travel*.

platonic to the plainly pornographic; day three, the busiest, lays out the whole gamut of erotic dojinshi for men, alongside more serious studies of manga and anime culture. The major publishing houses also attend Comiket, not just to promote their products directly to their readers but also to scout around for the next artists to sign up. Masamune Shirow, Kenichi Sonoda, Clamp and other favourites were first talent-spotted at Comiket. Even after turning professional, many stay involved with dojinshi for the fun and freedom they provide.

Because the artists or fans publish and sell their efforts personally, directly to the public or to their 'coterie' or 'circle' members, and via mail order and select outlets, some dojinshi can circulate outside the legal system, which allows them to present much more extreme content than most commercial publications dare to. This licence gave rise in the 1980s to the *rorikon*, or 'Lolita complex', a sizeable subgenre of men's pornographic dojinshi depicting all manner of sex with extremely cute or *kawaii* young girls, who, despite their often voluptuous figures, appeared to be under-age or barely pubescent virgins. Though bordering on paedophilia, this fantasy genre caught on and in the late 1980s spread to some mass-market magazines, even those for youngsters, and was adopted as a style by grown women who started to dress and act like innocent girls. The fantasy turned sour, however, in 1989 when 26-year-old Tsutomu Miyazaki was arrested for the abduction, murder and mutilation of three pre-school girls and was found to be a withdrawn and obsessive fan of manga and anime, and especially of rorikon. A media panic ensued and a nationwide campaign was started by mothers demanding the regulation of 'harmful manga'. This activity sparked a crackdown by local authorities on retailers and publishers, including the larger companies, and arrests of dojinshi creators. The industry had to respond. Respected senior mangaka set up the Association to Protect Freedom of Expression in Comics to speak out against censorship. Publishers showed they were being responsible by labelling their 'adults-only' titles accordingly and cleaning up the rest of their output. But this led to stores refusing to stock adult magazines and forced many to be cancelled. As such, by 1994, without resorting to regulation, the campaigners had got the results they wanted and had turned their attentions elsewhere.

Since that time, away from the spotlight, erotic manga have caught up with with the times and started to incorporate the increasingly uncensored imagery available as photographic, video and internet porn. This trend may now have to be reversed, though, following a recent ruling against a sex manga. In April 2002, the Shobunkan group published 20,000 copies of *Misshitsu*, or 'Honey Room', selling it in over 1,900 retailers across Japan enclosed in plastic with a warning sticker. This manga became the subject of the first major obscenity trial in Japan in over 20 years. Shobunkan publisher Monotori Kishi and the manga artist responsible, Suwa Yuuji, were convicted in January 2004 for violating article 175 of the Japanese penal code. The judge suspended Kishi's one-year sentence for three years, but ordered the removal from sale of all of the adult manga drawn by Yuuji, who was fined and, under protest, accepted a guilty plea to avoid going to jail.

Why was this manga singled out from so many? The judge's statement suggests that it was due to the heightened realism, the lack of cartoonish exaggeration, of its illustrations, combined with the failure to obscure genitalia and pubic hair. In the judge's view, 'bodies were drawn in a lifelike manner with little attention to concealment, resulting in sexually explicit expression and making the book pornographic matter'. Kishi's defence argued that this manga was not obscene, because it was not as arousing as photos or

videos and the internet disseminated much more exciting products. They also countered that article 175 is contrary to the constitutional principle of freedom of expression and that it is not the state's job to pronounce on what is or is not obscene. How Kishi's appeal to the High Court will be received remains to be seen. His mistake may be that he did not give in, that he dared to rock the boat. His arrest and conviction have had a chilling effect, pressuring several bookstore chains to eliminate their adults-only sections.

Adult manga also continue to upset Western critics. In evaluating manga, the latter frequently support their broad generalizations that manga demean women and glorify rape by focusing on one page or panel that offends them, instead of understanding it in its complete narrative context. In 2002, American researchers Timothy Perper and Martha Cornog closely read approximately 53,000 pages of manga translated into English since 1999. They found 87 stories that dealt with rape or sexual assault, of which 80 showed the woman or others taking violent, often murderous, revenge. They concluded: 'We do not agree that depictions of female sexuality in manga are underlain by uniform anti-female ideologies. If anything, the opposite seems true – the manga we have seen have strong but diverse pro-female qualities. Finally, we see anti-rape images of manga as arising from a sex-positive culture that nonetheless has had its history of sexual horrors. The anti-rape images in manga are resistance to, and reaction against, rape in war and in peacetime, set into an aesthetic background in which women are beautiful.'

The sexually explicit manga genre has also helped launch some exceptionally talented masters, such as the erotic-grotesque iconoclast Suehiro Maruo and the provocative stylist Takashi Ishii before his move into film-directing. At their best, these works offer some of the most exquisitely drawn and unfettered erotic art available today. Elsewhere there are chances for upcoming alternative talents to gain exposure, from such prestigious outlets as the annual *Comic Cue* to the big companies' unconventional monthlies *Afternoon* and *Ikki*. There is also a vogue for manga illustration, that is, essentially manga without the story, executed in technically wondrous graphics, as seen in *Style*, *Comickers* and other 'J-mags'. And 40 years on, *Garo* continues its mission after weathering changes in ownership and the death in 1996 of its founder Nagai. Respecting his spirit, several of *Garo*'s staff and contributors quit to set up a new monthly showcase in 1998. They named it *AX*, because even a small axe can cut down a big tree. Nagai would have approved of their manifesto, as printed on the cover of every issue: 'MANGA should be independent, MANGA should be open, MANGA should be experimental.'

Left, from top: Oil corporation Esso Petrol, of all people, were behind the 'art comic' *A-ha* published briefly in 1990 (cover by Toshiki Sawada). Other experimental monthlies include the independent *AX* (cover by Jun Miura and Takashi Nemoto), and *IKKI*, new from powerful mainstream publishers Shogakukan (cover by Taiyo Matsumoto).

Below: Did this book go too far? In January 2004 Suwa Yuuji's *Misshitsu* (translated variously as 'Honey Room' or 'Secret Room') was the first manga to be deemed obscene and in contravention of article 175 of the Japanese penal code.

Right: Two pages from Yoshiharu Tsuge's masterpiece *Nejishiki*, or 'Screw-Style', eventually translated in the special 250th issue of the American magazine *The Comics Journal* in 2003. Like the wounded boy in the story, the reader feels lost in an eerily calm nightmare.

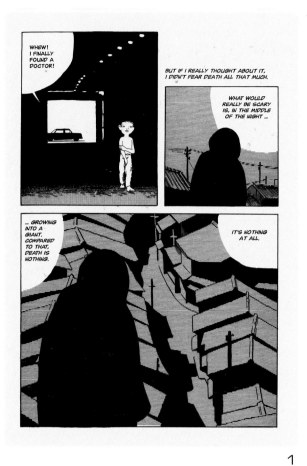

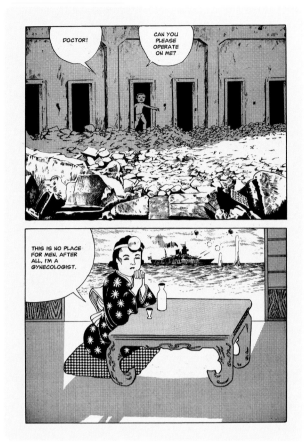

1 2

From a hardback collection (above) come these two examples of Tsuge's understated real-life tales. In *Red Flowers* (right), he depicts the anxieties of a 14-year-old girl reaching puberty, and in *Oba's Electroplate Factory* (far right) it is the daily grind of living and surviving that are scrutinized. Both were translated in *Raw*, Vol. 1, No. 7 and Vol. 2, No. 2.

Left: Shigeru Sugiura (1908–2002) described himself as a 'visionary cartoonist'. Popular in the 1950s and 1960s, he was rediscovered by the *Garo* artists of the next decade, who admired his unique approach to the medium. These are the closing pages of a special three-page story featuring his hero Jiraiya the Ninja Boy, which he drew for *Raw* magazine in 1984.

1 2

Two other influential innovators from the pages of *Garo* magazine. Far left: From 1968 to 1972 Yu Takita re-created his childhood experiences in his evocative series *Terashimacho Kitan*, or 'Singular Stories of the Terashima Neighbourhood'. Left: Now better known as an artist and illustrator, Maki Sasaki debuted in *Garo* in 1966 and explored the language of comics in her haunting short stories such as *My Fat Budgie*.

Above: Never have the sadistic and the grotesque been delineated with such razor-sharp precision and in such unrelentingly decadent detail as in the nightmare visions of Suehiro Maruo. **Right:** In *Putrid Night*, a jealous tyrannical husband punishes his young bride and her secret lover by amputating their arms, though even this cannot extinguish their lust for each other.

Right: In *Sewer Boy*, a baby flushed down a toilet by his mother grows up in the sewer and becomes a scatological psychopath. **Far right:** In *The Great Masturbator*, a boy becomes obsessed after being sexually aroused by his elderly aunt licking a stye in his eye. **Opposite:** Haunted by Japan's post-war trauma, Hideshi Hino depicts the deformed and demented in over 200 works in print, from his apocalyptic *Panorama of Hell* and *Hell Baby* to the folklore terrors of *The Red Snake*, which climaxes in an orgy of murder and mayhem.

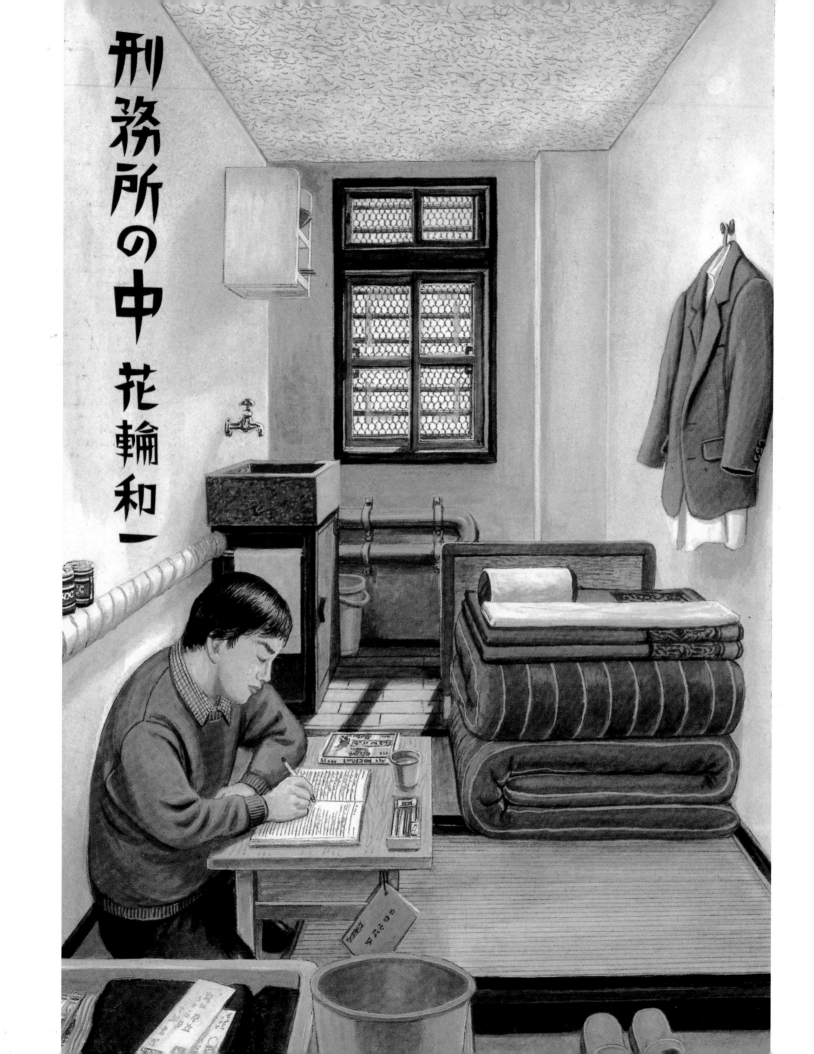

刑務所の中 花輪和一

Opposite and below: In December 1994 Hanawa was arrested and imprisoned for his hobby of collecting model guns. While in jail, he transcribed every repetitive and demeaning ritual in his manga *Doing Time*. Taken from the first instalment in *AX*, this two-page sequence shows his anguish at giving up smoking. His manga was later adapted into a film by director Tsutomu Yamazaki. Far left: Self-taught cult artist and self-confessed depressive Kazuichi Hanawa began his career in *Garo* in 1971 with macabre satires of Japan's decadent medieval aristocracy, drawn in period style. Left: Perhaps partly based on Hanawa's own rural childhood, *Kannomushi* ('Tantrum') is a strange portrait of a boy whose destructive behaviour fails to be cured by a sinister acupuncturist.

2 1

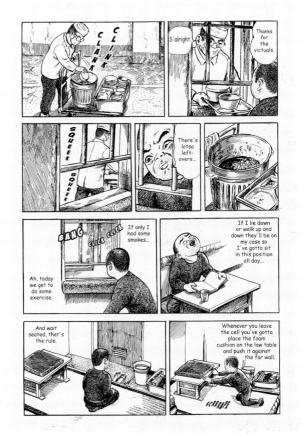

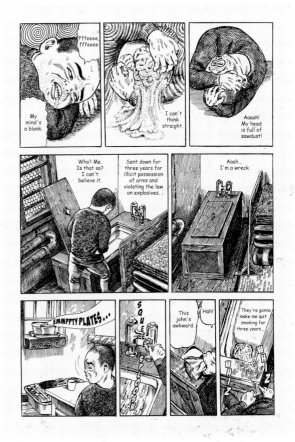

Pornographic manga for men can be inventive, arousing and outrageous in equal measures. The artist known as NeWMeN serves up a steamy teacher-pupil initiation (right), while in *Hot Tails* (above and far right) Toshiki Yui's five-way orgy features a man endowed with two penises. In Kondom's *Bondage Fairies,* how about sex between a nympho Tinkerbell and a randy squirrel (below right)? As for the future of sex, anything you desire is possible in Suehirogari's *Virtual Master* thanks to simulation 'love suits' (below far right). When erotic manga are translated, American publishers often ask the Japanese artists to draw in the genitalia and other details omitted in the originals. Publishers also add a notice that 'all characters... are aged 18 years of age or older. No actual or identifiable minor was used in the creation of any character depicted herein.'

In his lush ink washes and wordless panels, Hiroyuki Utatane eroticizes a Japanese myth about a virgin's first period and her deflowering by the dragon of the lake, creating a fusion of modern manga techniques with Japan's heritage of erotic prints.

Around the time of punk, the buzzword in manga was *heta-uma*, or 'unskilled/skilled'. A group of radicals in the late 1970s insisted that the balance had to be redressed to ensure that mere professional artistry did not drive all life and soul out of the medium. The movement's figurehead was 'Terry Johnson' (one of several aliases of Teruhiko Yumura), whose manic scrawlings energized the covers of *Garo* and *Comic Cue* (above) and inspired many others to let loose in a heady mix of *art brut*, children's daubs and toilet-wall lunacy. The zany conclusion to his *Shogun Tofu* (right) marked his debut in English in 1984's *Raw* magazine.

Nothing better symbolizes out-of-control lust in manga than *hana-ji*, or a dripping nosebleed. Top left: Yasuji Tanioka's crude and lewd humans and animals are always at the mercy of their libidos. Far left: Fired up by Terry Johnson's example, prolific Takashi Nemoto created his *art brut* physical comedies. Left and above: Leading painter and sculptor Makoto Aida had always wanted to draw manga and in 1999 created *Mutant Hanako*, a feverish revenge fantasy. Here his captured radioactive superheroine is brought to a phallic President Roosevelt hidden in the basement of 'The Black House'.

Right: Like a possessed Hello Kitty or the Powerpuff Girls on acid, the characters in the fractured fairytales of Junko Mizuno seduce with their perverse cuteness. Mizuno began her career with the rock magazine *H* and contributed to *Comic Cue*, where she illustrated *The Life of Momongo* (below far right) from a story by visual artist Norimizu Ameya. In her trilogy *Cinderalla* (sic), *Hansel and Gretel* and *Princess Mermaid*, she created her own bizarre spins on children's classics, all coloured in her distinctive pastel shades. Below and right: In a similar vein, the childlike appearance of Mimiyo Tomozawa's chubby-cheeked scamps in *Mushroom Travel* belies their extremely strange antics. Like a hallucinatory *Peanuts*, nothing is an innocent as it first seems.

Shu-kay ('Meeting') is an example of a *dojinshi* that does not parody existing characters but instead features original stories. Four young Tokyoites, two girls (Akiko Miura and Toriko) and two boys (Omuzi Suenaga and another using the Russian-sounding pen name Vassily Tabascova), started an 'underground manga' club in 1978, taking as their motto 'For Happy Life'. Shown above are three of their perfect-bound productions from 1985–87: Miura drew the covers of 4 and 6, Tabascova the cover of 5. After a visit to London, Anglophile Miura crafted a wry three-page portrait of 'Naive Young Matt' (top), a punk who doesn't understand punk, who poses for postcards and tourists and prefers Madonna and The Cure. His kindly landlady gives him some stew and over a footbath he thinks of his mum back in Glasgow.

Manga: Sixty Years of Japanese Comics

Above: Born in 1977, trained in contemporary art and as adept using a computer as working in conventional media, Kan Takahama is part of a new generation of mangaka. Acutely observant and with a sense of dialogue reminiscent of the films of Eric Rohmer, Takahama won a contest in *Garo* in 2000. Shown here are extracts from two of her surprising slice-of-life short stories collected together in *Kinderbook* (below). In *Red Candles, Futile Love* (right), the frissons between a young mother and a village fishmonger echo a local legend about a seductive mermaid with long black hair. In *Highway, Motel, Skyline* (below right), after her last day of high school Aiko is determined to go out on a date with her bleached-hair boyfriend, no matter what it may lead to.

2 1 ◀◀

2 1 ◀◀

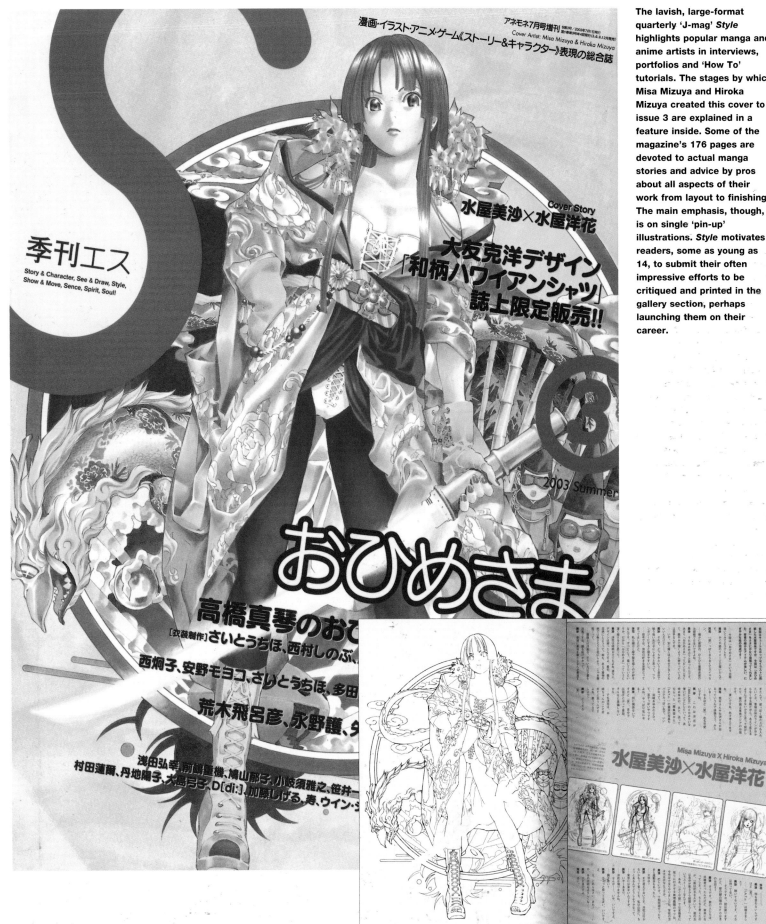

季刊エス
Story & Character, See & Draw, Style,
Show & Move, Sence, Spirit, Soul!

漫画・イラスト・アニメ・ゲーム《ストーリー&キャラクター》表現の総合誌

アネモネ7月号増刊 5第3刊／2003年7月1日発行
第1巻第3号年4回発行(3.6.9.12月発売)
Cover Artist: Misa Mizuya & Hiroka Mizuya

水屋美沙×水屋洋花 Cover Story

大友克洋デザイン
「和柄ハワイアンシャツ」
誌上限定販売!!

2003 Summer

おひめさま

高橋真琴のお

[衣装制作]さいとうちほ、西村しのぶ、

西炯子、安野モヨコ、さいとうちほ、多田

荒木飛呂彦、永野護、矢

浅田弘幸、前嶋重機、鳩山郁子、小岐須雅之、笹井一
村田蓮爾、丹地陽子、大島弓子、D[di:]、加藤しげる、寿、ウイン・シ

Misa Mizuya X Hiroka Mizuya

水屋美沙×水屋洋花

The lavish, large-format quarterly 'J-mag' *Style* highlights popular manga and anime artists in interviews, portfolios and 'How To' tutorials. The stages by which Misa Mizuya and Hiroka Mizuya created this cover to issue 3 are explained in a feature inside. Some of the magazine's 176 pages are devoted to actual manga stories and advice by pros about all aspects of their work from layout to finishing. The main emphasis, though, is on single 'pin-up' illustrations. *Style* motivates readers, some as young as 14, to submit their often impressive efforts to be critiqued and printed in the gallery section, perhaps launching them on their career.

Culture and Imperialism

WHO WOULD HAVE thought that Japanese comics could insinuate themselves so effectively into Western culture? That's how the upbeat media story goes anyway, cheering the recession-hit Japanese and unnerving some wary Westerners. The signs do seem to be everywhere. For the 2002 World Cup in Japan and Korea, both BBC Sports and sponsors Adidas chose to brand their coverage using manga graphics of football. You know that manga are spreading beyond the subculture cool of club flyers, computer games, music videos and fashion mannequins when they start being adopted by such bastions of tradition as London's English National Opera or Buxton Mineral Water, the official mineral water of the Wimbledon tennis tournament, or when a Paris mayor uses them to send New Year's greetings to his fellow citizens. Advertising agencies and art directors are clamouring for 'manga style'. Get them to define what they mean by this term, however, and it becomes apparent that all they want are manga's most instantly recognizable riffs used in the 'standard' look of Japanese animation. It's almost impressive how these 'taste-makers' have managed to boil such a diverse narrative medium down to a limited menu of its most superficial visual clichés.

That the reception of manga outside Japan should have been shallow and distorted ought to come as no surprise. Unlike Japanese cars, personal stereos and computers, manga were never conceived to be sold abroad. They started out as stylized stories and artworks for Japanese eyes only, culturally specific and rooted in shared values, created without regard to possible foreign responses to their treatment of sex, Christianity and other sensitive subjects. As for selling them abroad, why would any Japanese publisher bother when foreign markets for comics were so tiny by comparison with Japan's enormous home market, which seemed to be endlessly on the upsurge? Even now, after sales have levelled out somewhat, estimates put the annual turnover of the manga industry at $5 billion – that's around ten times the figure for comics across the whole of Europe.

Nonetheless, over the past decade both Japan and the West have woken up to the youth appeal of a certain sector of manga, anime, games and merchandising. According to a recent survey by the Marubeni Research Institute, exports of Japanese comics, films, art and video games leapt by 300 per cent between 1992 and 2002, where other sectors showed only 15 per cent growth. American culture may have dominated the world for most of the 20th century, but the 21st century is seeing a phenomenal boom in Japanese cultural exports, to the point where they are now nearly neck-and-neck with American ones. In recent years manga have become the fastest-growing category in American publishing. If we were looking for a 'winner' in an East versus West 'war' of cultural imperialisms, it might appear to be Japan. But is there really still a war to win?

Ironically, for decades, it proved nearly impossible to sell manga to the West. Xenophobia and trade protectionism were obviously significant obstacles; in addition, manga required costly practical modifications before they could be sold abroad. As well as the often formidable length of the works and the difficulties of translation, the panels need to be rearranged so they can be read from left to right. This is not just a matter of 'flopping' the entire page as if in a mirror, which can result in all the characters becoming left-handed or the folds and knots in traditional costumes being shown the wrong way round. On the other hand, if you keep panels 'unflopped' but reverse their sequence, characters can wind up speaking in the wrong order. It's little wonder that Western publishers balked initially at the challenges of adaptation; the last thing any of them expected was that readers would be prepared to read translated manga 'backwards'.

On the other hand, exporting Japanese animated cartoons required comparatively few, uncomplicated changes: new titles, dubbed voices, and perhaps the editing-out of violence to comply with foreign codes of content. This has proved to be a relatively cheap way of filling up children's TV schedules. But these anime broadcasts on TV primed viewers for eventual manga

Opposite: 'Otaku Culture Goes Out Into the World' – the story of manga's growing global exportation made the cover of *Newsweek* in Japan in 2003. Pictured is the warrior Keiji Maeda by Tetsu Hara. Right: Marianne, symbol of France, is given a New Year's manga makeover by 'Moko'. Below: For the 2002 World Cup, Adidas gathered together comics and pieces of illustration about football by artists from Japan, Korea and France in *Manga Fever* (cover by Katsuhiro Otomo shown here).

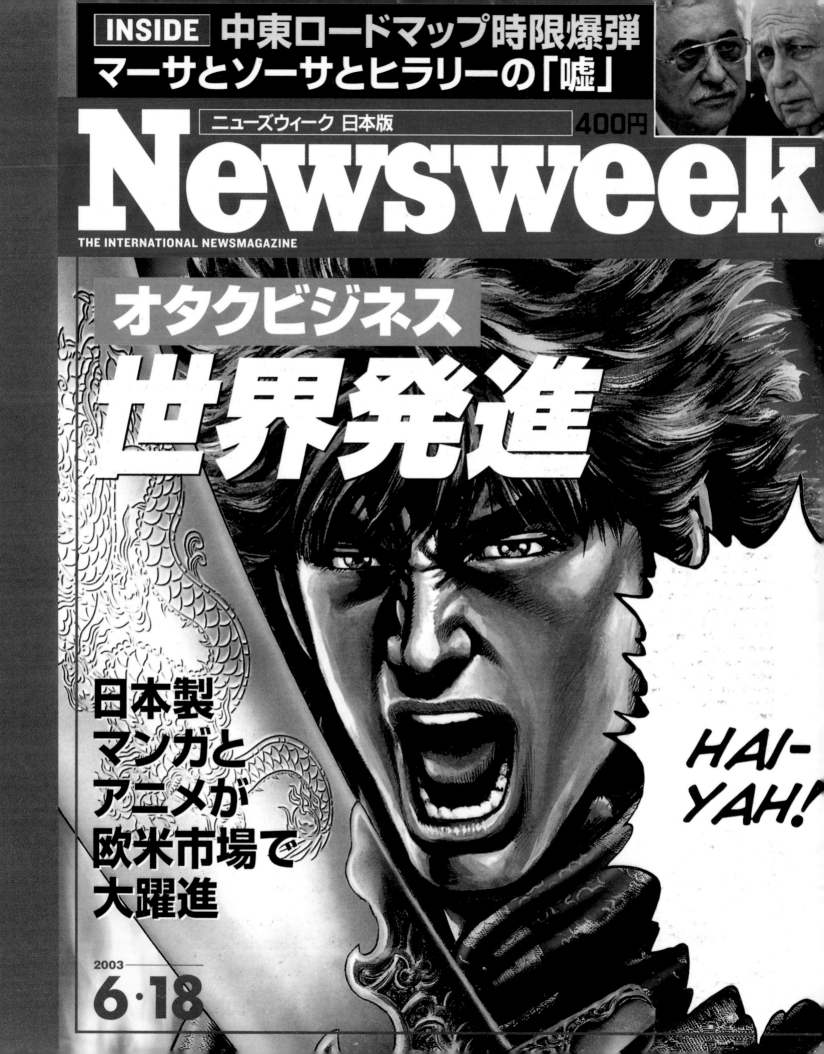

For years before real Japanese manga were exported, only locally produced versions of anime were available abroad. In France *Dorothée* cobbled together comics from stills of the TV cartoons, while Spanish artists redrew the stories for *Mazinger Z*; from 1976, six issues of *Le Cri Qui Tue* offered a taste of manga in French (below). But it was *Akira* (right) that opened the floodgates from 1988. For its Western premiere, Otomo's panels were computer-coloured by innovator Steve Oliff and Olyoptics.

consumption. This process might have started much sooner: in the US, youngsters watched *Astro Boy*, *Gigantor* and *Speed Racer* cartoons in the 1960s, but were offered no manga to read, with the exception of a single *Astro Boy* comic book produced in 1965 by a mediocre American team. A later effort, in 1987, at an American version of 'the original' *Astro Boy* was little better. Not until 2002 would Tezuka's true 'original' finally start to be translated into English.

Perhaps the earliest manga to appear in English were the bilingual colour comic-strip leaflets issued during World War II by the Japanese military to undermine enemy morale. One example showed a Western soldier's wife back home enjoying the advances of a leering stranger after being informed that her husband would never return. Whether such illustrated scenes caused any Allied troops to desert is unlikely, particularly as they had to compete with the gung-ho patriotism in American comic books. In fact, in this psychological warfare Japanese artists fought on both sides. Bob Fujitani, a half-Japanese New Yorker, joined the US Navy but after four months was discharged as 'unfit and undesirable'. Signing himself 'Fuje', he and his Japanese-American buddy Fred Kida contributed to the war effort by illustrating a flood of comic-book heroes beating up the Nazis and Japanese. Another example is cartoonist Taro Yashima. As an opponent of militarism, Yashima left his native Japan for America, where he devised comics for the government to drop onto his countrymen. In 1943 he also produced *The New Sun*, a 310-page account of the persecutions he and other dissidents endured during his last years in Japan. It was the powerful anti-war message in Keiji Nakazawa's *Barefoot Gen* which motivated a group of volunteer activists in Tokyo and San Francisco to publish it in English in 1978.

You might expect that manga would have been more easily exported to Japan's nearer neighbours in Asia. In fact, for years the manga published in Taiwan, Hong Kong, Thailand and elsewhere were frequently illegal pirated editions or redrawn copies. It was almost as if Japanese publishers were complacent about policing, let alone pushing, their product overseas. They changed that attitude only when the recession started to bite at home, beginning to crack down on the pirates and insisting on issuing official licences. Elsewhere Japanese publishers faced import bans, such as in South Korea, where anti-Japanese feeling ran deep due to the country's former occupation. Indeed, after the South Korean authorities in 1998 started to allow more Japanese popular culture into the country, the national comics, or *manwha*, profession called for protectionist restraints. The government refused but instead began the aggressive promotion of their

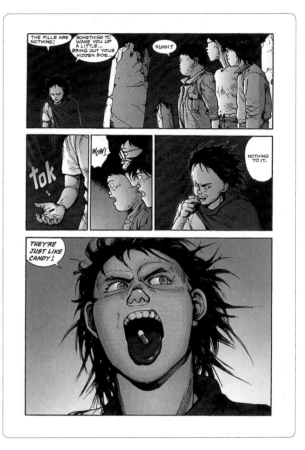

manwha abroad, which has resulted in Korean creators increasingly being translated, partly on the coat-tails of manga, as well as selling their works to Japan.

Cultural barriers existed in Europe too, where manga went unseen for years, despite the popularity of Japanese animated TV series based on them. In France, for instance, the Seventies girls' soap opera *Candy Candy*, the robot giant Grendizer (renamed Goldorak) and space pirate Albator, formerly Captain Harlock, enthralled a generation of kids. French publishers were keen to produce tie-ins, but were reluctant to pay for the rights to the manga. Their resistance may have been justified, since the Japanese comics did not always tell the same story as their anime adaptations or took a more adult approach. As a result publishers commissioned European artists to re-draw the stories in a European style or, even less satisfactorily, cobbled together cheapskate 'anime comics' using blurred stills photographed from the screen and superimposing hand-lettered dialogue balloons and captions. Elsewhere in Europe, kids weened on these crude patchworks from televised anime did go on to discover their 'real' manga counterparts in translation. It was the Italians, followed by the Spanish, who seemed to adopt the genuine article more readily. In Italy, the unregulated excess of private TV channels meant that 83

different anime series were broadcast between 1978 and 1983. Based on these, the always bustling Italian newsstands soon began to fill with genuine translated manga, for example *Candy Candy*, which in 1984 became the first manga export to catch on in Spain.

In America, pressure groups concerned about the level of violence in children's cartoons began forcing the networks to censor or reduce their anime programming. By the era of cable and video, those shows that were broadcast – *Star Blazers*, *Battle of the Planets*, *Robotech* and other SF series produced on the heels of *Star Wars* – were building strong followings. Despite this, comic-book publishers stuck resolutely to American imitations rather than printing the Japanese originals. But something had to change. By the mid-Seventies, when manga were selling more copies than ever in Japan, comic books were on the brink of extinction in America. Industry pundits forecast the worst because supermarket chains were replacing the traditional outlets of local Mom'n'Pop stores, and neither they nor the newsstands were keen on carrying such low-profit items as comic books. What saved them was a new distribution system which sold them only 'firm sale', with no risk of unsolds being returned, to a network of specialist stores supplying collectors. Though the superhero genre appealed most to buyers, this older, male-dominated audience proved large and dedicated enough to support translated manga too.

American fan-favourite Frank Miller had long enthused about *Lone Wolf and Cub* and its influence on his work. High on the success of his *Batman: The Dark Knight Returns*, Miller was the ideal choice in May 1987 to draw the cover and write an introduction to the debut issue of Kazuo Koike and Goseki Kojima's samurai epic from Chicago's First Comics. Comic book-sized but squarebound with card covers and 64 black and white pages, the first issue sold so well that it went through three printings. The second issue was over-printed by 50,000 copies but still had to be reprinted to meet demand. The same month saw California's Eclipse Comics strike with three manga in bi-weekly comic books. Editor Letitia Glozer explained: 'We wanted manga that weren't too Japanese or too American, and we wanted books from three different genres.' By 'too Japanese', she seems to have meant anything overly cartoonish or cute. Sanpei Shirato's *Kamui* shared *Lone Wolf*'s realistic illustration and violent action. Though no superheroine, Mai the Psychic Girl had to deal with her unexpected powers, a theme also found in

Marvel's mutants the X-Men. Mai's schoolgirl charm as drawn by Ryoichi Ikegami had a photorealist glamour inspired by American comics innovator Neal Adams. The big-eyed jet pilots in Kaoru Shintani's *Area 88* might have looked more jarring, but all three series needed second printings of their first two issues.

Following trailblazers First and Eclipse, in 1988 Marvel Comics caused a sensation by releasing Katsuhiro Otomo's *Akira*. Here was a manga that could truly 'cross over' to Western youth on a massive scale. It helped that Otomo's drawings looked less exaggerated and alien and that he had finished directing a costly, state-of-the-art animated feature in 1988 based on his story, which would go on release overseas from the following year. It also helped that *Akira* was received in the West as part of the 'cyberpunk' science-fiction trend led by William Gibson's *Neuromancer* from 1984. In fact, when Otomo began serializing *Akira* in *Young* magazine in 1984, he was unaware of Gibson's book, which was not translated into Japanese until 1985. Instead Otomo cited as an inspiration the earlier Japanese SF novels of Seishi Yokomizo and their preoccupation with 'new breeds' of humans mutating to adapt to volatile conditions. To preserve the clarity of Otomo's detailed illustrations, *Akira* was compiled in Japan in special oversized volumes. For its American release, Marvel kept this format and, with Otomo's approval, overlaid his monochrome, toned artworks with a rich colour palette that resembled the movie. In France and Belgium, in keeping with the local *bandes dessinées* tradition, *Akira* was published in eleven colour hardback albums of 200 pages each, over the course of just two years; in Germany, it went through three printings in the first year. Boosted by the film, *Akira*'s publication sent shockwaves worldwide.

Now 'flavour of the month', this nascent market was threatened in several countries by overproduction, poor editorial choices and translations, and prejudicial media coverage. It survived and prospered, nonetheless, by ensnaring further generations of young readers on the back of top-rating TV adaptations and computer games, as well as via the internet, as it became easier to view and download anime extracts or complete episodes, read manga samples and share discoveries, official or not, with global communities.

Manga appeal to people who are looking for something to claim as their own, something that their parents wouldn't approve of, let alone understand. As French publisher Jacques Glénat put it: 'Young people at

Above: Like movie ratings, TokyoPop put these handy advisories on the back covers of all their manga. Even so, manga's strong content can cause controversy in many countries. Recently, a Texan retailer was found guilty of selling obscene material when an adult manga (not a TokyoPop book) was bought from the adult section of his store by an adult police officer – the District Attorney convinced the jury that all comics are really intended for children. The Comic Book Legal Defense Fund mounted an appeal, but the Supreme Court failed to reverse the conviction. Left: Graphic-sha in Tokyo publish an extensive range of 'How To' manga guides, from tone techniques to luscious *bishojo* maids and military *mecha* machinery.

Manga: Sixty Years of Japanese Comics

Above: Veteran mangaka Yoshihiro Tatsumi, left, meets an admirer, Adrian Tomine, a Japanese-American cartoonist and editor of a new Canadian edition of his moving gekiga dramas. Right: This cute rabbit mascot was designed by Christina Plaka for Carlsen's German magazine for girls *Daisuki*, subtitled 'Mega-Manga-Mix für Mädchen'. Below: the first issues of two manga magazines in America: the weekly *Raijin Comics* from Gutsoon and the monthly version of *Shonen Jump* from Viz.

the age to consume comics are turning instead to television and video games. With manga and their rapid storytelling, we can win back the adolescent public. And if some people deplore it, I for one prefer to see kids queuing up outside manga shops than video-game stores.' Manga in the West are not just a boys' thing, but have also attracted teenage girls, a high-spending demographic that American publishers had all but abandoned. TokyoPop targeted this audience with shojo translations, and now 70 per cent of their readers are girls aged eleven to 17.

One significant shift has been Western publishers' and the public's embracing of the black and white compact paperback, the end product in Japan, as their format of choice. When Editions Glénat in France started publishing *Dragon Ball* this way every month in 1993, it became the company's biggest-selling title, with an average print run of 300,000 copies. The French market for manga paperbacks has expanded over the past seven years by 350 per cent; in Germany, manga have conquered more than half the market. American publishers took much longer to give up serializing stories in thin comic-book 'pamphlets'. TokyoPop, founded in 1996, took the lead in publishing manga directly as books, cunningly using the same proportions as DVDs so that they could be racked next to their anime versions; since 2003 Viz and most others have followed suit.

A more unexpected development in the West was the demand for 'unflopped' or '100 per cent authentic' manga. Initially, this seems to have come from the artists themselves, who were unhappy about the reversing of their artwork. For example, Blast Books honoured Hideshi Hino's wishes and issued his *Panorama of Hell* in 1989 in its 'original design' – they were possibly the first publishers to do so in America. In France, to keep Akira Toriyama happy, Glénat did the same in 1995 with his *Dr Slump*. Demand also grew from fans who wanted versions that were as close to the original as possible. This often means not translating or retouching any of the Japanese sound effects – integral hand-lettered elements of manga based on a vast vocabulary of onomatopeia and other words to

express moods and movements – but instead providing occasional explanatory notes or glossaries. Keeping manga 'authentic' not only saves on production costs, of course, but has the clever marketing attribute of turning them into a puzzle or secret language that baffles the understanding of parents. Retailers have been confused by them too and have been known to display manga with their back covers face out, or to return them, complaining that they are misprinted. Nevertheless, reading them from right to left is how more Westerners now consume manga, and how Japanese artists and publishers want them to.

The Western public is experiencing new manga quite differently from Japanese readers, because a complete story, which might have taken years to unfold first in magazine instalments in Japan, can be translated from start to finish over a much shorter period in monthly or bimonthly paperbacks. Originally serialized over seven years, all 28 of the 300-page volumes of *Lone Wolf and Cub* were issued by Dark Horse in the US over the course of just two years and four months. The rapid publication of such a vast accumulation of pages in book form makes manga seem even more enticing and immersive.

This may also explain why manga anthology magazines have had a difficult time in the West. The earliest of these, the sophisticated French-language *Le Cri Qui Tue*, published between 1978 and 1982 by Atoss Takemoto, a Japanese enthusiast living in Switzerland, was way ahead of its time. In America it was not until the 1990s that Viz tested the market with *Manga Vizion*, *Animerica Extra* and the adult *Pulp*, while TokyoPop started with *MixxZine*, the first magazine to offer 200 pages, and *Smile*, the first for girls; all these anthologies are gone now except Dark Horse's *Super Manga Blast*. There are two English-language titles which capture some of the quantity and quality of Japanese manga magazines, both offering 200 to 300 right-to-left pages: the American edition of *Shonen Jump*, published monthly by Viz, and the first ever manga weekly in America, *Raijin Comics*, initially published on a weekly basis by Gutsoon Entertainment in Tokyo. Of manga magazines in Europe, those in Germany have proven surprisingly successful, led by Carlsen's *Banzai!* for boys, essentially a German *Shonen Jump*, and *Daisuki* for girls. Their success may be explained by their knack for getting readers thoroughly involved, so that they feel the magazine belongs to them. Through talent searches, Carlsen hired two German teenagers, Robert Labs and Christina Plaka, to create new series to which readers can

submit story and design ideas. Now local stars, Labs and Plaka exemplify an important part of manga's appeal – the way they motivate fans throughout the West to try drawing their own and to dream of making a career out of them. All you need to do is buy enough of the manuals, the biggest-selling art-instruction books in years, and the proper pens and supplies and you too can become a mangaka. There is a real demand for Western artists who can draw in a 'manga style'. Seeing they were not reaching the manga audience, Marvel Comics in America went so far as to instigate 'Mangaverse' and 'Tsunami' lines based on their characters, while DC scored a surprise hit with Jill Thompson's manga-esque *Death* paperback. Whether any of these non-Japanese versions can strictly be called manga is a matter of contention. All too often, beneath outward appearances they reveal little understanding of manga's emphasis on pacing and psychology. To purists, they will never be more than pale imitations or 'pseudo-manga'; to others they only prove how multi-faceted manga's influence can be.

Any notion of manga's 'purity' starts to look flimsy anyway when you realize how strongly Japanese artists have been influenced by Western comics. The cross-currents between comics creators in Japan and those in the rest of world have flowed freely in both directions. Indeed, manga would not have continued to evolve as they have without enriching influences from 'outside'. Among mangaka, Jiro Taniguchi is not alone in describing his first exposure to French *bandes dessinées* or 'BD' (he is speaking particularly about the work of Jean Giraud aka Moebius) as being 'like a new view of the world opening up to me. I remember my astonishment at the realism in this type of comic, notably in depicting the characters and settings with a luxury of realistic detail that was unimaginable in manga of the period.' Applying these insights to his own work, Taniguchi went on to illustrate a manga written for him by Moebius and to become the first Japanese creator to win a coveted Angoulême Award at France's international comics festival in 2003. Taiyo Matsumoto was so impressed that he took off for France when he was 22 to learn about the aesthetics of BD.

The big European and American comics publishers have longed to sell their properties into Japan, but the results so far have been marginal at best. Instead it took a Japanese publisher, Kodansha, to try implanting foreign artists in Japan by signing them up to conceive new comics for *Morning* and *Afternoon*. There were grumblings that Japan was 'stealing' Western talent, but the last thing Kodansha wanted was for its recruits to ape manga; they wanted their fresh, distinctive styles to reinvigorate their titles so that they would perhaps be able to sell the results back to the West. Japan's very 'hands-on' editors proved something of a culture shock to artists used to being left alone or indulged, but many realized there was much to gain from the relationship and jumped at the chance to work on stories whose length would have been unthinkable in their homelands. Though none of these projects attained the success that Kodansha hoped for, they were harbingers of an open spirit of internationalism. Now Japanese artists are being hired to draw for American companies, and Shueisha in Tokyo and Dargaud in Paris are preparing joint Franco-Japanese productions.

For American Paul Pope, then only 24 years of age, his five-year Kodansha residency was unforgettable: 'World Comics, that's how the Japanese thought about it. They told me that their goal was to create a comics style that would be universal, the style of the 21st century understood by all readers.' Pope's work is one example of the unexpected hybrids springing up all over the world, from Frenchman Fréderic Boilet's *nouvelle manga* to the American online phenomenon *Megatokyo*. As artists combine the genes from manga, Euro-comics, American comics and other sources, rather than forging a single 'universal' style, they seem to be ushering in a post-imperialist, transnational culture of 'World Comics'.

The work of Japan's Taiyo Matsumoto and America's Paul Pope offers two prime examples of hybrid 'World Comics'. Matsumoto has specialized in stories of troubled kids, as in his story of two violent orphans known only as Black & White who prowl the rooftops (above and below), while life on Mars for an industrialist's daughter and her synthetic bodyguard THB is the subject of Pope's magnum opus (left).

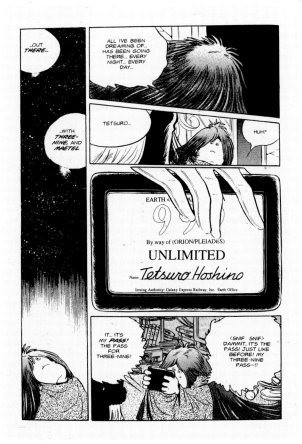

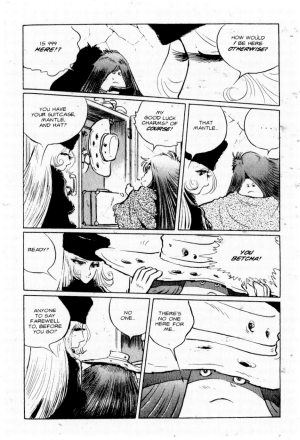

1 2

A direct heir of Tezuka, Leiji Matsumoto was one of the first creators in the 1970s whose manga and animation crossed over internationally. His scarred, stoic space pirate Captain Harlock (shown opposite) first sailed the sea of stars in the Arcadia in 1977 and was animated for TV a year later (opposite). Over the same period, Matsumoto created the loosely related *Galaxy Express 999* or 'Three Nine' (above), about the travels of orphan Tetsuro with the enigmatic Maetel on board an intergalactic train, here seen encountering Harlock. Matsumoto's patriotic 1974 SF anime *Space Cruiser Yamato* resurrected the sunken Japanese battleship Yamato as a starship and acquired cult status in America from 1979 under the title *Star Blazers*. French band Daft Punk were such fans that they commissioned Matsumoto to animate their music videos, compiled into the 2003 movie *Interstella 5555*.

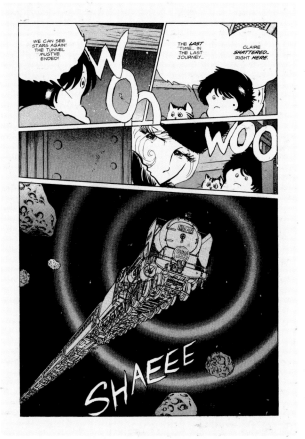

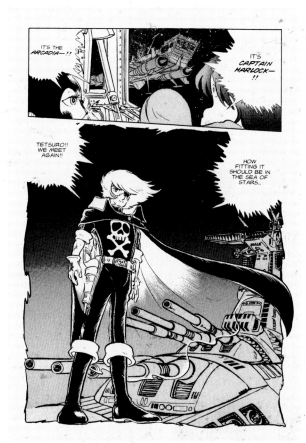

Manga: Sixty Years of Japanese Comics

Above and below: Worldwide, the look of manga is being copied by young fans-turned-pros. 'Manga Made in Germany' seem as popular as Japanese originals in German monthlies *Banzai!* and *Daisuki*. Right: Born in 1982, Robert Labs was 16 when he had his first short comics published. Now he is mobbed at the Frankfurt Bookfair and manga conventions for his space hero Crewman 3.

Right: In March 2002, publishers Carlsen Verlag awarded Christina Plaka second prize in their manga contest and gave her the chance to develop her first series for the girls' title *Daisuki*, a shojo rock'n'roll romance starring promising band Prussian Blue.

1 2

Left: A child of both Italian *fumetti* and anime, Vanna Vinci synthesizes manga with the elegance of Italy's Hugo Pratt, Gianni De Luca and other comics maestros in her visual storytelling. Her spooky mystery *Guarda che luna* ('Watch that Moon'), written by Giovanni Mattioli, was collected into a book in 1998 by 'the Kappa Boys', prime movers behind manga's success in Italy. Vinci was also one of the few Italian authors picked by Kodansha to be published in Japan.

In *L'année du dragon* ('The Year of the Dragon') (left) and *L'immeuble d'en face* ('The Building Opposite'), France's Vanyda Savatier, 23, adopts the willowy figure designs of Leiji Matsumoto's animation and applies manga's narrative codes and everyday themes to the *bandes dessinées* traditions she grew up with.

The illustrative aesthetics of French comics, or *bandes dessinées*, have been influencing manga since the Seventies. Right: With delicate clarity Jiro Taniguchi follows the story of a man who somehow returns to his chidhood with all his adult knowledge intact. Can the hero find out why his father disappeared and prevent it from happening again? With this tender story, Taniguchi was the first Japanese creator to win France's highest comics award at the Angoulême Festival.
Below right and far right: Also influenced by European uses of colour and form are Seizo Watase's Tintin-style *ligne claire* charm and Katsuya Terada's fully painted gothica *Neo Devilman* based on Go Nagai's creation.
Opposite: Following his artistic research throughout France when he was 22, Taiyo Matsumoto totally revised his approach. 'American comics are powerful and cool. European comics seem very intellectual. And Japanese comics are very light-hearted. If you could combine the best of all three, you could create some really tremendous work. That's my goal.' *Go-Go Monster* takes us inside a schoolboy's overactive imagination.

1　2

Above and right: What do you get when *bandes dessinées* meet manga? In Baru's social-realist road movie *L'Autoroute du soleil* ('Sunshine Freeway'), French-Algerian Karim Kemal and nerdy Alexandre escape their smalltown confines for the south of France. Exploring his characters across 430 pages, Baru's rare depth of characterization won him France's best album prize in 1996.

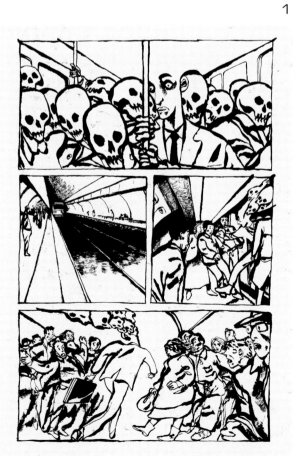

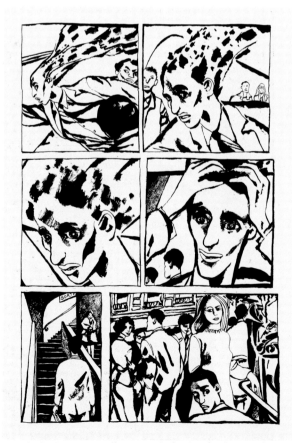

Above and right: For Kodansha, Edmond Baudoin expanded a comic he had written about a man under such pressure from life that he abandons his work and family and disappears – a common phenomenon in Japan. Baudoin's expressionist brushstrokes visualize his protagonist's mental states on his voyage of renewal.

Left and above: Could this giant electronic genie be the child-minder of the future? In Beb Deum's hyper-realist tableaux, a demanding little Japanese girl pesters her virtual child-minder, e-dad.

1 2

2 1

Left: Reading between the lines, a stream of complaints to a local mayor gradually reveal the correspondent's psychopathic delusions caught in Alex Barbier's frank and unsettling painted panels in *Lettres au Maire de V.* ('Letters to the Mayor of V.').

Finally she was called for questioning by the Tokkoka. I said to myself, "If it will help to set her free, I will stay here for another month, two months, half a year."

Suddenly I heard her voice from somewhere upstairs, screaming, screaming.

The sound set me afire. New baby, unborn baby, your father, can do nothing for you now. Please don't stop living!

1 2 3

Above: The comics by Japanese artists living outside Japan reveal local themes and influences. In the 1930s, Taro Yashima and his pregnant wife had been imprisoned as anti-militarist dissidents in Japan. Exiled to America, Yashima recalled the trauma he felt hearing his wife being questioned in this extract from *The New Sun*, a plea for Americans to understand that not all Japanese supported the war that was published in New York in 1943. Yashima produced over 300 illustrations using his expressive Van Gogh-like brushstrokes.

Right: During World War II, the half-Japanese, half-Irish American citizen Bob Fujitani drew such patriotic musclemen as Shock Gibson, Master of Electronics in the bold pulp style of the times. Here Gibson is seen saving his buddies from a Japanese ambush in issue 38 of *Speed Comics*, published in May 1945. Far right: The largest concentration of Japanese outside of Japan is in Sao Pãolo, whence some of Brazil's most gifted comic artists have emerged. Julio Shimamoto has been contributing since the 1950s to the country's horror genre, continuing in the vein of such imported American comics as *Tales from the Crypt*. Here he introduces a band of samurais as the victims of his twist-ending chiller.

WE KNEW WE WERE DIFFERENT FROM THE OTHERS. ESPECIALLY WHEN THEY GAVE US WEIRD LOOKS.

BUT HAVE THEY EVER THOUGHT...

OF HOW NICE IT WOULD BE

TO BE ABLE TO HUG OR TO BE HUGGED BY MOM AT THE SAME TIME,

TO HAVE A SISTER WHO'S ALWAYS THERE FOR YOU,

Far left: Among current artists of Japanese origin working abroad is Yuko Shimizu in New York. She brings an illustrator's freshness to her tale of separated Siamese twins in *New Thing*. Left: Over the course of ten issues of *Pause*, Mitsuba Wajima and 'Chiwawa' relate the 'coming out' in London of Japanese art student Kaito. Below: In *White on Rice* from *Optic Nerve*, Japanese-American Adrian Tomine shows how deep old prejudices run when a Korean lesbian gets her Japanese friend to pretend to be her boyfriend in order to fool her parents.

Beyond the simple adoption of their graphic conventions, manga are having more subtle effects on some Western creators. Right: The storytelling insights he picked up working for Kodansha for five years have energized American Paul Pope's 'World Comics'. Here his schoolgirl heroine H.R. Watson drops a small ball into water to reconstitute her rubbery guardian, THB, who has been concentrated within. Below: Both the works of Rumiko Takahashi and those of Seizo Watase inform Englishman Andi Watson's series, from the teenage troubles of living with a fox-spirit friend in *Skeleton Key* (left) to budding android artist *Geisha* (right).

1 2

Yukiko...

You knew I was in love with you, right?

What a funny question... since you already know the answer.

Aren't you a little strange today?

No... It's just that... I wondered...

Who am I gonna draw when you're no longer here?

1 2
3 4

I haven't exactly disappeared yet!

I mean. I started this story with your face...

... So what am I gonna do when you don't want me anymore?

Well I guess you'll have to start all over again from the beginning!

Mmm!

Eeee!

The *nouvelle manga* 'movement' was born in Japan in 2001 from Frédéric Boilet's picture stories, a mixture of characteristics from *bandes dessinées* and manga. The style is reminiscent of French *nouvelle vague* art cinema, which is very popular in Japan. Above and left: Boilet's *Yukiko's Spinach* is a sensual love story about a relationship between his alter ego, a French comic artist living in Tokyo, and his model. As a creator, translator and promoter of the form, Boilet believes that French and Japanese comics set in the universal realm of daily life, be it autobiography, documentary or fiction, can speak across any cultural barriers. 'At least half of manga tell stories of men and women and their everyday lives. For me this is the principal reason for manga's success in Japan with a broad range of open-minded people who read comics as they would read novels or go to the cinema. By creating a bridge between the two genres, the goal is to present readers with the best of the two countries' BDs and manga, and not just what sells the most.'

Below: Born in Bangkok, Thai-American artist Pop Mhan exemplifies the smooth blending of American superheroics with Japanese action manga in *Spyboy*, written by Peter David.

Below: Influenced by the frank autobio comics of French-Canadian Julie Doucet, Toko records her fantasies and reactions to the strangeness of living with the British in *Japanize*.

Above: In the internet era everything can connect. When Berlin-based collective Moga Mobo met Tokyo artist group NouNouHau (as in 'New Knewhow'), they found that they had so much in common that they decided to come up with a bilingual Japanese/German one-of-a-kind jam issue.
Right: One of the NouNouHau crew known as 'Smelly' has his own action figure with Afro wig and raygun accessories.

アレキサンダーアンギノアの禁断の銀河による

南蛮画
NAMBANGA
ナンバンガ
vol.1

Quality, quirky, kutting edge graffik entertainment by over 60 artists from 23 countries.
23ヶ国、60人を超すアーティストの、素晴らしくてヘンテコな最先端の視覚的エンターテインメント。

メガトーキョー
megatokyo
story & art
fred gallagher ② co-creator
rodney caston

We have the technology. Above: In London, Japanese VJ Tak Ryusa Narita's computer-generated eco-fairytale *Jungle Co* came in a digitally printed limited edition. Far left: In Tokyo Alexander Unginor and Forbidden Galaxy united 'kutting-edge komix' from Japan and 22 other nations online and on the CD-Rom *Nambanga*. Left: Americans Fred Gallagher and Rodney Caston co-created the webcomic sitcom *Megatokyo*. Posting a fresh page three times a week won them a sizeable global fanbase keen to read it offline, in book form – 'Do you want to save before you quit?'

Resources

Books

Allison, Anne: *Permitted & Prohibited Desires: Mothers, Comics, and Censorship in Japan*, Westview Press, Boulder, 1996.

Berndt, Jaqueline: *Das Manga Phänomenon*, Edition Q, Berlin, 1995. (Spanish edition: *El fenómeno manga*, Martínez Roca, Barcelona, 1996.)

Clements, Jonathan, and Motoko Tamamuro: *The Dorama Encyclopedia – A Guide to Japanese TV Drama since 1953*, Stone Bridge Press, Berkeley, 2003.

DesignEXchange Company Limited (eds): *Japanese Comickers*, Harper Design International, New York, 2003.

Drazen, Patrick: *Anime Explosion!*, Stone Bridge Press, Berkeley, 2003.

Glickman, Adam (ed.): *Sake Jock*, Fantagraphics, Seattle, 1995.

Groensteen, Thierry: *L'univers des mangas*, Casterman, Tournai, 1991.

Horn, Maurice (ed.): *The World Encyclopedia of Comics*, Chelsea House Publishers, New York, 1976; updated edition 1998.

Hosogaya, Atsushi (ed.): *A Guide to Books on Japanese Manga*, The Society for Manga Studies – www.kyoto-seika.ac.jp/hyogen/ gaikoku/ book_guide.htm, Yokohama, 2002.

Kinsella, Sharon: *Adult Manga: Culture & Power in Contemporary Japanese Culture*, Curzon, Richmond, Surrey, 2000.

Kiyama, Henry: *The Four Immigrants Manga*, translated and with notes by Frederik L. Schodt, Stone Bridge Press, Berkeley, 1998.

Korea Culture & Contents Agency (ed.): *La Dynamique de la BD Coréenne: Catalogue of the Manwha Exhibition*, KOCCA, 2003.

Lent, John (ed.): *Illustrating Asia: Comics, Humour Magazines and Picture Books*, Curzon, Richmond, Surrey, 2001.

Lent, John (ed.): *Themes and Issues in Asian Cartooning: Cute, Cheap, Mad and Sexy*, Popular Press, Bowling Green, 1999.

Lowe, Adam (ed.): *Radical Boredom: Manga Books from Japan*, Lowe Culture, London, 1991.

Lu, Alvin (ed.): *Fresh Pulp: Dispatches from the Japanese Pop Culture Front (1997–2000)*, Viz Communications, San Francisco, 1999.

Luyten, Sonia: *Mangá, o poder dos quadrinhos japoneses*, Hedra, São Paulo, 1999.

McCarthy, Helen: *Hayao Miyazaki, Master of Japanese Animation*, Stone Bridge Press, Berkeley, 1999.

— and Jonathan Clements: *The Anime Encyclopedia*, Stone Bridge Press, Berkeley, 2001.

Moliné, Alfons: *El Gran Libro de los Manga*, Ediciones Glénat, Barcelona, 2002.

Narita, Hyoe (ed.): *Secret Comics Japan: Underground Comics Now*, Viz Communications, San Francisco, 2000.

Natsume, Fusanosuke, and Atsushi Hosogaya: *Manga: Short Stories from Modern Japan*, The Japan Foundation, London, 2001.

Perper, Timothy, and Martha Cornog: *Eroticism for the Masses: Japanese Manga Comics and their Assimilation into the U.S.*, Sexuality & Culture, Volume 6, Number 1, Transaction Periodicals Consortium, New Brunswick, 2002.

Quigley, Kevin (ed.): *Comics Underground Japan*, Blast Books, New York, 1996.

Sawa, Fumiya, Kyoichi Tsuzuki and Mark Sanders (eds): *Reflex: Contemporary Japanese Self-Portraiture*, Trolley, London, 2003.

Schodt, Frederik L.: *Manga! Manga! The World of Japanese Comics*, Kodansha International, Tokyo, 1983.

—, *Dreamland Japan: Writings on Modern Manga*, Stone Bridge Press, Berkeley, 1996.

Silverman, Laura K. (ed.): *Bringing Home the Sushi: An Inside Look at Japanese Business through Japanese Comics*, Mangajin, Atlanta, 1995.

Suvilay, Bounthavy (ed.): *AnimeLand: Hors-série No. 5*, Anime Manga Presse, Paris, 2003.

Thorn, Matt: *Four Shojo Stories – Introduction*, Viz Communications, San Francisco, 1996.

—, 'Girls and Women Getting Out of Hand: The Pleasure and Politics of Japan's Amateur Comics Community', in William W. Kelly (ed.), *Fanning the Flames: Fandoms and Consumer Culture in Contemporary Japan*, State University of New York Press, New York, 2004.

Vaz, Mark Cotta (ed.): *Visions of the Floating World*, Cartoon Art Museum, San Francisco, 1992.

Wong, Wendy Siuyi: *Hong Kong Comics: A History of Manwha*, Princeton Architectural Press, New York, 2002.

Magazines and Journals

Animerica, Viz Communications, San Francisco; www.viz.com

Calliope, Semic, Paris; www.semic.com

Comics International, Quality Communications, Brighton; www.comics-international.com

The Comics Journal, Fantagraphics, Seattle; www.tcj.com

Giant Robot, Giant Robot, Los Angeles; www.giantrobot.com

International Journal of Comic Art, John Lent, Drexel Hill; www.ijoca.com

9eme Art, Editions de l'An 2/Centre National de la Bande Dessinée et de l'Image, Angoulême; www.editionsdelan2 and www.cnbdi.fr

NewType USA, NewType USA, Inc., Houston; www.newtype-usa.com

Raijin Game & Anime, Gutsoon! Entertainment, Inc., Tokyo; www.raijincomics.com

Virus Manga, Anime Manga Presse, Paris; www.animeland.com

No longer published but still available as back issues: *Amazing Heroes*, *Anime UK*, *Anime FX*, *Comic Collector*, *Comics Interview*, *Comic World*, *Mangajin*, *Manga Mania*, *Manga Max*, *Pulp*.

Manga books are increasingly being stocked by bookshops and public libraries in the West. The largest range is usually to be found in specialist comic shops. Manga in Japanese can be found in Japanese bookshops in most cities and are also accessible in e-book form, for example from http://bb.10daysbook.com/shop/.

Websites

Go to any good search engine and type in the name of an artist, character or publisher and you're likely to discover a profusion of

websites. Listed below are some useful ones.

Japanese publishers

Akita Shoten – www.akitashoten.co.jp
Hakusensha – www.hakusensha.co.jp
Kodansha – www.kodansha.co.jp
Ohzora – www.ohzora.co.jp
Seirindo – www.digigaro.co.jp
Seirinkogeisha – www.seirinkogeisha.com
Shinshokan – www.shinshokan.jp
Shobunkan – www.shobunkan.com
Shodensha – www.shodensha.co.jp
Shogakukan – www.shogakukan.co.jp
Shueisha – www.shueisha.co.jp
Tokuma Shoten – www.tokuma.jp

Japanese publishers with English-language pages

Kodansha – www.KodanClub.com (catalogue,
 previews and story synopses)
Shogakukan – www.shogakukan.co.jp/
 english/htm/m_manga.html (A–Z by author and title)
Shueisha – www.shonenjump.com (American monthly edition)

English-language manga publishers

ADV – www.advmanga.com
Blast Books – www.blastbooks.com
Broccoli Books – www.broccolibooks.com
ComicsOne – www.comicsone.com
CPM Press – www.centralparkmedia.com
Creation Books – www.creationbooks.com (Maruo)
Dark Horse Comics – www.darkhorse.com
DC Comics – www.dccomics.com (Gon)
Del Rey Books – www.randomhouse/delrey/manga
DH Publishing – www.dhp-online.com (Hino)
Drawn & Quarterly – www.drawnandquarterly.com (Tatsumi)
Digital Manga Publishing – www.emanga.com
EduComics – rifas@earthlink.net (Keiji Nakazawa)
Eros Comics – www.eroscomix.com
Fantagraphics – www.fantagraphics.com (Sake Jock, Tsuge)
Graphicsha – www.graphicsha.co.jp (How To books)
Gutsoon Entertainment – www.raijincomics.com
ibooks – www.komikwerks.com (Taniguchi)
Ironcat – www.ironcat.com
Kodansha International – www.thejapanpage.com
Last Gasp – www.lastgasp.com (Keiji Nakawzawa)
Ponent Mon – www.ponentmon.com
TokyoPop – www.tokyopop.com
Vertical – www.vertical-inc.com (Tezuka)
Verotik – www.danzig-verotik.com (Devilman)
Viz Comics – www.viz.com

Worldwide, thousands of artists are creating their own imitations
and interpretations of manga, online and in print. Here are few
American sites to start your exploring:
Antarctic Press – www.antarctic-press.com
Dynamanga – www.dynamanga.net
Megatokyo – www.megatoyko.com
Oni Press – www.onipress.com

Information sites

Many of these are crammed with facts and offer portals to
plentiful links for hours of surfing. Bear in mind that sites come
and go.

www.anipike.com. Massive list of links.
www.artistic-inks.net. News, reviews with shonen bias.
www.callenreese.com/mangayomi.html. Shojo manga.
www.comiket.co.jp. Comiket home page.
www.comiketservice.com. Dojinshi mail-order service.
www.faqs.org/faqs/manga/guide/. Steve Pearl's three-part guide.
www.finalmanga.net. Reviews and articles in French.
www.geocities.com/ omuniversity/. Online Manga University.
www.hikyaku.com/manga/mangag.html. Sites in Japan translated.
www.howtodrawmanga.com. Range of instruction manuals.
www.lib.umd.edu/prange/index.jsp. The Gordon W. Prange
 Collection, 1945–49.
www.mangabonbons.net. Specializing in shojo and boy's love.
www.mangacenter.com. Search engine for books.
www.matt-thorn.com. Insights and essays on shojo, redikomi and
 other manga.
www.oop-ack.com/manga/soundfx.html. Dictionary of sound
 effects and what they mean.
www.worldfamouscomics.com. 143 creators' links.
http://otakuworld.com/. Includes thematic guide.
http://users.skynet.be/mangaguide/mangap.htm/. A–Z of authors.

Some creators' websites

Tetsuya Chiba – www.aruke.com/tetsuya
Clamp – www.clamp-net.com
Hiroshi 'Fujiko' Fukimoto – www.dora-world.com
Riyoko Ikeda – www.ikeda-riyoko-pro.com
Takehiko Inoue – www.itplanning.co.jp
Go Nagai – www.d-world.jp
Monkey Punch – www.monkeypunch.com
Osamu Tezuka – www.tezuka.co.jp

Museums and Archives in Japan

Contemporary Manga Library: Naiki Collection
 Established in 1978 with the collection of Chief Librarian Mr
 Naiki, the collection now exceeds 130,000 items, including rare
 rental-library and red-book manga; www.naiki-collection.com.
Hasegawa Machiko Memorial Museum of Art
 The personal museum of the creator of *Sazae-san*, displaying
 her original comic strips; www.city.setagaya.tokyo.jp/english.
Kawasaki Shimin Museum
 Opened in 1988, this houses the collection of manga scholar
 Suyama Keiichi, sketches by Yoshiharu Tsuge and extensive
 cartoon and comic archives, and organizes annual temporary
 and touring exhibitions; kcm-gaku@rp.catv.nejp.
Omiya Municipal Cartoon Art Museum Manga – Kaikan
 On the site of Rakuten Kitazawa's home, the museum
 holds regular exhibitions, conferences and a festival;
 www.city.omiya.saitama.jp.
The Osamu Tezuka Manga Museum
 In 1994 in Takarazuka, the city where Tezuka grew up, a
 museum opened to exhibit his original artwork, early sketches
 and rare editions and to celebrate his work via an interactive
 attraction; www.city.takarazuka.hyogo.jp/tezuka.
Yokoyama Museum
 A collection of thousands of paintings and materials by Ryuichi
 Yokoyama of *Fuku-chan* fame and a recreation of his studio
 opened in 2002 in his native city of Kochi; www.i-
 koichi.pr.jp/hp/bunshin.

Thanks

First and foremost, I want to
thank Peter Stanbury, Ian
Rakoff, Robert Shore and Kim
Sinclair for their inspiration,
motivation and patience in
helping me to start and finish
this book, and Kazuyo Yasuda
and Mitsuba Wajima for all
their cross-cultural assistance.
I am also enormously grateful
to the following for their
help and support: Mitsuhiro
Asakawa, Tony and Carol
Bennett, José-Maria
Berenguer, Jaqueline Berndt,
Frédéric Boilet, Jonathan
Clements, Martha Cornog,
Philip Dodd, Heike Drescher,
John Dunning, Steve Edgell,
Chelsey Fox, Clive France,
Erick Gilbert, everyone @
Gosh, Shinobu Hanashima,
Kinko Ito, Jean-Paul
Jennequin, Sharon Kinsella,
Andrzej Klimowski, Maki
Kusumoto, Matthew Lane,
Kelvin Lee, John Lent, Adam
Lowe, Sonia Luyten, Marc &
Montse @ Magma, Steve
Marchant, Helen McCarthy,
Stephen McEnally, Alfons
Moliné, Hyoe Narita,
Fusanosuke Natsume, Silke
Niehusmann, Kosei Ono,
Natsu Onoda, Naoya Otsuka,
John Parker, Didier
Pasamonik, John Parker,
Timothy Perper, Neil Rae, Eric
Reynolds, Stephen Robson,
Roger Sabin, Megumi Sako,
Matthias Schneider, Frederik
L. Schodt, Danni Segal,
Simona Stanzi, Fredrik
Stromberg, James Swallow,
Pierre-Alain Szigeti, Akito Tani,
Louise Tucker, David
Wybenga, Marilyn Yamada,
Akiko Yanagisawa, Megumi
Yoshinaka.

Acknowledgements

Copyright credits are listed by page number and, where there is more than one on a single page, clockwise starting with A from the top left. Creators' names may be followed by those of the Japanese publishers who originally published their works.
T = Translated version.

INTRODUCTION 8: B © United States Marines–William H. Wise. 9: A Photo © Fredrik Strömberg; B © Keiji Nakazawa/ Shueisha Inc., T © Last Gasp and Project Gen.

CHAPTER 1 10: Photos © Fredrik Strömberg. 11: © Makoto Kobayashi/ Kodansha. 13, 14 & 15: Photos © Fredrik Strömberg. 16: A © Kentaro Takekuma and Koji Aihara/ Shogakukan; B © Keiji Nakazawa/ Shueisha Inc., T © EduComics. 17: © Eiichiro Oda/ Shueisha Inc.

CHAPTER 2 18: © Katsushika Hokusai. 19: © Suiho Tagawa/ Kodansha. 20: A & B © Kiseki Ejima; C © Charles Wirgman. 21: A & B © Rakuten Kitazawa; C and D © Ryuichi Yokoyama. 22: © Suiho Tagawa/ Kodansha. 23: © Henry (Yoshitaka) Kiyama, T © Fredrik L. Schodt/ Stone Bridge Press.

CHAPTER 3 24–31: © Tezuka Productions, All Rights Reserved. 32 & 33: © Tezuka Productions, All Rights Reserved © Dark Horse Comics. 32: Photo © Natsu Onoda. 34 & 35: © Tezuka Productions, All Rights Reserved, T © Viz Communications. 36 & 37: © Tezuka Productions, All Rights Reserved, T © Vertical Inc.

CHAPTER 4 38: © Omachi-Town All Rights Reserved. 39: © Yoshihiro Tatsumi. 40: © Tetsuya Chiba. 41: A © Takao Saito; B © Yoshiharu Tsuge. 42: © Sanpei Shirato. 43: A & B © Sanpei Shirato/ Seirindo; C © Yoshiharu Tsuge/ Seirindo; D © Shigeru Mizuki/ Seirindo; E © the artist/ Seirindo. 44: © Yoshihiro Tatsumi, T © Catalan Communications. 45: A & B © Yoshihiro Tatsumi; C & D © Yoshihiro Tatsumi, T © Catalan Communications. 46: © Sanpei Shirato/ Seirindo. 47: © Sanpei Shirato/ Shogakukan, T © Viz Communications. 48: A © Shigeru Mizuki/ Kodansha International; B © Shigeru Mizuki/ Seirindo; C © Shigeru Mizuki. 49: © Shigeru Mizuki, T © Kodansha International. 50 & 51: © Tezuka Productions, All Rights Reserved, T © Viz Communications.

CHAPTER 5 52: A Photo © Fredrik Strömberg; B Photo © Tetsuya Chiba. 53: © Nobuhiro Watsuki/ Shueisha Inc. 54: A © Takao Yaguchi/ Kodansha; B © Tetsuya Chiba/ Kodansha. 55: A © Inoue Takehiko-IT Planning Inc.; B & C © Yoichi Takahashi/ Shueisha Inc.; D © Shinji Saijyo, T © ComicsOne. 56: A © 1975–1976

Go Nagai/ Dynamic Planning Inc. All Rights Reserved; B © Mitsuteru Yokoyama; C © Shogakukan; D © Kodansha. 57: A © Koichi Yamato/ Kodansha; B © Buichi Terasawa/ Shueisha Inc.; C © Sotsu Agency/ Sunrise. 58: A © Buronson/ Tetsuo Hara/ Coamix Inc.; B © Hiro Mashima/ Kodansha; C © Fukio Akatsuka/ Kodansha International. 59: A © Bird Studio/ Shueisha Inc.; B © Shogakukan; C © Akita Shoten; D © Kodansha. 60 & 61: © Tetsuya Chiba/ Asao Takamori/ Kodansha. 62: A © Shotaro Ishinomori; B © Shotaro Ishinomori/ T © TokyoPop. 63: A © Tsuburaya Productions/ Shogakukan; B © Yudetamago/ Shueisha Inc.; C © Noboru Sakaoka/ Shogakukan. 64 & 65: © Keiji Nakazawa/ Shueisha Inc., T © Last Gasp & Project Gen. 66: A & B © 1979–1981 Go Nagai/ Dynamic Planning Inc. All Rights Reserved; C © Kazuo Umezu/ Shogakukan; E © Tatsuhiko Yamagami/ Akita Shoten. 67: © Hiroshi 'Fujiko' Fujimoto, T © Shogakukan. 68 & 69: © Tezuka Productions, All Rights Reserved, T © Viz Communications. 70: © Bird Studio/ Shueisha Inc., T © Viz Communications. 71: A, B, D, E & F © Bird Studio/ Shueisha Inc., T © Viz Communications; C © Pokémon Properties. 72: A © Hiroyuki Takei/ Shueisha Inc., T © Viz Communications; B, C & D © Kazuki Takahashi/ Shueisha Inc., T © Viz Communications. 73: A © Masahi Kishimoto/ Shueisha Inc., T © Viz Communications; B © Eiichiro Oda/ Shueisha Inc., T © Viz Communications; C & D © Hajime Ueda/ Gainax, T © TokyoPop.

CHAPTER 6 74: A © Mihou Kotou/ My Birthday Comics; B © Waki Yamato, T © Kodansha International. 75: © Naoko Moto/ Akita Shoten. 76: A © Shosuke Kurogane; B, C & D © Machiko Hasegawa, T © Kodansha International. 77: A © Takarazuka Productions; B © Kodansha; C © Shogakukan. 78: A © Naoko Takeuchi/ Kodansha, T © TokyoPop; B © Suzue Michi/ Hakusensha 79: A © Takao Shigemitsu/ Akita Shoten; B © Riyoko Ikeda Productions. 80: A © (Magajin Magajin) San [Sun] Shuppan; B © Riho Sachima/ Akita Shoten; C © Akita Shoten. 81: A © Akita Shoten; B © Miwa Ueda/ Kodansha, T © TokyoPop. 82: © Tezuka Productions, All Rights Reserved, T © Kodansha International. 83: © Tezuka Productions, All Rights Reserved. 84: © Mayumi Muroyama/ Shogakukan. 85: A © Kimiko Uehara/ Shogakukan; B © Chieko Hosogawa/ Akita Shoten; C & D © Kazumi Umekawa/ Coamix Inc.; E © Natsumi Ando/ Kodansha. 86 & 87 © Riyoko Ikeda Productions, All Rights Reserved. 88: © Moto Hagio/ Shogakukan. 89: © Keiko Takemiya/ Hakusensha. 90: A & B © Yasuko Aoike/ Akita Shoten; C © Mineo Maya/ Hakusensha; D

© Ozaki Minami/ Shueisha Inc.; E © Akimi Yoshida/ Shogakukan, T © Viz Communications. 91: A, B & D © Marimo Ragawa/ Hakusensha; C © Be x Boy/ Biblios. 92: © Suzue Miuchi/ Hakusensha. 93: © Kyoko Ariyoshi/ Akita Shoten. 94: © Setona Mizushiro/ Akita Shoten, T © TokyoPop. 95: A, B & C © Wataru Yoshizumi/ Shueisha Inc., T © TokyoPop; D, E & F © Reiko Momochi/ Shodensha, T © TokyoPop.

CHAPTER 7 96: A © Monkey Punch/ Chuokoron-Shinsha Inc., T © TokyoPop; B © Tsukasa Hojo/ Coamix Inc. 97: © Masamune Shirow. 98: A © Kodansha; B © Shogakukan; C © Takao Saito/ Leed Publishing; D © Kazuo Koike & Ryoichi Ikegami/ Shogakukan, T © Viz Communications. 99: © 'Oh! Great!'/ Shueisha Inc. 100: A © Kazuhiro Kiuchi/ Kodansha; B © Tohru Fujisama, T © TokyoPop; C © Sukebe; D © Kazuo Koike & Seisaku Kano/ Shogakukan; E & F © Kazuo Koike & Ryoichi Ikegami/ Shogakukan, T © Viz Communications. 101: A © Hirohiko Araki/ Shueisha Inc.; B © Chen Weng/ Kodansha. 102: A & B © Monkey Punch/ / Chuokoron-Shinsha Inc., T © TokyoPop; C, D & E © Takao Saito, T © Leed Publishing. 103: A & B © Sho Fumimura & Ryoichi Ikegami/ Shogakukan, T © Viz Communications; C & D © Ryuji Tsugihara & Yoshiki Hidaka, T © Coamix Inc.; E © Naoki Urasawa/ Shogakukan. 104, 105 & 106: A & B: © Kazuo Koike & Goseki Kojima/ Originally published in Japan in 1995 by Koike Shoin Publishing Co., Ltd., T © Dark Horse Comics. 106: C © Hiroaki Samura/ Kodansha, T © Dark Horse Comics; D & E © Reiko Okano/ Hakusensha. 107: A & B © Takehiko Inoue/ IT Planning Inc.; C & D © Hisashi Sakaguchi/ Kodansha. 108: A & B © Katsuhiro Otomo/ Mashroom Co. Ltd./ Kodansha, T © Dark Horse Comics; C & D © 1998 Gainax,T © Viz Communications. 109: © Katsuhiro Otomo/ Mashroom Co. Ltd./ Kodansha, T © Dark Horse Comics. 110: A & B © Hiroyuki Utatane & Toshiya Takeda/ Kodansha, T © Dark Horse Comics; C , D & E © CLAMP/ Kodansha, T © TokyoPop. 111: A & B © Naoki Yamamoto/ Shogakukan, T © Viz Communications; C, D & E © Rumiko Takahashi/ Shogakukan, T © Viz Communications. 112: © Kazuo Umezu/ Shogakukan. 113: A & B © Junji ito/ Shogakukan, T © Viz Communications; C, D, E & F © Hitosi Awaaki/ Kodansha. 114: © Masahi Tanaka/ Kodansha. 115: © 1989 Hayao Miyazaki/ Tokuma Shoten, T © Viz Communications.

CHAPTER 8 116: © Kenshi Hirokane, T © Kodansha International. 117: © George Asakura/ Shodensha. 118: A

© Anklet; B & C © Ohzora; C © Makoto Kobayashi/ Kodansha. 119: A © Tochi Ueyama/ Kodansha; B © Risu Akizuki, T © Kodansha International. 120: A, B & E © Moyoco Anno/ Shodensha, T © TokyoPop; C & D © Erica Sakurazawa/ Shodensha. T © Tokyo Pop. 121: © Maki Kusumoto/ Shodensha. 122: A & E © Jiro Gyu & Yosuke Kondo, T © Mangajin; B © Juzo Yamasaki & Kenichi Kitami, T © Mangajin; C & D © Kazuyoshi Torii, T © Mangajin. 123: A & B © Makoto Kobayashi/ Kodansha, T © Dark Horse Comics; C & D © Tetsu Adachi, T © CPM Manga. 124 & 125: © Jiro Taniguchi/ Kodansha. 126: A © Shogakukan; B & C Hiroshi 'Fujiko' Fujimoto/ Shogakukan ; C & D © Yoshito Usui/ Futabasha, T © ComicsOne. 127: A & B © Shungiku Uchida/ Shodensha; C & D © Hideki Arai/ Shogakukan, T © Editions Delcourt; E © Hakime Furukawa/ Shogakukan. 128: A & B © Shotaro Ishinomori, T © University of California Press; C © Kodansha; D © Yumeji Tanima/ Anklet. 129: A & B © Nojyo Junichi/ Shogakukan; C © Minamoto Taro/ Leed Publishing; D © Tochi Ueyama/ Shogakukan. 130: A © Katsuhiko Hotta/ Take Shobo/ Bamboo Comics; B & C © Shungiku Uchida/ Shodensha; C & D © Fumiko Takano/ Hakusensha. 131: A, B & C © Kenshi Hirokane/ Shogakukan; D © Kazumi Yamashita/ Kodansha.

CHAPTER 9 132: © Yoshiharu Tsuge. 133: © Siriagari Kotobuki/ Seirinkogeisha. 134: A © Manga Erotopia; B © Barazoku; C © Christy; D © Teruhiko Yumura. 135: © Suehiro Maruo. 136: A & B © Comiket; C © Mimiyo Tomozawa/ Seirinkogeisha. 137: A © Toshiki Sawada/ A-ha; B © Jun Miura & Takashi Nemoto/ Seirinkogeisha; C © Taiyo Matsumoto/ Shogakukan; D © Suwa Yuuji/ Shobunkan. 138: A & B © Yoshiharu Tsuge, T © The Comics Journal; C & E © Yoshiharu Tsuge; D © Yoshiharu Tsuge, T © Raw. 139: A & B © Shigeru Sugiura; C © Maki Sasaki/ Seirindo; D © Yu Takita/ Seirindo. 140: © Suehiro Maruo, T © Creation Books. 141: © Hideshi Hino, T © DH Publishing. 142: © Kazuichi Hanawa. 143: © Kazuichi Hanawa, C & D, T © Ponent Mon. 144: A & C © Toshiki Yui, T © Eros Comix; B © NeWMeN, T © Eros Comix; D © Suehirogari, T © Eros Comix; E © Kondom, T © Eros Comix. 145: © Hirayuki Utatane, T © Eros Comix. 146: © Teruhiko Yumura. 147: A & B © Yasuji Tanioka; C & D © Makoto Aida; E © Takashi Nemoto. 148: A & B © Junko Mizuno; C & D © Mimiyo Tomozawa/ Seinkogeisha. 149: A, B, C, D & F © Akiko Miura; E © Vassily Tabascova. 150: © Kan Takahama, T © Ponent Mon. 151: © Misa Mizuya & Hiroka Mizuya/ Style Co. Ltd.

CHAPTER 10 152: A © 'Moko'/ Bastille Nation République/ L'Association du X1e Arrondissement, Paris; B © Katsuhiro Otomo. 153: © Tetsu Hara// Newsweek Japan. 154: A © Katsuhiro Otomo/ Mashroom Co. Ltd./ Kodansha, T © Marvel Comics; B © Club Dorothée; C © Ediciones Junior SA; D © Atoss Takemoto. 155: A © TokyoPop; B © Graphic-sha Publishing. 156: A Photo © Wendy Jung; B © Christina Plaka/ Carlsen Verlag GmbH; C © Shueisha Inc./ Viz Communications; D © Gutsoon Entertainment Inc. 157: A & B © Taiyo Matsumoto/ Shogakukan; C © Paul Pope. 158 & 159: © Leiji Matsumoto/ Shinchousha/ Bandai Visual, T © Viz Communications. 160: A, B & C © Robert Labs/ Carlsen Verlag GmbH; D, E & F © Christina Plaka/ Carlsen Verlag GmbH. 161: A & B © Vanna Vinci & Giovanni Mattioli; C, D & E © Vanyda Savatier. 162: A, B & C © Jiro Taniguchi/ Kodansha, T © Editions Casterman; D Neo Devilman © Go Nagai/ Dynamic Planning Inc. All Rights Reserved, © Katsuya Terada/ Kodansha; E © Seizo Watase/ Kodansha. 163: © Taiyo Matsumoto/ Shogakukan. 164: A, B & C © Baru/ Kodansha, T © Editions Casterman; D, E & F © Edmond Baudoin/ Kodansha, T © L'Association. 165: A,B & C © Beb Deum/ Kodansha, T © Editions PMJ; D & E © Alex Barbier/ Kodansha. 166: A, B & C © Taro Yashima; D © Julio Shimamoto; E © Harvey Publications. 167: A © Yuko Shimizu; B & C © Mitsuba Wajima & 'Chiwawa'; D & E © Adrian Tomine. 168: A, B & C © Paul Pope; D, E & F © Andi Watson. 169: © Frédéric Boilet, T © Ponent Mon.170: A © Moga Mobo/ NouNouHau; B © Peter David/ Pop Mhan/ Dark Horse Comics; C © Toko; D © 'Smelly'/ NouNouHau. 171: A © Tak Ryusa Narita; B © Fred Gallagher & Rodney Caston; C © Alexander Unginor & Forbidden Galaxy.

All illustrations are copyright their respective copyright holders and are reproduced for historical purposes. Any omission or error should be notified to the publisher so that it can be rectified in any future edition.

Index

Adachi, Mitsuru 59
Adachi, Tetsu 123
Adams, Neal 155
Adolf 34, 35
Adorufu ni Tsugu 34, 35
Afternoon 99, 137, 157
Age of Cohabitation, The 96
A-ha 137
Aida, Makoto 147
Aihara, Koji 16, 17
Airboy 57
akabon 28, 38
Akatsuka, Fujio 58, 78
Akira 98, 100, 101, 108, 109, 154, 155
Akizuki, Risu 119
Albator 154
Alice 135
All Man 101
Ameya, Norimizu 148
Ando, Natsumi 85
Angoulême 157, 162
anime 8,9, 24, 26, 30, 31, 58–60, 68, 82, 108, 109, 115, 152, 154–56
Animerica Extra 156
Anklet 118
Anmitsu-hime 76, 77
L'année du dragon 161
Anno, Moyoco 120
Aoike, Yasuko 90
Aoyama, Gosho 59
Arabesque 81
Arai, Hideki 127
Araki, Hirohiko 101
Archie 13
Area 88 155
Ariyoshi, Kyoko 93
Armoured Alchemist 52, 53
Article 175 100, 137
Asahi Shimbun 24, 76, 77, 116
Asakura, George 116
Asari-chan 84
Ashita no Jo 52
L'Assiette au Beurre 21
Association to Protect Freedom of Expression in Comics 136
Asterix 15
Astro Boy 30, 32, 33, 55, 56, 57, 154
Astro Kyu-Dan 58
Aum Shinrikyo cult 119
L'Autoroute du soleil 164
Awaaki, Hitosi 113
aware 76
AX 132, 133, 137
Aya 118

Bakshi, Ralph 30
Banana Fish 80, 90
bandes dessinées 157, 162, 164, 165, 169
Banzai! 156, 160
Barazoku 134
Barbier, Alex 165
Barefoot Gen 9, 57, 64, 65, 154
Baru 164
Batman 56
Batman: The Dark Knight Returns 155
Battle of the Planets 155
Baudoin, Edmond 164
Beb Deum 165
Be-Bop High School 100
Be Love 116
Ben Is Dead 118
Bessatsu shojo comikku 88
Between the Sheets 120
Be x Boy 91
Big Comic 47, 98, 99, 101
Bilderbogen 21
bishojo 155
Black & White 157
Black Blizzard 38, 39, 45

Black Jack 59, 68, 69
Blade of the Immortal 106
Blast Books 156
Blondie 76, 77
Boilet, Frédéric 157, 169
Bondage Fairies 144
Bonita 116
Book of Five Rings, The 107
Bow Wow Wata 85
boys' love 80, 81, 88, 89–91
Brecht, Bertolt 29
Bringing Up a Rich Man 21
Bringing Up Father 21
Buddha 29, 36, 37
bunkobon 14
Buraku 41
Buronson 58
Busch, Wilhelm 21
Bushido 54, 98, 106
Buso Renkin 52, 53
Business Jump 127

Candy, Candy 154, 155
Captain America 57
Captain Harlock 154, 158, 159
Captain Tsubasa 54, 55, 90
Carlsen Verlag 156, 160
Carter, Angela 8
Caston, Rodney 171
Cat's Eye 14
censorship 58, 99, 100, 134–37
chanbara 99
Chaplin, Charlie 26
Characters of Worldly Young Men 20
Chiba, Tetsuya 40, 52, 54, 56, 57, 60, 61, 78
'Chiwawa' 167
Chobits 110
Christy 134
Cinderalla 148
City Hunter 96
Clamp 59, 81, 110, 136
Club 9 118, 123
Cocona 58, 59
COM 42, 50, 96, 135
Comet-san 78
Comic Amour 118
Comic Baku 135
Comic Book Legal Defense Fund, The 155
comic books, American 12, 13, 17, 28, 99, 154, 155, 157, 162, 166, 170
Comic Cue 137, 146, 148
Comickers 137
Comic Ran 98
Comics Journal, The 138
comic strips, American newspaper 12, 21, 23, 26, 28, 30
Comiket 136
Confidential Confessions 95
Cooking Papa 116, 129
Cornog, Martha 137
CoroCoro 84
cosplayers 136
Crayon Shinchan 126
Crewman 3 156
Le Crie Qui Tue 154, 156
Crime and Punishment 29
Crying Freeman 98
Cyborg 009 62

Daft Punk 159
Daisuki 156, 160
Dance Till Tomorrow 111
Dargaud 157
Dark Horse 156
David, Peter 170
DC Comics 157
Deadman 101
Death 157
Deka 41

De Luca, Gianni 161
Dennis the Menace 126
Detective Conan 59
Devilman 66, 162
Diary of a Fishing Freak 116, 122
Dick Tracy 12
Disney, Walt 24, 26, 28, 40
Division Chief Kosaku Shima 116
Dr Slump 156
Doing Time 142, 143
dojinshi 99, 132, 135, 136
Domu 98
Donsha 21
Doraemon 15, 57, 67, 126
Dorothée 154
Dostoevsky 29
Doucet, Julie 170
Dragon Ball 15, 16, 17, 18, 59, 70, 156
Dragon Ball Z 71
Dragonhead 101

Easy-Going Daddy 21
Eclipse Comics 155
e-dad 165
Eight Man 57
Eisner, Will 24, 119
Ejima, Koseki 20
Eng, Karen 118
Erino, Miya 118
ero-gekiga 135
Erogenica 135
Evangelion 101, 108
Even a Monkey Can Draw Manga 16, 17

Faust 29
Feel Young 116, 119, 121
Felix the Cat 22, 23
First Comics 155
First President of Japan 103
Fist of the North Star 58
FLCL 73
Fleischer Brothers 26
flopping 152, 160
Forbidden Galaxy 171
Forbidden S&M 118
Ford, Henry 12
For Lady 116
Four Immigrants Manga, The 23
Fritz the Cat 30
Fujimoto, Hiroshi 'Fujiko' 67
Fujisama, Tohru 100
Fujitani, Bob 154, 166
Fuku-chan 21
Fumimura, Sho 103
Funnjitachi 129
Funny 116
Furukawa, Hajime 127
Futsu jan! 74

gaijin 10
Gainax 73
Gaki Deka 66
Gallagher, Fred 171
Galaxy Express 999 159
Garo 41, 42, 43, 47, 48, 54, 96, 132, 134, 135, 137, 139, 143, 146, 150
GeGeGe-no-Kitaro 48, 49, 72
Geisha 168
gekiga 38–42, 49, 132
Gekiga Sonjoku 17
Genius Bakabon, The 58
Ghost Family 48
Ghost in the Shell 96, 98
Gibson, William 155
Gigantor 56, 57, 154
Gillray, James 21
Giraud, Jean 157
Glénat, Jacques 155
Glozer, Letitia 155
Godzilla 38

Go-Go Monster 162, 163
Gojira 38
Golden Bat 38
Goldorak 154
Golgo 13 41, 96, 102
Gon 114
Goto, Hiroki 59
Gottfredson, Floyd 30
Graphic-sha 155
Grappler Baki 59
Great Masturbator, The 140
Great Teacher Onizuka 100
Grendizer 56, 154
GTO 100
Guarda che Luna 161
Gundam 56, 57, 58
Gutsoon Entertainment 156
Gyu, Jiro 122

H (magazine) 148
Hagio, Moto 78, 80, 81, 88, 89
hana-ji 147
Hana to Yume 92
Hanawa, Kazuichi 142, 143
Haneko 21
Hansel and Gretel 148
Happy Mania 120
Hara, Tesu 58, 152
Harenchi Gakuen 58
Harlequin 118
Hasagawa, Machiko 76
Heart of Thomas, The 88
Hell Baby 140
hentai 118
Hergé 21, 24
heta-uma 135, 146
Hidaka, Yoshiki 103
Hikaru no Go 119
Hino, Hideshi 140, 141, 156
Hirata, Hiroshi 98
Hirohito, Emperor 57
Hirokane, Kenshi 116, 131
Hiroshima 57, 64, 65
Hohki, Kazuko 80
Hojo, Tsukasa 59
Hokusai, Katsushika 9, 18, 21
Homebuilding 127
Hosokawa, Chieko 85
Hotta, Katsuhiko 130
Hot Tails 144
Huge Love for Women in their 30s 118
Human Crossroads 116

ideograms 8, 9, 18
I Don't Like Friday 127
Ienaga, Saburo 41
Ikeda, Riyoko 78, 79, 80, 86, 87
Ikegami, Ryoichi 98, 103, 155
Ikki 137
Ikkyu 107
I'm No. 1! 122
I'm Teppei 54
Inoue, Takehiko 55, 99, 107
Inu Yasha 59
Interstella 5555 159
Iron Wok Jan 55
I Saw It 16
Ishii, Takashi 137
Ishinomori, Shotaro 28, 62, 119, 128
Ito, Junji 113
Ito, Kinko 118
Izubuchi, Yutaka 58

Japan Foundation 9
Japan Inc. 128
Japanize 170
Japanese Red Army 54
Japan Punch, The 20, 21
jidaigeki 98
Jiji Manga 21

Jiji Shinpo 21
J-literature 98
J-mags 137, 151
Johnson, Terry 146, 147
Jo-Jo's Bizarre Adventures 101
Josei Comic Papillon 116
Judge Dredd 15
June 80
Jungle Co 171
Jungle Taitei 28, 30
Junichi, Nojyo 129

Kabuki 9, 77
Kage 40
Kajiwara, Ikki 52, 58, 60, 61
Kamen Rider 57, 62
kami-shibai 38
Kamui Den 42, 43, 47, 54
Kamui Gai-Den 47, 155
kanji *see* ideograms
Kannomushi 143
Kappa Boys 161
Kasukobe, Takumi 16
Katsu 59
kawaii 136
Kida, Fred 154
Kimba the White Lion 28, 30
Kinderbook 150
Kinkichiro, Honda 21
Kinnikuman 63
Kirby, Jack 24
Kishi, Monotori 137
Kitami, Kenichi 122
Kitazawa, Rakuten 21
Kitchen 98
Kiyama, Henry (Yoshitaka) 23
Kobayashi, Makoto 10, 11, 123
Kodansha 10, 14, 41, 52, 56, 157, 161, 164, 168
Koike, Kazuo 17, 98. 104, 105, 106, 155
Kojima, Goseki 104, 105, 106, 155
Kondo, Yosuke 122
Kondom 144
Kotobuki, Siriagari 132, 133
Kotou, Mihou 74
Kurasawa, Akira 40
Kure, Tomafusa 98
Kurogane, Shosuke 76, 77
Kusumoto, Maki 121

Labs, Robert 156, 157, 160
ladies' comics 10, 116, 118, 119
Lady Victoria 74
Lang, Fritz 29
Left Hand of God, Right Hand of the Devil 113
Lettres au Maire de V. 165
Life of Momongo, The 148
Life of Professor Yanagisawa 131
Like Shooting Stars in the Twilight 119, 131
Lion King, The 28
Little Orphan Annie 12
Live Action Cartoonists 32
Little Witch Sally 78
Lolita complex 134, 136
Lone Wolf and Cub 17, 96, 98, 104, 105, 106, 155, 156
Lost World 24
Love from Eroica 90
Lupin III 96, 102

MacArthur, General Douglas 8, 10, 54, 77
Machi 40
Macross 58
Maeda, Keiji 98, 152
Magister Negi Magi 59
Magnificent 24s 78, 79, 80

Index

Maiko no Uta 85
Maiko's Poem 85
Maison Ikkoku 99, 111
Mai the Psychic Girl 155
Makoto-chan 66
Manga Action 96
manga cafés 14
Manga Erotopia 134
Manga Fever 152
mangaka 15, 16, 54, 55, 74, 78, 79, 81, 96, 132
mangashi 13
Manga Shonen 28
Manga Vizion 156
manwha (Korea) 154
Man Who Walks, The 124, 125
Margaret 78, 86, 90, 93
Marine Express 30, 31
Marmaru Chinbun 21
Marmalade Boy 95
Maruo, Suehiro 135, 137, 140
Marvel Comics 155, 157
Mashima, Hiro 58
Masked Rider 57, 62
Mask of Glass 78, 92
Matsumoto, Leiji 158, 159, 161
Matsumoto, Taiyo 54, 137, 157, 162, 163
Mattioli, Giovanni 161
Max & Moritz 21
Maya, Mineo 90
Mazinger Z 56, 57, 58, 154
McCloud, Scott 98
McManus, George 21
mecha 58, 155
Megatokyo 157, 171
Metropolis 24, 29
Mhan, Pop 170
Mickey Mouse 22, 30
Miller, Frank 155
Minami, Ozaki 90
Ministry of Education 18, 41
Minute Movies 30
Mishima, Yukio 98
Miso Curds 78
Misshitsu 137
Mr Arashi's Amazing Freak Show 135
Mr Sex Hero 118
Miuchi, Suzue 78, 92
Miura, Akiko 149
Miura, Jun 137
MixxZine 156
Miyamoto, Musashi 99, 107
Miyazaki, Hayao 98, 115
Miyazaki, Tsutomu 136
Mizuki, Shigeru 38, 43, 48, 49, 132
Mizuno, Junko 148
Mizushiro, Setona 94
Mizuya, Hiroka 151
Mizuya, Misa 151
Moebius 157
Moga Mobo 170
'Moko' 152
Momochi, Reiko 95
Monkey D. Luffy 73
Monkey Punch 96, 98, 102
Monster 103
Morning 15, 98, 99, 101, 119, 157
Moto, Naoko 74
Muno no hito 132
Muroyama, Mayumi 84
Muscleman 57, 63
Mushi Productions 30, 82
Mushroom Travel 136, 148
Mutant Hanako 147
My Birthday Comics 74
My Fat Budgie 139

Nagai, Go 56, 57, 58, 66, 162
Nagai, Katsuichi 41, 43, 132, 137
Nagamatsu, Tatsuo 38
Nagasaki 65
Nakayoshi 77, 78, 82
Nakazawa, Keiji 9, 16, 57, 64, 65, 154
Nambanga 171
Narita, Tak Ryusa 171

Naruto 73
Natsume, Fusanosuke 18
Nausicaä of the Valley of Wind 101, 115
Nejishiki 132, 134, 138
Nemoto, Takashi 137, 147
Neo Devilman 162
Neon Genesis Evangelion 101, 108
Neuromancer 155
NeWMeN 144
New Sun, The 154, 166
New Thing 167
New Treasure Island 26, 27, 38
Ninja Bugeicho 40, 42
Nobuhiro, Watsuki 52, 53
Noh 77
Norakuro 18, 19, 22, 23
Notes from the Frantic World of Sales 122
NouNouHau 170
nouvelle manga, la 157, 169
November Gymnasium, The 88
N.Y.N.Y 91

Oba's Electroplate Factory 138
obatalian 119, 130
Oda, Eiichiro 17, 73
Office Ladies 116, 119
Oh! Great! 99
Ohzora 116, 118
Okano, Reiko 106
Oke no Monsho 85
Oliff, Steve 154
Omiyoshi 106
One Piece 14, 17, 73
1001 Nights 30
Onoda, Natsu 32
Open 101
Optic Nerve 167
Ordinary, Isn't It? 74
Oshima, Takeshi 118
Oshima, Yumiko 81
otaku 14, 17, 136, 152
Otomo, Katsuhiro 98, 108, 109, 152, 154, 155
Ozu, Yasujiro 40

Panorama of Hell 140, 156
Parasyte 113
Pataliro 90
Patlabor 58
Pause 167
Paying the Bills 118
Peach Girl 81
Peanuts 16, 148
Perper, Timothy 137
Pharaoh's Seal 85
Phoenix 42, 50, 51
Phoenix 2772 30
Ping Pong 54
Pinoko 69
Plaka, Christina 156,157, 160
Planet of the Cotton County 81
Poe Clan, The 88
Le Poème du Vent et des Arbres 89
Pokémon 71, 78
Pomeroy Purdy 9
ponchi-e 21
Pope, Paul 157, 168
Portrait of Pia 74
Power Rangers 57
Pratt, Hugo 161
Princess 74, 79, 80, 85
Princess Beanjam 76, 77
Princess Gold 80
Princess Knight 77, 82, 83
Princess Mermaid 148
Prussian Blue 160
pseudo-manga 157
Puck 21
Pulp 156
Punch 21
Putrid Night 140

Ragawa, Marimo 91
Raijin Comics 156
Rave 59

Raw 134, 138, 139
red-book 24, 28, 29, 38, 40
Red Flowers 138
redikomi 10, 116, 118, 119
Red Snake, The 140
rental libraries 40, 132
Reservoir Chronicle 59
Retired, No Boss, No Work 119
Revenge of the Hunchback 40
Ribon 74, 77, 78
Ribon no Kishi 77
Rikidozan 38
Le Rire 21
Robotech 155
Roman June 80
rorikon 134, 136
Rose of Versailles, The 79, 86, 87
Rouge 118

Sachimi, Riho 80
Saijyo, Shinji 55
Sailor Moon 14, 78
Saito, Takao 41, 102
Sakaguchi, Higashi 107
Sakai, Shishima 28
Sakaoka, Noboru 63
Sakurazawa, Erica 120
salarymen 116, 119, 122
Samura, Hiroaki 106
Samurai Deeper Kyo 59
Sanctuary 103
Sasaki, Maki 137
Satonaka, Machiko 74
Savatier, Vanyda 161
Sawada, Toshiki 137
Sazae-san 76, 77
Schodt, Frederik 9, 100
Schulz, Charles 16
Screw-Style 132, 134, 138
scrolls 18
Section Chief Kosaku Shima 116, 119
Seedy 41
Seraphic Feather 110
Sewer Boy 140
Shadow 40
Shaman King 72
Shameless School 58, 66
Shigemitsu, Takao 79
Shikibu, Murasaki 74, 76
Shimamoto, Julio 166
Shimizu, Yuko 167
Shimoda, Carol (Emiko) 135
Shin-Takarajima 26, 27
Shintani, Kaoru 155
Shirato, Sanpei 38, 40, 41, 42, 43, 46, 47, 54, 155
Shirow, Masamune 96, 97, 136
Shobunkan 137
Shock Gibson 166
Shogakukan 14, 56, 137
Shogaku Ninensei 63, 126
shogi 129
Shogun Tofu 134, 146
Shojo 77
Shojo Club 76, 77, 82
Shojo Comic 89
Shojo Friend 78
Shojo Kai 76
Shojo Tsubaki 135
Shonen 55
Shonen Ace 56
shonen ai 80, 81, 88, 89–91
Shonen Champion 56, 59, 68
Shonen Club 80
Shonen Jump 14, 17, 52, 53, 55, 56, 57, 58, 59, 63, 66, 72, 73, 156
Shonen King 56, 62
Shonen Magazine 41, 52, 54, 56, 58, 59, 116
Shonen Sunday 13, 14, 56, 59
Shueisha 14, 58, 157
Shukan Bunshun 34
Shu-kay 149
Shumbuku, Ooka 20
shunga 20

Silver Valkyries 80
Skeleton Key 168
Slam Dunk 55
'Smelly' 170
Smile 156
Son Goku 70
Sonoda, Kenichi 136
Space Cruiser Yamato 159
Speed Comics 166
Speed Racer 154
Spider-Man 15
Spirou 15
Spyboy 170
sports 54
Star Blazers 155, 159
Star Wars 155
Street 40
Style Magazine 137, 151
studios 16, 17, 55, 56, 81
Suehirogari 144
Suenaga, Omuzi 149
Sugiura, Shigeru 135, 139
suiseki 132
Superman 15
Super Manga Blast 156
Survival in the Office 119
Susano-Oh 66
Swan 93
Switch 59

Tabascova, Vassily 149
Tagawa, Suiho 19, 22, 76
Takahama, Kan 150
Takahashi, Kazuki 72
Takahashi, Rumiko 16, 59, 81, 111, 168
Takahashi, Yoichi 54, 55
Takano, Fumiko 130
Taka of the Violet Lightning 57
Takarazuka 24, 26, 32, 33, 68, 77, 80
Takeda, Toshiya 110
Takehiko, Inoue 55
Takei, Hiroyuki 72
Takekuma, Kentaro 16, 17
Takemiya, Keiko 78, 80, 89
Takemoto, Atoss 156
Takeuchi, Naoko 78
Takita, Yu 139
Tale of Genji, The 74, 76
Tales from the Crypt 166
Tanaka, Masashi 114
Taniguchi, Jiro 124, 125, 157, 162
Tanima, Yumeji 128
Tanioka, Yasuji 147
tankobon 14
Tarayama, Shuji 52
Taro, Minamoto 129
Tarzan 38
Tatsumi, Yoshihiro 38, 39, 40, 42, 44, 45, 156
Tenjho Tenge 99
Tensai Bakabon 58
Terada, Katsuya 162
Terashimacho Kitan 139
Tetsujin 28 go 56, 57
Tetsuwan Atom 30, 33
Tezuka, Osamu 14, 16, 17, 18, 23, 24–37, 40, 42, 50, 51, 55, 56, 59, 62, 68, 69, 77, 78, 79, 82, 83, 116, 154
THB 157, 168
Theroux, Paul 8
Things to Come 29
Three Metres to the Sun 79
Tintin 21
Toba 18
Toba-e 20
Tödliche Dolis, Die 121
Toei Productions 62
Tokiwaso 55
Toko 170
TokyoPop 155, 156
Tokyo Story 99
Toma no Senso 88
Tomine, Adrian 156, 167
Tomorrow's Joe 40, 52, 54, 60, 61
Tomozawa, Mimiyo 136, 148

Torii, Kazuyoshi 122
Toriko 149
Toriyama, Akira 16, 17, 59, 70, 156
Toward the Terra 89
Truly Horrifying Mother-in-Law and Daughter-in-Law Comics 118
Truman, President Harry 8, 119
Tsuge, Yoshiharu 41, 42, 43, 132, 134, 138
Tsugihara, Ryuji 103
Tsurikichi Sanpei 54

Uchida, Shungiku 127, 130
Ueda, Hajime 73
Ueda, Miwa 81
Uehara, Kimiko 85
Ueyama, Tochi 119, 129
U-Jin 99
ukiyo-e 20
ukiyo-zoshi 20
Ultimate Muscle 63
Ultra Brothers 63
Ultraman 57, 63
Umekawa, Kazumi 85
Umezu, Kazuo 66, 112, 113
Understanding Comics 98
Unginor, Alexander 171
Unknown Kingdom 59
Urasawa, Naoki 103
Usui, Yoshito 126
Utatane, Hiroyuki 110, 145
Uzumaki 113

Vagabond 107
Vanyda 161
Vinci, Vanna 161
Virtual Master 144
Viz 156

Wajima, Mitsuba 81, 167
Walker, Mort 79
Ware, Chris 23
Watase, Seizo 162, 168
Watson, Andi 168
Weather Woman 123
Weng, Chen 101
Whelan, Ed 30
White on Rice 167
Wirgman, Charles 20, 21

X-Day 94
X-Men, The 155

Yaguchi, Takao 54
Yamagami, Tatsuhiko 66
Yamagishi, Riyoko 78, 80, 81
Yamamoto, Naoki 111
Yamasaki, Juzo 122
Yamashita, Kazumi 131
Yamato, Waki 79
Yamazaki, Tsutomu 143
Yashima, Taro 154, 166
Yasuda, Kazuo 15
yokai 20
Yokomizo, Seishi 155
Yokoyama, Mitsuteru 78
Yokoyama, Ryuichi 21
Yoshida, Akimi 80, 90
Yoshida, Mitsuhiko 9
Yoshikawa, Eiji 107
Yoshimoto, Banana 98
Yoshinaka, Megumi 80
Yoshizumi, Wataru 95
You 116
Young 10, 11, 96, 99, 155
Young, Chic 76
Youth Policy Unit 54, 58, 100
Yudetamago 63
Yu-Gi-Oh! 59, 72
Yui, Toshiki 144
Yukiko's Spinach 169
Yumemakura, Baku 106
Yumura, Teruhiko 134, 135, 146
Yuuji, Suwa 137

Zetsu ai 1989 90
Zettai anzen kamisori 130
Zodiac P.I. 85